ANNI ALBERS AND ANCIENT AMERICAN TEXTILES

Anni Albers
and Ancient American Textiles

From Bauhaus to Black Mountain

Virginia Gardner Troy

ASHGATE

Published by
Ashgate Publishing Limited Ashgate Publishing Company
Gower House 131 Main Street
Croft Road Burlington
Aldershot Vermont 05401–5600
Hants GU11 3HR USA
England

Ashgate website: http://www.ashgate.com

British Library Cataloguing-in-Publication data
Troy, Virginia Gardner
 Anni Albers and Ancient American Textiles: From Bauhaus to Black Mountain
 1. Albers, Anni – Criticism and interpretation
 I. Title
 709.2

Library of Congress Cataloging-in-Publication data
Troy, Virginia Gardner
 Anni Albers and Ancient American Textiles:
From Bauhaus to Black Mountain/Virginia Gardner Troy.
 p. cm
 Includes bibliographical references.
 1. Albers, Anni – Criticism and interpretation. 2. Hand weaving – History –
 20th century. 3. Textile design – Influence. 4. Textile fabrics, Ancient –
 Andes Region. I. Title.
 NK8998.A45 T76 2002
 746'.092–dc21 2001046401

 ISBN 0 7546 0501 9

Designed and typeset by Paul McAlinden

Printed in Great Britain by Biddles Limited, Guildford and King's Lynn

Contents

Illustrations

Reiss and A. Stübel, *The Necropolis of Ancon in Peru*, trans. A.H. Keane, Vol. 2, Berlin: Asher & Co., 1880–87, plate 104)

3.6 Ica, detail of textile with maize plant, wool and cotton, Museum für Völkerkunde, Berlin (reproduced in Max Schmidt, *Kunst und Kultur von Peru*, Berlin: Propyläen-Verlag, 1929, p. 485)

3.7 Margarete Willers, slit tapestry, 1922, linen warp, linen and wool weft, leather ribbons, 39.5 × 32 cm (15.8 × 12.8 in), Bauhaus-Archiv, Berlin (1417). Photograph by Atelier Schneider

3.8 Chancay textile, fish pattern, cotton and supplementary wool brocade weft, 17.8 × 27.9 cm (7 × 11 in), four selvages, Anni Albers Collection, Josef and Anni Albers Foundation, Bethany, Connecticut (PC013). Reproduced courtesy of the Foundation

3.9 Ida Kerkovius, tapestry, c. 1920, interlocked tapestry, present location unknown. Photograph courtesy of the Bauhaus-Archiv, Berlin

3.10 Andean checkerboard and step-form textile fragments, 'Dress Materials with Geometrical Patterns' (reproduced in W. Reiss and A. Stübel, *The Necropolis of Ancon in Peru*, trans. A.H. Keane, Vol. 2, Berlin: Asher & Co., 1880–87, plate 54)

3.11 Max Peiffer-Watenphul, slit tapestry, c. 1921, hemp warp, wool weft, 137 × 76 cm (54.8 × 30.4 in), Bauhaus-Archiv, Berlin (586). Photograph by Fred Kraus

3.12 Tunic, Inca/Early Colonial, Ancón, Peru, tapestry, cotton and camelid, height 84 cm (33.6 in), Museum für Völkerkunde, Berlin, Macedo Collection, 1884. Photograph by Dietrich Graf

3.13 Lore Leudesdorff, 1923, slit tapestry, silk and wool, 18 × 17.5 cm (7.2 × 7 in), Bauhaus-Archiv, Berlin (3669). Photograph by Hermann Kiessling

3.14 Andean painted cotton textile with feather motifs, 79 × 88 cm (31.6 × 35.2 in) (reproduced in W. Reiss and A. Stübel, *The Necropolis of Ancon in Peru*, trans. A.H. Keane, Vol. 2, Berlin: Asher & Co., 1880–87, plate 39)

3.15 Marcel Breuer and Gunta Stölzl, 'African Chair', 1921, present location unknown. Photograph courtesy of the Bauhaus-Archiv, Berlin

3.16 Marcel Breuer and Gunta Stölzl, chair, 1921, Kunstsammlungen zu Weimar (no. 225155). Photograph by Roland Doepler

3.17 Benita Koch-Otte, woven wall hanging, 1922–24, wool and cotton tapestry, 214 × 110 cm (85.6 × 44 in), Bauhaus-Archiv, Berlin (3643)

3.18 Gunta Stölzl, tapestry, 1923–24, wool, silk, mercerized cotton, metal thread, 176.5 × 114.3 cm (69.5 × 45 in), Museum of Modern Art, New York,

Phyllis B. Lambert Fund. © 2001 Artists Rights Society (ARS), New York/Beeldrecht, Amsterdam

3.19 Anni Albers, illustration from *On Weaving*, plate 63, 'interlocking warp and weft (Peru)'. Reproduced courtesy of the Josef and Anni Albers Foundation, Bethany, Connecticut

Chapter Four
Anni Albers at the Bauhaus

4.1 Anni Albers, wall hanging, 1924, cotton and silk, 169.6 × 100.3 cm (66.8 × 39.5 in), Josef and Anni Albers Foundation, Bethany, Connecticut. © 2001 The Josef and Anni Albers Foundation/Artists Rights Society (ARS), New York. Photograph by Tim Nighswander

4.2 Anni Albers, wall hanging, 1924, wool, silk, cotton, 120 cm wide (48 in), present location unknown. Photo courtesy of the Josef and Anni Albers Foundation, Bethany, Connecticut

4.3 Tunic, Inca, 'key' pattern, cotton and camelid, 92 × 79.2 cm (36.8 × 31.7 in), Museum für Völkerkunde, Munich

4.4 Anni Albers, illustration from *On Weaving*, plate 23, 'cross section of double cloth in contrasting colors, interlocked for pattern effect'. Reproduced courtesy of the Josef and Anni Albers Foundation, Bethany, Connecticut

4.5 Anni Albers, wall hanging, 1925, silk, cotton, acetate, 145 × 92 cm (58 × 36.8 in), Die Neue Sammlung, Staatliches Museum für angewandte Kunst, Munich. Photograph by Die Neue Sammlung

4.6 Josef Albers, *Upward*, c. 1926, sandblasted glass, 44.4 × 31.9 cm (17.75 × 12.75 in), Josef and Anni Albers Foundation, Bethany, Connecticut. © 2001 The Josef and Anni Albers Foundation/Artists Rights Society (ARS), New York, GL-2

4.7 Anni Albers, wall hanging, 1926, silk, multi-weave, 182.9 × 122 cm (72 × 48 in), Busch-Reisinger Museum, Harvard University Art Museums, Association Fund (BR48.132). Photograph by Michael Nedzweski

4.8 Tunic, Pachacamac, double weave, red and white, 64 × 55 cm (25.6 × 22 in), views of both sides, Museum für Völkerkunde, Berlin (reproduced in Walter Lehmann, *Kunstgeschichte des Alten Peru*, Berlin: Wasmuth, 1924, p. 117)

4.9 Anni Albers, wall hanging, 1964 reconstruction of a 1927 original, cotton and silk double weave, 147 × 118 cm (58.8 × 47.2 in), Bauhaus-Archiv, Berlin

4.10 Anni Albers, wall hanging, 1964 reconstruction of a 1926 original, cotton and silk, triple weave,

175 × 118 cm (70 × 47.2 in), Bauhaus-Archiv, Berlin (1475). Photograph by Gunter Lepkowski

4.11 Tunic, Inca/Early Colonial, *tocapu*, 96.3 × 92.5 cm (38.5 × 37 in), found in stone chest near Moro-Kato, Island of Titicaca, now in the American Museum of Natural History, New York, Garces Collection, purchased by A.F. Bandelier in 1896 (32601). Photograph by Thomas Lunt

4.12 Tunic, Inca, black and white checkerboard pattern with red yoke, cotton and camelid, with gold beads, 96.5 × 80.5 cm (38.6 × 32.2 in), Museum für Völkerkunde, Munich

4.13 Tunic, 'Royal Tunic', Inca, cotton and camelid, 71 × 76.5 cm (28.4 × 30.6 in), Bliss Collection, Research Library and Collection, Dumbarton Oaks, Washington, DC. Photograph © Justin Kerr

4.14 Paul Klee, *Beride (Wasserstadt)* (Beride (Town by the Sea)), 1927, 51 (01), pen on paper on cardboard, 16.3 × 22.1 cm (6.5 × 8.75 in), Paul-Klee-Stiftung, Kunstmuseum Bern (Z618 4264). © 2001 Artists Rights Society (ARS), New York/VG Bild-Kunst, Bonn

4.15 Paul Klee, *Farbtafel (auf Majorem Grau)* (Color Table, on Major Gray), 1930.83 (R3), pastel on paper mounted on board, 37.7 × 30.4 cm (15.1 × 12.2 in), Paul-Klee-Stiftung, Kunstmuseum Bern (F73, 5199). © 2001 Artists Rights Society (ARS), New York/VG Bild-Kunst, Bonn

4.16 Anni Albers, page 13 from a notebook for Paul Klee's course, 'Gebiet der Vermehrung' (Area of the Increase), c. 1927, pencil and typing on tracing paper, 29.6 × 21.1 cm (11.8 × 8.4 in), Bauhaus-Archiv, Berlin (1995/17.105). Photograph by Markus Hawlik

4.17 Paul Klee, 'Pädagogischer Nachlass (Principielle Ordnung)', 23 October 1923, pencil on paper, pp. 2 and 3, 22 × 28.7 cm (8.8 × 11.5 in), Paul-Klee-Stiftung, Kunstmuseum Bern (PN10 M9/7, 755 b, c). © 2001 Artists Rights Society (ARS), New York/VG Bild-Kunst, Bonn

4.18 Paul Klee, 'Pädagogischer Nachlass (Specielle Ordnung)', no date, colored pencil and lead pencil on paper, 33 × 21 cm (13.2 × 8.4 in), Paul-Klee-Stiftung, Kunstmuseum Bern (PH30 M60/68, 2760). © 2001 Artists Rights Society (ARS), New York/VG Bild-Kunst, Bonn

4.19 Textile fragment, Chancay, plain cotton ground with discontinuous complementary wool warp pattern, 13.3 × 15.2 cm (5.25 × 6 in), Anni Albers Collection (PC079), Josef and Anni Albers Foundation, Bethany, Connecticut. Reproduced courtesy of the Josef and Anni Albers Foundation,

Bethany, Connecticut. Photograph by Tim Nighswander

4.20 Ernst Kallai, Paul Klee as 'The Bauhaus Buddha', 1929, photo-collage, Bauhaus-Archiv, Berlin

4.21 Open-weave textile with stepped fret (reproduced in R. and M. d'Harcourt, *Les Tissus indiens du vieux Pérou*, Paris: Albert Morancé, 1924, plate 29)

4.22 Anni Albers, open-weave textile, no date, Josef and Anni Albers Foundation, Bethany, Connecticut. © 2001 The Josef and Anni Albers Foundation/Artists Rights Society (ARS), New York

4.23 Anni Albers, Zeiss Ikon analysis of wall-covering material for the auditorium of the Allgemeinen Deutschen Gewerkschaftsbundesschule (General German Trades Union School), Bernau, Germany, 1929, cotton, chenille, and cellophane, 22.9 × 12.7 cm (9 × 5 in), Museum of Modern Art, New York, gift of the designer. Photograph courtesy of the Josef and Anni Albers Foundation, Bethany, Connecticut

Chapter Five
Anni Albers in the United States and Mexico

5.1 Josef Albers, 'Teotihuacan Museum, etc.', no date, contact prints mounted on cardboard, 263 × 20.3 cm, Josef and Anni Albers Foundation, Bethany, Connecticut (PH577). © 2001 The Josef and Anni Albers Foundation/Artists Rights Society (ARS), New York. Photograph by Tim Nighswander

5.2 Josef Albers, 'Santo Thomas, Oaxaca', no date, contact prints mounted on cardboard, 20 × 30.2 cm (8 × 12.1 in), Josef and Anni Albers Foundation, Bethany, Connecticut (PH578). © 2001 The Josef and Anni Albers Foundation/Artists Rights Society (ARS), New York. Photograph by Tim Nighswander

5.3 Anni Albers, woven belts, c. 1944, Josef and Anni Albers Foundation, Bethany, Connecticut. © 2001 The Josef and Anni Albers Foundation/Artists Rights Society (ARS), New York. Photograph by Genevieve Naylor

5.4 Quipu, from the coastal valley of Chancay, Peru, 120 × 80 cm (48 × 32 in), American Museum of Natural History, New York (325190). Photograph by Logan

5.5 Anni Albers, *Monte Alban*, 1936, 143.8 × 111.3 cm (57.5 × 44.5 in), Busch-Reisinger Museum, Harvard University Art Museums, gift of Mr and Mrs Richard G. Leahy (BR81.5). Photograph by Michael Nedzweski

5.6 Anni Albers, *Ancient Writing*, 1936, woven rayon and cotton, 147.5 × 109.4 cm (59 × 43.75 in),

Smithsonian American Art Museum, Washington, DC, gift of John Young

5.7 Josef Albers, 'Anni at Monte Albán', photograph, c. 1935, 11.9 × 8.1 cm (4.75 × 3.25 in). © 2001 The Josef and Anni Albers Foundation/Artists Rights Society (ARS), New York

5.8 Paul Klee, *Zwei Kräfte* (Two Forces), no. 23, 1922, watercolor and ink on cardboard, 28.4 × 19.2 cm (11.4 × 7.7 in), formerly in the collection of Anni Albers, now in Die Sammlung Berggruen, Staatlichen Museen, Berlin. © 2001 Artists Rights Society (ARS), New York/VG Bild-Kunst, Bonn

5.9 Serape, Queretaro, Mexico, nineteenth century, woven silk and cotton, 205.7 × 127 cm (81 × 50 in), Harriett Englehardt Memorial Collection, gift of Mrs Paul Moore, Yale University Art Gallery, New Haven, Connecticut (1958.13.22)

5.10 Anni Albers, *With Verticals*, 1946, 152.5 × 115.6 cm (61 × 46.5 in), collection of Robert Pottinger, Chicago. Photograph courtesy of the Josef and Anni Albers Foundation, Bethany, Connecticut

5.11 Textile fragment, Nazca, cotton, double-faced double weave, 8.6 × 9.5 cm (3.5 × 3.8 in), Anni Albers Collection (PC069), Josef and Anni Albers Foundation, Bethany, Connecticut. Reproduced courtesy of the Foundation

5.12 Anni Albers, *La Luz I*, 1947, sateen weave with discontinuous brocade, linen, metal gimp, 47 × 82.5 cm (19 × 32 in), Josef and Anni Albers Foundation, Bethany, Connecticut. © 2001 The Josef and Anni Albers Foundation/Artists Rights Society (ARS), New York. Photograph by Tim Nighswander

5.13 Installation view of the exhibition 'Anni Albers Textiles', Museum of Modern Art, New York, 14 September 1949 – 6 November 1949. Photograph © 2001 The Museum of Modern Art, New York

Chapter Six
Anni Albers at Black Mountain College: weaver, teacher, writer, and collector

6.1 Black Mountain College students weaving on backstrap looms, 1945. Photograph by John Harvey Campbell

6.2 Anni Albers, studies made with twisted paper and corn, no date, in Anni Albers, *On Weaving*, Middletown, CT: Wesleyan Press, 1965, plates 34 and 35. © 2001 The Josef and Anni Albers Foundation/Artists Rights Society (ARS), New York. Photograph by Todd Webb

6.3 Josef Albers, *America* (detail), 1950, masonry brick, 330 × 260.6 cm (11 ft × 8 ft 8.25 in),

Harkness Graduate Center, Harvard University Law School. Photograph by Steven Smith

6.4 Josef Albers, no title (Mitla, detail of Palace of the Columns, Oaxaca), no date, 21 × 17.7 cm (8.4 × 7.1 in), Josef and Anni Albers Foundation, Bethany, Connecticut (PH376). © 2001 The Josef and Anni Albers Foundation/Artists Rights Society (ARS), New York. Photograph by Tim Nighswander

6.5 Stamp, Guerrero, Late Post-classic, 1250–1521 CE, ceramic, 7 cm (2.8 in), Peabody Museum of Natural History, New Haven, Connecticut, gift of Josef and Anni Albers (251685)

6.6 Schematic human statuette, possibly Colima, Proto-classic, 100 BCE – 300 CE, gray mottled stone, 4 cm (1.6 in), Peabody Museum of Natural History, New Haven, Connecticut, gift of Josef and Anni Albers (257392)

6.7 Tunic fragment, Wari, South Coast Peru, 700–900 CE, camelid wool over cotton tapestry weave, 15.6 × 60.4 cm (6.5 × 23.75 in), Hobart and Edward Small Moore Memorial Collection, Yale University Art Gallery, New Haven, Connecticut, gift of Mrs William H. Moore (1937.4583)

Chapter Seven
Anni Albers: pictorial weavings in the 1950s and 1960s

7.1 Anni Albers, *Black-White-Gold I*, 1950, cotton, jute, and metallic ribbon, 63.5 × 48.3 cm (25 × 19 in), Josef and Anni Albers Foundation, Bethany, Connecticut. © 2001 The Josef and Anni Albers Foundation/Artists Rights Society (ARS), New York

7.2 Peruvian knitted cap, hand-spun wool, 28 × 20.2 cm (11 × 8 in), Harriett Englehardt Memorial Collection, Yale University Art Gallery, New Haven, Connecticut, gift of Mrs Paul Moore (1958.13.13)

7.3 Anni Albers, *Code*, 1962, 58.4 × 18.4 cm (23 × 7.25 in), Josef and Anni Albers Foundation, Bethany, Connecticut. © 2001 The Josef and Anni Albers Foundation/Artists Rights Society (ARS), New York. Photograph by Tim Nighswander

7.4 Anni Albers, *Two*, 1952, cotton, rayon, linen, 45 × 102.5 cm (18 × 41 in), Josef and Anni Albers Foundation, Bethany, Connecticut. © 2001 The Josef and Anni Albers Foundation/Artists Rights Society (ARS), New York. Photograph by Tim Nighswander

7.5 The Klee exhibition at the Buchholz Gallery, 1948. Photograph courtesy of the Paul-Klee-Stiftung, Kunstmuseum Bern

7.6 Theo van Doesburg, *Composition in Black and White*, 1918, from the catalogue of the De Stijl exhibition, Museum of Modern Art, New York, 1952. © 2001

Artists Rights Society (ARS), New York/Beeldrecht, Amsterdam

7.7 Section of tunic, Wari, camelid and cotton, tapestry weave, 151.1 × 112.1 cm (60.5 × 45 in), Bliss Collection, Dumbarton Oaks Research Library and Collection, Washington, DC. Photograph © Justin Kerr

7.8 Bag, Nazca, tubular double weave, 31 × 22 cm (12.4 × 8.8 in), Art Institute of Chicago (1955.1795), formerly in the Eduard Gaffron Collection, Schlachtensee (reproduced in Walter Lehmann, *Kunstgeschichte des Alten Peru*, Berlin: Wasmuth, 1924, p. I)

7.9 Textile fragment, Wari or Chancay, cotton warp, wool weft, tapestry with supplementary-weft brocade, 18.1 × 10.2 cm (7.13 × 4 in), Anni Albers Collection, Josef and Anni Albers Foundation, Bethany, Connecticut (PC074). Reproduced courtesy of the Foundation

7.10 Anni Albers, *Pictographic*, 1953, cotton with embroidered chenille, 45.7 cm × 103.5 cm (18 × 40.75 in), Detroit Institute of Arts, Founders Society Purchase, Stanley and Madalyn Rosen Fund, Dr and Mrs George Kamperman Fund, Octavia W. Bates Fund, Emma S. Fechimer Fund, and William C. Yawkey Fund (79.166)

7.11 Photograph of the Robert Woods Bliss Collection at the National Gallery of Art, Washington, DC, taken between 1947 and 1960, of objects acquired in the 1940s, Dumbarton Oaks Research Library and Collection, Washington, DC (reproduced in Elizabeth Boone, ed., *Collecting the Pre-Columbian Past*, Washington, DC: Dumbarton Oaks, 1993, p. 22). Reproduced with permission of the Dumbarton Oaks Research Library and Collection, Washington, DC

7.12 Anni Albers, *Red Meander*, 1954, linen and cotton, 65 × 50.6 cm (26 × 20.25 in), collection of Ruth Agoos Villalovos. Photograph by Tim Nighswander

7.13 Anni Albers, *Tikal*, 1958, cotton, plain and leno weave, 75 × 57.5 cm (30 × 23 in), American Craft Museum, New York, gift of the Johnson Wax Company 1979, donated by the American Craft Council, 1990. Photograph by Eva Heyd

7.14 Anni Albers, *Open Letter*, 1958, 57.5 × 58.8 cm (23 × 23.5 in), Josef and Anni Albers Foundation, Bethany, Connecticut. © 2001 The Josef and Anni Albers Foundation/Artists Rights Society (ARS), New York. Photograph by Tim Nighswander

7.15 Anni Albers, *Play of Squares*, 1955, wool and linen, 87.6 × 62.2 cm (35 × 24.9 in), Currier Gallery of Art, Manchester, New Hampshire, Currier Funds (1956.3)

7.16 Anni Albers, *Six Prayers*, 1965–66, cotton, linen, bast, and silver Lurex threads, six panels, 186 × 51 cm (73.06 × 19.69 in) each, Jewish Museum, New York, gift of Albert A. List Family (JM 149-71.1-6). © Artists Rights Society, New York

Acknowledgments

This book could not have been completed without the unceasing help from the Josef and Anni Albers Foundation in Bethany, Connecticut. I am especially grateful to Nicholas Fox Weber, Executive Director, for offering me his personal recollections of Josef and Anni Albers, for granting access to the Albers archives and permission to reproduce works in the collection, and for inviting me to write an essay for the Anni Albers retrospective catalogue, parts of which have been incorporated here. I also wish to thank Kelly Feeney, formerly of the Foundation, and in particular Brenda Danilowitz, Curator, for their invaluable assistance and expertise. Moreover, I am sincerely thankful for their generous contribution to support publication expenses.

I would like to extend my thanks to Professors Rebecca Stone-Miller and Clark V. Poling for their insights and inspiration. Many of the ideas for this book were formed under their guidance and supported with grants while I was a graduate student at Emory University. More recently, Berry College has generously supported this project through publication grants, release time, and travel grants that enabled me to conduct research abroad and in the United States on numerous occasions. Annie and Biddy Hurlbut of the Peruvian Connection, Tonganoxie, Kansas, have provided additional financial support, for which I am deeply grateful.

Many of Albers's former students and colleagues provided me with information. I am particularly grateful to Don Page, a former student at Black Mountain College, for his wonderful letters. I also thank Tony Landreau, Else Regensteiner, Yvonne Bobrowicz, Sheila Hicks, Lore Kadden Lindenfeld, and Jack Lenor Larson for their recollections.

Numerous museum curators and staff members of institutions in the United States and Europe have offered their support over the years. I am grateful to Craig Morris, of the American Museum of Natural History, for granting access to the Junius B. Bird files; Mary Jane Jacob, Independent Curator, Chicago, for her comments on Albers; Emilie Norris, Assistant Curator, Busch-Reisinger Museum, for her gracious help with the Bauhaus Weaving Workshop material; Jane Adlin and Cristina Carr, of the Metropolitan Museum, New York, for providing access to the Bauhaus material at the Ratti Textile Study Center; the staff at the North Carolina State Archives, Raleigh, for helping me work with the Black Mountain College Papers; Susan Matheson, Curator

of Ancient Art, Yale University Art Gallery, for allowing me to see the Harriett Englehardt Memorial Collection; Elisabeth Lundin, of the Landskrona Museum, Sweden, for helping with the Nell Walden material; and Patricia Malarcher, Editor of *Surface Design Journal*, for publishing and supporting my work with textiles. I am particularly grateful to Dr Manuela Fischer and Frau Renate Strelow, of the Berlin Museum für Völkerkunde, for allowing me to see the great collection of Andean textiles there and for helping me to locate early museum publications. I thank Dr Anja Baumhoff, Professor at the Weimar Hochschule für Architektur und Bauwesen, for information regarding the Bauhaus Weaving Workshop. I am grateful to Dr Magdalena Droste, formerly of the Bauhaus-Archiv, for allowing me to conduct research there – with the help of Fräulein Eckert – and for providing me with significant information related to my project. I thank Dr Josef Helfenstein, former Associate Director of the Kunstmuseum Bern and the Paul-Klee-Stiftung, now Director of the Krannert Art Museum, for his support and expertise, and for inviting me to write an essay for the 1998 catalogue 'Josef und Anni Albers: Europa und Amerika', portions of which appear here in English. I also thank the staff of the Paul-Klee-Stiftung, and Frau Heidi Hofsteter of the Ethnography Department at the Bernisches Historisches Museum. I am grateful to the many museums, collectors, and photographers who granted permission to reproduce art for this book.

I extend warm thanks to my editor at Ashgate, Pamela Edwardes, for supporting this project, as well as to copyeditor Maureen Street, my desk editor Kirsten Weissenberg and designer Paul McAlinden. For their help with the manuscript and translations I thank Brenda Danilowitz, Sigrid Weltge, Sarah Lowengard, and Tina Bucher. At Berry Alicia Ray helped to compile the index, and student Jenny Ackridge helped with the details.

Most of all, I thank my husband Robert Troy for all that he has done to help make this project a reality. I dedicate this work to him and our son, Adam.

Introduction

Anni Albers (1899–1994) was 66 years old when she completed her book *On Weaving* in 1965, the culminating point of a weaving career that spanned nearly half a century. Soon after finishing the book she gave up weaving altogether. By then, however, she had already made a significant contribution to twentieth-century art and design by challenging traditional Western notions of art materials, subject matter, and pedagogy. Albers created art through weaving. Her belief that weaving could function as art was based not on European artistic conventions that typically relegated weaving to 'secondary' status but on her understanding of an ancient society that regarded weaving as high art. This book seeks to explore the fascinating cross-cultural and cross-historical relationship between Anni Albers and her ancient American predecessors, her 'teachers' as she called them, the weavers of ancient Peru.

From the utilitarian world of the German Bauhaus (1919–1933), which developed out of nineteenth-century arts reform movements, through the poetic world of post-World War II America, Albers was an extraordinary twentieth-century artist-designer who tested the parameters of modern art through her unique translation of the ancient past. Albers is known today for her textile work, primarily for the geometric wall hangings from her Bauhaus years that served as prototypes for industrial production. She has only recently been acknowledged for her role in reviving and redefining the ancient Peruvian (Andean) fiber art tradition. Now the significance of this textile tradition for her woven and pedagogical work can be more fully understood.[1]

At the time Albers wrote *On Weaving*, few discussions of Andean textiles *as art* had appeared in weaving textbooks, but there were many publications, many of which were German books published between 1880 and 1929, that documented and described them.[2] Albers almost single-handedly introduced weaving students to this ancient textile art through her writing and her artistic work. Her basic premise – formed when she was a student of the Bauhaus, and still highly relevant today – was that modern textile workers, both in industry and in art, should thoroughly study the forms and structures of Andean textiles because these textiles represent 'a standard of achievement that is unsurpassed' in the field of textile design and production, despite modern machinery.[3]

Albers was extremely inventive and articulate in the way she connected the Andean textile with contemporary notions of truth to materials and the interconnectedness of structure and design. At the same time, she was acutely aware of the semantic function of thread and textiles within the context of artistic language. Through her continuous investigation of thread *as a carrier of meaning*, not simply as a utilitarian product, she created art that she believed functioned within the context of visual language, as practiced by her ancient Andean predecessors.[4]

In *On Weaving*, Albers reveals her fundamental approach to art and design: namely that Andean textiles set the standards by which one could most completely understand the possibilities of fiber as a medium for creative expression. Indeed, Albers believed that Andean textiles were 'the most outstanding examples of textile art [from which] we can learn most'.[5] Using Andean textiles as her guides, Albers developed an innovative approach to the teaching, practice, and understanding of weaving in the twentieth century, paving the way for the medium of fiber to be included in the fine arts mainstream. Anni Albers, artist, teacher, writer, and collector, held a unique position as an intermediary between the ancient past and the modern machine age by applying the lessons she learned from the visual and structural language of Andean textiles to the needs and sensibilities of her time.

Albers was among many artists and writers working during the first decades of the twentieth century who studied the material culture of non-European societies. The Western interest in so-called 'primitive' art and the discourse of primitivism during this period was complex and far-reaching, involving, in part, the supposition that 'primitive' art – the hand-made art produced by small-scale pre-industrialized cultures – was both useful and artistically designed according to fundamental social and spiritual beliefs.[6] This was in contrast to the perceived uselessness and poor design of much European art, especially decorative art. 'Primitive' art was perceived by theorist Wilhelm Worringer and members of Die Brücke and Der Blaue Reiter as authentic and pure, untainted by mechanical contrivance or conventional illusionistic devices, and that the visual form of this art was inherently abstract.[7] 'Primitive' art and practice represented a significant alternative to traditional European artistic conventions, and thus it was studied, its abstract motifs borrowed, and its hand-made production processes emulated in an attempt to revive and understand the basis of human creative processes and visual forms. Textiles played an important role in these theoretical and artistic explorations.

At the same time in Germany, the Berlin Museum für Völkerkunde was under-

taking an intensive acquisition program of non-European art, particularly Andean textiles, thanks to extensive archaeological work conducted by German scholars and collectors working in Peru, whose collections ultimately ended up in the Berlin museum. For example, by 1907 the Andean art collection at the Berlin Museum für Völkerkunde was enormous; the textile collection alone exceeded 7500 pieces, by far the largest collection of Andean textiles in Europe at the time.[8] Collectors were fascinated by the technical complexity and abstract pictorial imagery of these textiles created on simple hand looms by a sophisticated culture that did not use conventional Western writing systems but instead employed symbols to communicate their ideas.[9]

This direct communication of use and design resonated fully with Bauhaus ideals; the abstract visual language and incredible technical mastery of Andean woven textiles were qualities that many modern artists admired and adapted, Albers chief among them. It is not surprising to learn that her lifelong interest in Pre-Columbian art began in Germany and that she frequently visited the ethnographic museums there.[10]

After rejecting the traditional handicraft training at the Hamburg Kunstgewerbeschule (School of Arts and Crafts), Anni Albers, then Annelise Fleischmann, joined the Bauhaus in 1922 at the age of 23, where she met and married fellow Bauhausler Josef Albers (1888–1976) in 1925.[11] They became two of the longest-tenured members of the Bauhaus: he stayed for thirteen years, she for nine. Albers was the daughter of furniture manufacturer Sigfried Fleischmann and Antonie Ullstein Fleischmann, a member of the prominent Ullstein publishing family. Ullstein published among other journals and books *Die Dame, BIZ, Der Querschnitt, Uhu*, and the extensive Propyläen-Kunstgeschichte series, which included art historian Max Schmidt's important 1929 book, *Kunst und Kultur von Peru*, which Anni Albers owned and consulted.[12] While the story of the Bauhaus is well documented, Anni Albers's role in the Weaving Workshop has not been fully examined within the larger context of applied arts reform, primitivism, the teachings of Paul Klee, and the impact of Andean textiles.[13] The first half of this book will illuminate this fascinating and interrelated set of conditions.

Anni and Josef Albers immigrated to the United States in November of 1933 to begin teaching at Black Mountain College, a newly established liberal arts school located in the mountains of North Carolina. This close proximity to Mexico was important to Anni's development as an artist and teacher. At Black Mountain she was the sole weaving teacher; this position enabled her to develop new pedagogical techniques to

complement her Bauhaus ideology. Importantly, as she looked back upon her Bauhaus years and filtered her memories of it, she began to fully understand the impact of Klee's work and teaching.

Anni initiated the Alberses' first trip to Mexico in 1935, and they made almost annual trips thereafter throughout their tenure at Black Mountain.[14] From the start, she combed the markets in Mexico for 'old things', primarily Pre-Columbian textiles, as well as modern Latin American textiles for her personal collection; she also assembled a substantial collection of textiles for Black Mountain College, most of which were Andean and modern Latin American.[15] Anni acquired the first piece for her and Josef's collection of Mesoamerican and Andean art, a collection that grew to over 1000 pieces and that included ceramics, stonework, jade, and textiles. At the time, her collection practices were unique in that as an artist and teacher she gathered examples of ancient art to study them carefully, not necessarily to showcase them. Indeed, she took scissors to a number of the Andean textiles she owned in order to fully understand their construction!

Albers's approach to art and design, which encouraged a healthy relationship between art, craft, and industry, ran counter to the craft revivals taking place at the same time in the nearby Appalachian Mountains where the emphasis was on building moral character through hard handwork, encouraging self-sufficiency through small cottage industries, and gaining independence from the machine through total control over the product, from spinning to weaving. Even though these goals come directly from the nineteenth-century applied arts reform movement that had such an impact at the Bauhaus, Albers was never so romantic as to advance hand-weaving as the sole method for producing yardgoods. Similarly, she was never interested in spinning or dyeing fiber, preferring to utilize the conveniences of modern life by purchasing manufactured yarn products. Yet, by the 1950s, Albers's interest in the utilitarian aspects of weaving diminished in favor of her pursuit of the artistic possibilities of weaving, a pursuit that was fueled by her ever-increasing understanding of Andean textiles.

Albers's pictorial weavings from the 1950s and 1960s are visually and conceptually stunning, representing the culmination of decades of exploration and study; On Weaving represented the peak of her written work. After nearly half a century of working with thread, writing about weaving, and studying Andean textiles, she had arrived at a point where she clearly understood the role of textiles as art. The book, therefore, was her final testament, her last great homage to the Andean textiles she so admired.

1. Some historical background

Anni Albers's interest in ancient, non-European art was part of an overall trend in the early twentieth century by European and American artists to study and appropriate aspects of what they termed 'primitive' art. Unlike most of her contemporaries, however, who focused primarily on African and Oceanic art, Albers studied the textiles of ancient Peru. While her admiration for Andean art was unique and far-reaching, it did not develop from a void. Rather, it developed from the conflation of many factors, including innovations in applied arts and education reform, cultural studies of non-European art by theorists, new exhibiting practices that juxtaposed ancient and non-European art with modern European art and design, and her access to extraordinary collections of these textiles in her native Germany. These were also factors that impacted German artists from the Brücke and Blaue Reiter groups such as Paul Klee and Wassily Kandinsky, her teachers at the Bauhaus.

By the late nineteenth century, the term 'primitive' was broadly applied by Westerners to describe a range of art products produced by groups perceived to be different from, or removed in time and context from, contemporary European societies.[1] 'Primitive' was, however, an inconsistently used term that presents the present-day scholar with the task of making explicit the varying contexts for its usage. Attitudes to and definitions of the term continually shifted because the notion itself involved positioning one set of values against another, as different 'primitive' models were investigated for different reasons. Art considered to be 'primitive' in the late nineteenth and early twentieth centuries included the art of the pre-historic, Gothic, and folk traditions of Europe; the art of Asian and Near Eastern empires, including Chinese, Japanese, Indonesian, Indian, Persian, and Egyptian – occasionally referred to as 'exotic' art; the art of ancient American empires, including Andean, Mesoamerican, and Native American cultures; and African and Oceanic art, often referred to as art of 'tribal' or 'savage' societies. In addition, the art of children, peasants, and the insane was also classified as 'primitive' because this art represented a supposedly uncorrupted artistic expression. The unifying factors of these vast and diverse groups were that their members represented 'others' to modern Westerners and that their art served as a contrast to European art of the post-Renaissance period. 'Primitive' art, because it was not governed by the conventions of what was considered to be 'civilized'

European art, was thought by many scholars and artists during the decade preceding World War I to be a purer art, a technically simpler art, and a more abstract art than conventional European art.

Non-European textiles played a central role in the conceptualization of 'primitive' ideals, in the related revival of handicrafts, and in the developments of cultural theories in pre-World War I Germany. The 'primitive' textile model provided an alternative to the machine model and to conventional Western forms and techniques, and stimulated significant changes in nineteenth- and twentieth-century art and design.

Applied arts reform

Numerous scholars have noted that the formation of the Bauhaus in post-World War I Germany was in part a continuation of the discourse associated with the applied arts reform movement, which originated in England during the mid-nineteenth century primarily through the writings and textile designs of William Morris. Textiles figured prominently in Morris's ideology. He believed that the machine had poisoned traditional crafts aesthetically, economically, and spiritually, and that artists could improve the conditions under which the decorative arts were created by becoming designers themselves and reviving traditional handicraft training and production.[2] Morris established several decorative arts guilds in the 1870s that produced hand-made textiles, including Morris and Co. and Hammersmith, the carpet workshop in London that produced hand-made carpets based on his designs (Figure 1.1).

Morris and other designers (including Arthur Lasenby Liberty and Christopher Dresser) believed that textile designs should suggest the organic forms found in nature and that their patterns should follow natural laws of growth.[3] They looked first to Asian textiles as models to reinforce these principles, and found – particularly in the Near Eastern and Asian carpet designs that Owen Jones reproduced in his 1856 book *The Grammar of Ornament*, as well as in the textiles that Dresser saw in the Far East in 1876, and in the fabrics that Liberty imported from the Middle and Far East for the store he opened in 1875 – examples of the flat patterns they tried to achieve in their own work.[4]

The general principles of applied arts reform that took place in England in the nineteenth century were influential throughout Europe, becoming the basis of the broad movement known as Art Nouveau. The primary goals of practitioners of Art Nouveau were to revive handicrafts, unite art with craft, derive the design of an object from its material and function, and maintain artistic control over the design and pro-

duction of a product. While Morris relied exclusively on the hand-made process, other artists and theorists, particularly in Germany, introduced the possibility of machine production into the discourse of applied arts reform, as manifested in the German incarnation of Morris's Arts and Crafts movement, Jugendstil, 'the style of youth'.

The goal of reviving handicrafts stimulated a far-reaching interest by scholars, theorists, and artists of the late nineteenth and early twentieth centuries in historical textile processes, such as tapestry, lace-making, and embroidery from pre-industrial Europe, as well as in historical textile patterns, such as rugs and cloth with abstract floral patterns from the countries around the Mediterranean and in Asia. The carpets produced by Morris's Hammersmith workshop, for example, reveal a strong indebtedness to the designs and production methods of Persian carpets from Turkey and Iran, which were in great demand at the time.[5] Morris is certainly one of the most famous of the nineteenth-century designers who established a precedent in the field of modern textile design of looking to the textile products of non-European cultures for inspiration.

In fin-de-siècle Germany, Jugendstil designers such as Hermann Obrist and Otto Eckmann also used textiles to address issues associated with applied arts reform. In a ground-breaking 1896 exhibition at Littauer's Salon in Munich, Obrist exhibited thirty-five embroideries, executed by hand by his assistant Berthe Ruchet according to his designs. These designs, such as his famous *Peitchenheib* (Whiplash) of c. 1895 (Figure 1.2), were important because they introduced a new visual language of naturalistic abstraction in decorative art. The plant-like forms suggest those found in nature without representing them illusionistically, a decided break from conventional European principles and industrial production. Obrist was aware of the flat, abstracted forms of Japanese woodblock print designs, and his 'modern' designs reveal a formal indebtedness to them.[6] The influence of the 1896 exhibition, which was shown in Munich, Berlin, and London, was attested by the German Jugendstil artist and architect August Endell's statement, 'The starting point of my work was the embroidery of Hermann Obrist, in which for the first time I got to know free, organically invented, not externally composed forms.'[7] Otto Eckmann's 1896–97 tapestry *Fünf Schwäne* (Five Swans) (Figure 1.3), woven by students at the Kunstgewerbeschule, Scherrebek, was also considered an example of the new art movement and was similarly inspired by the flat patterns and abstracted naturalistic forms of Japanese art.[8]

Jugendstil textile designers, and those of the Wiener Werkstätte in Vienna as well, maintained Morris's concern with decorative design and, also like Morris, con-

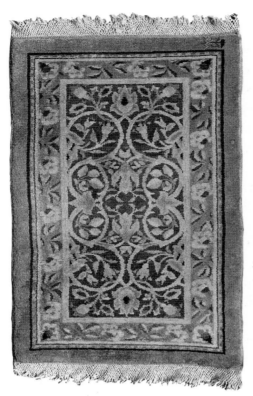

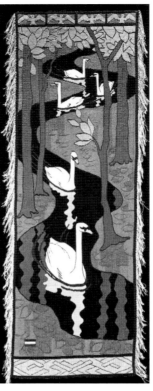

1.1 William Morris, 'Woodpecker' carpet produced by the Hammersmith workshop, 1885, hand-knotted woolen pile on cotton warp, 248.8 × 135.9 cm (99.5 × 54.5 in), Victoria and Albert Museum, London

1.3 Otto Eckmann, *Fünf Schwäne* (Five Swans), 1896–97, wool and cotton tapestry, 240 × 103 cm (96 × 41.2 in), woven at the Kunstgewerbeschule, Scherrebek, Germany (est. 1896), Museum of Fine Arts, Boston

1.2 Hermann Obrist, *Peitchenheib* (Whiplash), c. 1895, wool with silk embroidery, 117.5 × 180.6 cm (47 × 72.25 in), Stadtmuseum, Munich

tinued to utilize preliminary drafts from cartoons for their patterns rather than thinking of the pattern as a direct result of the inherent over-and-under structural process of weaving.[9] In other words, the design remained separated from the textile structure. This contradiction was not resolved until the 1920s by members of the Bauhaus Weaving Workshop, Anni Albers being the chief proponent. This difference in approach from decorative design to structural design would reflect the use of a different non-European model: the Andean textile model in place of the Asian textile model. As we will see, some time needed to pass before the Andean model could be effectively put into place.

Cultural theorists: Riegl, Semper, and Worringer

Paralleling applied arts reform movements and museum acquisition campaigns during the late nineteenth and early twentieth centuries, art historians and cultural theorists analyzed a diverse range of non-European art, in a quest to locate the supposed origins of ornamental design patterns. The Germanic scholars Alois Riegl, Gottfried Semper, and Wilhelm Worringer asserted that the ornamental arts, which included textiles, most fully revealed the essence of a culture's visual vocabulary. Accordingly, textiles from diverse chronological, geographic, and stylistic categories were studied and written about in scholarly publications.

Semper and Riegl studied a wide range of textiles, including those of Asia, ancient Greece, Rome, and the Islamic countries around the Mediterranean, in order to investigate what they considered to be the migration of artistic styles and processes from one medium to another and from one cultural group to another. Riegl's interest in ornament arose from his contact with textiles while he was Curator of Textiles at the Österreichische Museum für Angewandte Kunst (Austrian Museum of Applied Arts) from 1885 to 1897, during which time he wrote his book *Stilfragen: Grundlegungen zu einer Geschichte der Ornamentik* (Problems of Style: Foundations for a History of Ornament), published in 1893. In *Stilfragen* Riegl argued that each culture has a unique will to create ornamental design (*Kunstwollen*), apart from mimetic or materialist motivations, and thus ornamental design could be seen as a historical and cultural phenomenon transformed according to time and place.[10]

Riegl, with his careful formal study of historic and non-European textiles, was among the first to emphasize textiles as a point of departure for the understanding of pattern and iconography in the decorative arts.[11] Like the work of Owen Jones and Semper, Riegl's study did not involve the art of ancient America. This omission most

likely reflected the fact that these writers did not have access to substantial quantities of ancient American objects. In Vienna, for example, until 1914 the Museum für Völkerkunde probably had fewer than 100 Andean textiles in its collection, and Andean textile collections in Britain were similarly limited.[12] In Semper's Germany, the bulk of the Andean material did not arrive until after 1879, the date his book, *Der Stil in den Technischen Künsten, oder Praktischer Aesthetik* (Style in the Technical Arts, or Practical Aesthetics), appeared.

Riegl's argument opposed Semper's theory of technical determinism, often called 'materialism', which argued that art originated as the product of material and technique rather than from a creative drive. For example, Semper contended that the vertical/horizontal patterns of weaving were simply the direct results of the technique of crossing warp with weft and that all geometric ornamental patterns were generated from the interlaced structure of woven and twined textiles. According to Semper, the earliest material technology was that of woven fibers, and from it the linear patterns that it generated subsequently migrated to other media such as ceramics and architecture. While Riegl also assigned textiles a central role in cultural development, he contended that their geometric patterns did not simply appear as a response to weaving technology but rather originated from an inherent human need to decorate and arrange. He argued that these patterns were the result of early attempts at artistic expression, embodying principles of abstract rhythm and symmetry.[13] In essence, the dichotomy presented by Semper and Riegl parallels the continuing debate concerning craft and art, which Albers would come to terms with in the 1930s with the creation of her 'pictorial weavings'.

The importance of Riegl in Germany in the first decades of the twentieth century is suggested by the statement of the Expressionist critic Hermann Bahr in his 1916 text, *Expressionismus*:

> Who is Riegl? … there is not a book of contemporary art criticism that does not contain [his] thoughts … To Germans, a piece of art was a mechanical product derived from necessity, material, and technique … This attitude only defines the margins of a total product … Riegl objected to the dogma of materialism and felt that art came from the spirit of the living human being.[14]

Bahr's comments reveal his understanding of Riegl's disagreement with Semper and the relevance of his notion of the *Kunstwollen* to later Expressionist investigations regarding the spiritual nature of art. German Expressionist artists generally believed that the

essential condition under which 'primitive' art was produced involved the connection between inner spirit and creative process, a connection that had not yet been severed by 'civilization', as it was in modern times. This particular notion would become relevant during the War period when Bahr, among others, called for a revival of the 'primitive' state as a solution to the chaos brought on by 'civilization'. He continued,

> We ourselves have to become barbarians to save the future of humanity from mankind as it now is. As primitive man, driven by fear of Nature, sought refuge within himself, so we too have to adopt flight from a 'civilisation' which is out to devour our souls.[15]

Riegl's German follower Wilhelm Worringer explored the links between 'primitive' art, geometric abstraction, and spiritual expression in his important 1907 dissertation, *Abstraktion und Einfühlung: ein Beitrag zur Stilpsychologie* (Abstraction and Empathy: A Contribution to the Psychology of Style), published in Munich in 1908. In this work, intended to continue and enhance Riegl's investigations, Worringer argued for a return to an originary state of human awareness in order to rediscover the spiritual basis of art.[16] Riegl's basic premise was that the geometric style occupied the initial position in a culture's aesthetic development: formal characteristics such as registers, meanders, checkerboards, and diamonds represented 'elementary means of dividing space' in a progression toward more illusionistic and curvilinear forms.[17] Worringer built on Riegl's notion of the *Kunstwollen* by contending that the initial geometric stage of expression was altogether different from later developments toward illusionism because of a difference in artistic motivation. The art produced at the lowest, most 'primitive' level of artistic development, Worringer argued, was the earliest example of abstract decorative expression in addition to being the purest of all arts in its 'geometric-crystalline regularity', and thus it should be studied both for its own sake and for its relevance to modern abstract art.[18] This last point, coupled with the intersection of the 'primitive' with geometric abstraction, had a great impact on Worringer's artist-colleagues, such as members of Der Blaue Reiter, who began to perceive their own abstract art as in some way 'primitive'.[19]

Worringer believed that because 'primitive' peoples experienced the world as chaotic, the 'primitive' artist could not look objectively at the world, and that the 'urge to abstraction', rather than being a drive to imitate natural phenomena, served as a means of achieving tranquillity amidst this chaos.[20] As humans gained a feeling of security in the world, they became more 'civilized', Worringer continued, and they controlled their world by reproducing it, imitating it, and projecting themselves into

it. Worringer referred to this impulse toward imitation as 'empathy'. Because the modern world is once again a chaotic world, Worringer postulated, the modern artist must again embrace the 'primitive' principles of abstraction.

Worringer's greatest influence on pre- and post-War Expressionist circles came from his basic premise that the essence of the visual expression of 'primitive' peoples is abstract. The critic Eckhart von Sydow, for example, wrote in his 1920 book *Die Deutsche Expressionistische Kultur und Malerei* (German Expressionist Culture and Painting), 'Worringer has a theory about primitive people which encompasses the world view of the close relationship between abstract and geometric art as an artistic expression in the early stages of human development.'[21] Worringer's idea that abstract art arises from a need to understand external forces beyond human control by representing the abstract essence of these forces became particularly relevant to artists during the War years. Paul Klee, for instance, wrote in 1915, 'The more terrifying this world – as is the case especially today – the more abstract the art, whereas a happy world brings forth an art of the here and now.'[22] Anni Albers, too, would come to reference Worringer in her work and writing.

Art educational reform

During the first decade of the twentieth century, two important concepts were developed by European art educators that paralleled aspects of Riegl's and Worringer's concepts: that in children's art abstraction precedes naturalism and that all visual forms are inherently connected to emotional states.[23] The first of these concepts supported Worringer's theory that the initial human artistic inclination is not toward imitation but toward abstraction; the second supported Riegl's and Worringer's assertions that human beings possess a basic will to create that is related to their historical and psychological context. Pre-dating Worringer's study were two texts by art educators who saw parallels between children's art and primitive art: Alfred Lichtward's *Die Kunst in der Schule* (Art in the School), of 1887, and Corrado Ricci's 1887 *L'Arte dei Bambini* (Children's Art), which was translated into German in 1906 as *Die Kinderkunst*.[24] Both theorized laws of creation that connected the natural creative abilities of children, unspoiled and untainted by adult logic, to the natural creative abilities of 'primitive' people, untainted by civilization.[25] The German art historian Sigfried Levinstein also associated primitive art with children's art in his 1905 text *Kinderzeichnungen bis zum 14. Lebensjahre* (Children's Drawings up to Age Fourteen).[26] The Viennese art educator Franz Cizek, who was Johannes Itten's teacher, recognized children's art as being 'the first

and purest source of artistic creation' and was one of the first to emphasize that children's art should be acknowledged not simply as a root of adult art, but as valid on its own and with its own set of laws.[27]

Related to the above investigations were those of a Berlin doctor, Theodor Koch-Grünberg, who spent two years during the first decade of the twentieth century living with and studying the indigenous societies of Northwest Brazil. In 1905, Koch-Grünberg published his *Anfänge der Kunst im Urwald* (Origins of Art in the Primeval Forest) and in 1909 *Zwei Jahre unter den Indianern* (Two Years with the Indians). In the first, he discussed certain formal devices characteristic of indigenous Brazilian art that also occur in children's art, noting that his book 'is not just of interest to ethnologists but also specialists in children's art'.[28]

In general, Koch-Grünberg believed, as do art educators today, that children's artistic expression develops in stages from schematic to complex, from expressive to representational, and from ideographic to imitative; children often repeat favorite schematic signs, using the same primary shapes to stand for different things. They rarely use illusionistic space but apply other methods of spatial organization such as x-ray and bird's-eye views, fusion of profiles, and non-sequential narratives.[29] Koch-Grünberg essentially analyzed the adult art he saw in Brazil as if children had done it. However misinformed the evolutionary theories that equated the 'primitive' with the child may have been, they constituted a part of early-twentieth-century German notions about non-European and unconventional art.

The nineteenth-century German educator Friedrich Fröbel, who modeled his kindergarten classes on the theories of Swiss educator Heinrich Pestalozzi, believed that sensory engagement, rather than the imposition of formulae, was crucial to the stimulation of a child's natural learning ability. Fröbel also believed that children naturally understood primary forms such as the circle, square, and triangle, and that the child's natural development progressed from the mastery of simple systems involving these forms to more complex systems. From these beliefs, Fröbel developed in the mid-1850s a series of pedagogical materials and exercises to help children develop their mental and physical dexterity. This program, which he called 'gifts' (materials) and 'occupations' (activities), involved, among other tasks, building structures with simple wooden blocks (gifts), connecting dots within a gridded field (occupations), and, of significance to this study, weaving with different-colored paper strips (occupations).

Fröbel's investigations into originary forms, his application of these primary

forms in pedagogical exercises, and his and his followers' position that children's art is valid in its own right, fueled the ongoing interest in 'primitive' art products, and also contributed to the foundation of Bauhaus design principles.[30] It is important to note here that numerous Bauhaus teachers were informed by these reforms in education. Johannes Itten modeled his Bauhaus 'Preliminary Course' (Vorkurs), particularly his practice of allowing students to engage in guided free play, on the new sensory-based art education.[31] J. Abbott Miller has pointed out that Kandinsky was educated according to the Fröbel kindergarten method and suggested that the additive and constructive method of Fröbel's 'gifts and occupations' exercises had an impact on the work and pedagogy of both Kandinsky and Klee.[32] Certainly Klee's Weimar Bauhaus lessons that dealt with constructive approaches to composition, such as building up a composition by simulating the under-and-over process of weaving and by connecting dots on a gridded field, were in part informed by innovative art education reforms. Significantly, Josef Albers was a trained art teacher and a practicing public school teacher in Germany during the first two decades of the twentieth century. Perhaps more than the others, Josef was keenly aware of the new 'hands-on' approach to education, which he utilized carefully in his classroom teaching after he became a Bauhaus Master in 1923. As Marcel Franciscono has discussed, many of the philosophies and exercises associated with education reform were familiar to Bauhaus members, and it was at the Bauhaus that the implementation of such methods was most successfully achieved in a professional design context.[33]

Klee, Kandinsky, and Josef Albers all lived in Munich during the pre-World War I period and studied art with Franz Stuck. Munich was one of the most important centers for educational reform in Europe during this time, and textiles played a role in the reform movement. It was in Munich that Hermann Obrist had used the attention he received from the 1896 exhibition of his embroideries to call for the union of fine art and craft within the educational reform movement.[34] Later, in 1901, Obrist and Wilhelm von Debschitz opened the Obrist-Debschitz School, which trained many important artists, including Ernst Ludwig Kirchner and Sophie Täuber Arp; Paul Klee briefly worked as an assistant in the figure-drawing course there.

The Obrist-Debschitz School served as a model for the Bauhaus, prefiguring Bauhaus goals by teaching students to break down the boundaries dividing art and craft and by emphasizing that good design comes from understanding and following the inherent laws of materials.[35] The school's revolutionary practice of co-educational admissions was also adopted as Bauhaus policy.[36] The school succeeded in reforming

traditional approaches to art education by following the idea of *total education*: learning through active engagement and experimentation with materials and forms.[37] In contrast to conventional educational practices, total education involved *going back* to a supposedly simpler, more intuitive state, and it paralleled investigations by German artists and writers within the context of primitivism. The link between educational reform, applied arts, and notions of 'primitive' art was thus well established in Munich and elsewhere in Germany before World War I. The search for originary forms, techniques, and expressions continued well after it.

Karl Osthaus and the presentation of non-European art and textiles in early-twentieth-century Germany

'Primitive' art served many purposes in the formation of modernist ideas. Besides serving as a contrast to the modern industrial age, 'primitive' art was believed capable of providing models for modern design. In the first decade of the twentieth century, the textile industrialist and art collector Karl Osthaus, who had studied with Riegl in Vienna, exhibited examples of non-European art along with modern art in his Folkwang Museum in Hagen (now Essen), which he established in 1904. Just as interest in non-European textiles increased by the early twentieth century, new ways of presenting this art were explored in museums and galleries. Through his exhibitions, Osthaus hoped to inspire a positive dialogue between modern artists and industrial designers and to promote unification between art, craft, and industry.[38] For example, in 1904 he organized an exhibition that juxtaposed Javanese, Japanese, and Indian textiles with industrial textiles designed by the Jugendstil artist and architect Peter Behrens.[39] Osthaus directly addressed applied arts issues by showing that aesthetic value was not exclusively tied to European fine art, but that ancient and non-European hand-made models provided legitimate formal, structural, and socially integrated models for a new society. He believed that 'the display of ancient decorative arts should provide an example for contemporary art [because of their] aesthetic worth'.[40]

Osthaus's ideas, developed shortly after the turn of the century and continuing after the War, are important to this study because both his and the Bauhaus's goals were to improve industrial design through a revival of artist-designed handicrafts. Indeed, Osthaus and Walter Gropius corresponded frequently with one another in 1914 on this issue.[41] Osthaus's projects were motivated by economics; his great inherited wealth was partly derived from Hagen's large textile industry, and it was in his best interest to support it by reforming it.[42] His solution was to educate modern

industrial designers about the design and structural attributes of non-European models, models that he believed were superior to the poorly designed examples from the industrial age. He organized exhibitions at the Folkwang in which modern artworks were juxtaposed with non-European ones in order to show what were considered their common characteristics. This approach to exhibition design and pedagogy was to be used later in Germany by Kandinsky in the *Blaue Reiter Almanach* (Osthaus was one of three patrons who pledged to finance the first edition of the almanac) and also by gallery owner Herwarth Walden at his Gallery Der Sturm and by curator Gustav Hartlaub at the Städtisches Kunsthalle Mannheim.[43]

Josef Albers, who met Osthaus at the Folkwang Museum in 1908, said of the museum, 'I spent my time as often as I could there.'[44] Visiting the Folkwang would have been relatively convenient for Albers because he attended classes at the Kunstgewerbeschule (Arts and Crafts School) in nearby Essen from 1916 to 1919. During this period, and in the decade preceding it, there were at least thirteen exhibitions at the Folkwang that featured textiles and many more that included non-European art.[45] Albers's contact with the Folkwang may well have contributed to his lifelong interest in non-European art, and in cross-cultural and cross-historical connections in art.

Textiles and German Expressionism

Non-European textile materials and processes provided a number of German artists with a perfect alternative to the European 'high art' painting tradition and conventional European narrative and figurative tapestries. Unlike the European tapestry tradition in which a weaver, usually a woman, was primarily responsible only for the rote reproduction of a pre-existing picture typically created by someone else, usually a man, the fiber arts of 'primitive' cultures, on the other hand, were seen as being more valued by the societies that produced them, more integrated into the needs of the society, and created by artists or craftspersons more fully engaged in the design and production process than their European counterparts. These features made 'primitive' textiles very attractive to modern artists eager to achieve the same results for their own time.

For example, the studio decorations that Die Brücke artist Ernst Ludwig Kirchner produced in his Dresden and Berlin studios between 1909 and 1915 demonstrate that he explored decorative arts simultaneously with primitivism. He hung painted textiles as well as embroidered and appliquéd coverings in his studios as

'primitive' people were thought to do, in order to create an environment where a primitivizing art and bohemian lifestyle merged.[46]

Kirchner was particularly interested in the resist textile technique of batik, a method of textile design that was enjoying a revival in pre-War Germany.[47] Batik was, and continues to be, frequently used in the Near East and Asia, and was also used by Andean artists in addition to another resist technique, tie-dye. Resist techniques involve masking parts of the cloth – with wax, resin, or tight folds – so that dye will not be absorbed into that area when the cloth is immersed in a dyebath. When wax (or resin) is used, as in the case of batik, the technique requires an immersion and re-coating process that ultimately cracks and breaks down the wax lines, causing the dyes to seep into earlier waxed areas. This eroded quality would have certainly attracted Kirchner because it recalled the appearance of an ancient, 'primitive' product.

Emil Nolde also engaged with primitivist issues through an eclectic mixing of epochs and cultures. He spent countless hours in 1912 studying non-European art in the Berlin Museum für Völkerkunde as preparation for a book on 'primitive' art he intended to write.[48] His awareness of textiles was perhaps inspired by his wife Ada, a weaver, and his friend and supporter Karl Osthaus, who also supported other members of the Brücke group.[49] In his comments in the projected book Nolde contrasted the 'beautiful' products and hand-made processes of 'primitive' art with the 'saccha-rinely tasteful decorations' of post-Renaissance art, in order to show the superiority of the 'primitive' model, an ironic and chilling twist considering Nolde's racist pro-clivities. He wrote,

> Why is it that we artists love to see the unsophisticated artifacts of the primitives? …
> Primitive people begin making things with their fingers, with material in their hands.
> Their work expresses the pleasure of making … The fundamental sense of identity, the
> plastic – colorful – ornamental pleasure shown by 'primitives' for their weapons and
> their objects of sacred or daily uses are surely often more beautiful than the saccha-
> rinely tasteful decoration on the objects displayed in the show cases of our salons and
> in the museums of arts and crafts. There is enough art around that is over-bred, pale,
> and decadent … We 'educated' people have not moved so wondrously far ahead.[50]

His comments exemplify the popular desire at the time to return to primary tech-niques and forms in order to be reunited with the universal process and act of cre-ation. To Nolde, the hand-made, 'primitive' model was superior partly due to his own suspicions about the contemporary European art world.

Nolde's art demonstrates that his notion of the 'primitive' was, like that of others of this period, based on a *composite* of various epochs and cultures. Such a notion is expressed in his *Exotische Figuren II* (Exotic Figures II) (1911) (Figure 1.4), in which a Hopi Kachina figure is juxtaposed with Andean feline figures in front of a background of stepped-fret motifs from an Andean textile. Indeed, Nolde most likely had seen numerous examples of the stepped-fret motifs in Berlin collections. Nolde probably appropriated the feline motif from a Nazca feather tunic that belonged to Eduard Gaffron, a collector of Andean textiles who lived near Berlin (see Figure 1.5).[51] The tunic, illustrated in Walter Lehmann's 1924 book, *Kunstgeschichte des Alten Peru*, discussed below, is now at the Art Institute of Chicago. Gaffron also owned a stunning Wari tunic that may have served as Nolde's model for the geometric stepped-fret form (see Figure 1.6), which was also illustrated in Lehmann's book.[52]

Nolde's composite image of the American 'primitive', drawn from a feather tunic, a stepped-fret tapestry, and a Kachina figure, reveals that he was looking at a range of source material in order to investigate his idea of the 'primitive'. He enlivened these inanimate objects by removing them from their original context and then juxtaposing them in a way that suggests a narrative. The cats, for example, removed from their placement on the tunic, appear to be stalking the Kachina doll. Like other members of the Brücke group, Nolde created an imaginary environment in which he could engage emotionally and physically with the 'primitive'.[53]

Der Blaue Reiter

It is significant that Kandinsky's introduction to his pivotal 1912 text, *Über das Geistige in der Kunst* (Concerning the Spiritual in Art), should make reference to 'primitive' art. He wrote,

> When there is, as sometimes happens, a similarity of inner direction in an entire
> moral and spiritual milieu, a similarity of ideals, at first closely pursued but later lost
> to sight, a similarity of 'inner mood' between one period and another, the logical con-
> sequence will be a revival of the external forms which served to express those insights
> in the earlier age. This may account partially for our sympathy and affinity with and
> our comprehension of the work of primitives. Like ourselves, these pure artists sought
> to express only inner and essential feelings in their works.[54]

Kandinsky's endorsement of the 'primitives' was plainly allied with Worringer's, whose *Abstraktion und Einfühlung* Kandinsky read at the time of its publication.[55] Like his

friend and colleague Klee, Kandinsky made it clear that he did not want to imitate the forms of 'primitive' art but rather was interested in the process of making an art that 'nourished the spirit'.[56]

It is not surprising to find that Kandinsky's interest in 'primitive' art occurred simultaneously with his experiments in the decorative arts, including textiles, for like other artists and theorists coming out of Jugendstil aesthetics, he found a strong connection between ornament, abstraction, spirituality, and the art of 'others', including his own.[57] Significantly, this connection also included 'primitive' art. Kandinsky's concern with universalist primitivism, an aspect of primitivism that allowed him to embrace an eclectic range of 'primitive' art for the purpose of finding the supposed universal affinities between them, was made clear in the *Blaue Reiter Almanach*, published in 1912 by Piper-Verlag, Munich, and co-edited by Kandinsky, Franz Marc, and August Macke.

The *Almanach* appeared the year after the first Blaue Reiter exhibition at the Thannhauser Gallery, Munich, an exhibition that subsequently went on to Berlin as the inaugural exhibition at the Gallery Der Sturm, under the direction of Herwarth Walden.[58] The almanac was broader in scope than the Blaue Reiter exhibitions, and included essays by artists, musicians, and writers. The publication was profusely illustrated with non-European art from a broad range of cultures selected by the editors, probably with help from Paul Klee, from ethnographic material in Munich, Berlin, and Bern.[59] Along with examples of European Gothic and folk art and crafts were children's art, art from Africa, Oceania, and Asia, as well as art from the ancient Americas, including an Aztec stone sculpture from the fifteenth century, a Brazilian mask made of woven reed and bark fiber, and a Native American Tlingit woven blanket from the nineteenth century. These were juxtaposed with works by modern Europeans including Van Gogh, Henri Rousseau, Marc, Macke, Kandinsky, Gabriele Münter, and Robert Delaunay. The editors sought to trace what they considered to be the true sources of art, and to illustrate art that was inspired by pure inner necessity. Concerning the art of early cultures, for example, Kandinsky wrote, 'The further we look back into the past, the fewer faked and spurious works we find.'[60]

Kandinsky, Marc, and Macke were aware of ancient American art, which was readily available for them to see in Munich and Berlin. Marc wrote to Macke in 1911 that no 'primitive' art he had seen in the Berlin Museum für Völkerkunde could surpass 'the sublime works of the Incas'.[61] What did Marc mean by this? While he may have been referring to actual Inca objects he saw at the Berlin museum, or photo-

graphs of Inca monuments and stonework, it is more likely that he was making a more general statement by calling all Andean works Inca, for lack of a more precise understanding. Indeed it was only around this same time that Max Uhle, an archaeologist and curator at the Dresden Museum für Völkerkunde, announced his stratigraphic and stylistic findings regarding pre-Inca and non-Inca-influenced societies, the evidence for which he discovered at the ancient sites of Tiwanaku, Pachacamac, and Ancón, Peru.[62] So while the profusion of objects that had been excavated from these sites, particularly the textiles, had already been acquired by the Berlin Museum für Völkerkunde, Marc may not have been aware of the recent scholarly findings.

Like the other *Blaue Reiter Almanach* editors, Macke agreed that an appreciation of 'primitive' art could break down the barriers separating modern artists from intuitive expression. Macke's almanac essay, 'Masks', is testimony to the great value he placed on the expressive forms that he believed were found in 'primitive' art, similar to those of the 'savages' of the avant-garde, including the Blaue Reiter and Brücke members. He wrote,

> The contemptuous gesture with which connoisseurs and artists have to this day banished all artistic forms of primitive cultures to the fields of ethnology or applied art is amazing at the very least. What we hang on the wall as a painting is basically similar to the carved and painted pillars in an African hut.[63]

This remark appeared underneath the reproduction of the Tlingit Chieftain's Cape from Alaska that members of the Blaue Reiter would have seen in the Munich Museum für Völkerkunde. Macke's non-specificity – suggesting an equation between the pillars in an African hut and a Tlingit weaving – reveals his interest in finding universal connections among all art. Like others, therefore, Macke used textiles as a means of addressing primitivist issues.

Even before his association with the Blaue Reiter group, beginning in 1911, Paul Klee was well aware of non-European art from his exposure to it at the ethnographic museums in Bern and Berlin.[64] Indeed, as early as 1902, Klee's primitivism, a primitivism that would embrace non-European and non-academic expression, was already formed. 'I want to be as though new-born', he wrote in his diary that year, 'knowing absolutely nothing about Europe, ignoring poets and fashions, to be almost primitive.'[65] Klee was also to be inspired by the writings of Worringer, whom he probably met through Kandinsky's urging, and whose book he may have read as early as 1908.[66] Klee's universalist primitivism was conceptually similar to Kandinsky's but dif-

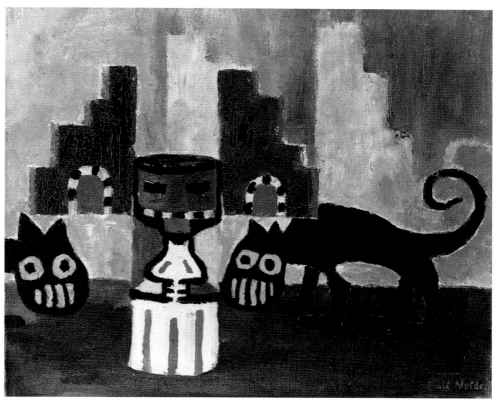

1.4 Emil Nolde, *Exotische Figuren II* (Exotic Figures II), 1911, oil on canvas, 65.5 × 78 cm (25.75 × 30.75 in), Nolde-Stiftung, Seebüll, Germany

1.7 Andean woven and embroidered textile, 16.5 × 20.5 cm (6.6 × 8.2 in), Weber Collection, 1918, Bern Historisches Museum

ferent in its application. Like Kandinsky, he would become very interested in universal primary symbols during the Bauhaus period, but he utilized a wider repertory of abstract motifs including pictographic signs and geometric patterns that, while not imitations of specific motifs, are often found in non-European art, particularly textiles.[67] As James Pierce pointed out, Kandinsky used primitivism as a state to pass through in order to achieve liberation from Western conventions, whereas Klee's primitivism was more far-reaching. Pierce stated that Klee 'certainly surpassed any single artist of the [Blaue Reiter] group in his comprehension of the emotions and formal processes embodied in the works of primitive art'.[68]

Klee was also extremely interested in the vision and art of children. He analyzed children's art, and by 1911 he had even collected and dated his own childhood work, an interest that paralleled ongoing investigations taking place in art education, as well as being partly inspired by the birth of his son, Felix, in 1907. To Klee, the child represented purity just as the 'primitive' did. As he wrote later, 'We must never forget: the child knows nothing of art. In looking at the works of children, the artist is interested in the way the primitive instinct finds a formal structure to suit the content.'[69]

Klee's universalist primitivism, whereby he linked children's art to 'primitive' art and modern art, is exemplified in the review he wrote of the first Blaue Reiter exhibition at the Thannhauser Gallery in Munich, published in 1912 in the Swiss art journal, *Die Alpin*. He called for the reform of art through serious contemplation of non-European art, the art of children, and the art of the insane. He wrote,

> There are still primal beginnings in art, which one is more likely to find in ethnographic museums or at home in the nursery (don't laugh, dear reader); children can do it too, and that is in no sense devastating for the latest efforts [to reform art]; on the contrary, there is positive wisdom in this state of affairs. The more helpless these children are, the more instructive is the art they offer us; for there is already a corruption here: when children begin to absorb developed works of art or even imitate them. Parallel phenomena are the drawings of the mentally ill, and so madness is not an apt word of abuse either. All that, in truth, must be taken far more seriously if present-day art is to be reformed. So far back will we have to go if we are not simply to imitate antiquity.[70]

Many scholars have observed that Klee incorporated aspects of children's art into his own. For example, he used line to scribble and schematize, he experimented with interchangeability and transparency, and, like Kandinsky, he investigated the emotion-

al, expressive values of forms. Yet, Klee insisted, perhaps to distinguish himself from members of Die Brücke, that he was not a 'primitive' artist: 'If my works sometimes produce a primitive impression', he wrote in 1909, 'this "primitiveness" is explained by my discipline, which consists in reducing everything to a few steps.'[71] Klee's understanding and appropriation of children's art, resulting in a formal reductiveness, led him to explore a variety of mark-making strategies, including ideographic expression (signs arbitrarily designating ideas) and pictographic expression (distillations of recognizable subject matter). These methods of expression would have particular relevance to Anni Albers, and allowed both artists to investigate new approaches to pattern and form.

Klee appreciated and understood the patterns and structures of textiles. Interestingly, his approach to composition during his Bauhaus period involved the building up of an image line by line, register by register, layer by layer, similar to the construction of a woven textile. His grid-based works from the 1920s and 1930s, as well as his accompanying pedagogical notes, remind us how close and significant this relationship between painting and textile was. Klee most likely developed such an approach from his study of 'primitive' handicrafts, particularly Near Eastern rugs.[72] Because of the widely held assumption that 'primitive' art was a direct result of the hand-made process and that it was somehow more intuitively created and more primarily expressive than conventional European art, Klee and members of the Blaue Reiter group were drawn to it, studied it, and admired it.

Klee possessed a keen awareness of art from many cultures and epochs; his diverse library attests to that.[73] He was also a frequent visitor to natural history and ethnographic museums, and was probably familiar with the substantial collection of Andean textiles and art at his hometown museum, the Bernisches Historisches Museum.[74] The Weber Collection, for example, purchased by the museum in 1918, included a number of important and diverse Andean textiles such as a woven and embroidered checkerboard panel (Figure 1.7), and a resist-dyed fragment with bird and step motifs. However, his art presents challenges to those seeking evidence of direct borrowings from 'primitive' sources because he utilized such a wide repertory of signs and processes. It is precisely Klee's interest in visual signs and systems of organization that made his art and teaching so relevant to a new generation of artists and designers at the Bauhaus (which he joined as a teacher in 1921), who were seeking clarification and inspiration to engage in the realm of abstraction.

2. Andean textiles in German primitivist discourse and ethnographic scholarship, 1880–1930

One common feature among the various uses and definitions of the 'primitive' in pre-World War I Germany was the interest in hand-made textiles as a way to engage in discourses related to applied arts reform and avant-garde artistic concerns. This conception of textiles involved issues such as the role of handicraft within industry, the role of art and the artist within society, and the role of abstract and ideographic forms in creative expression. Andean textiles would come to represent to modern artists and designers such as Anni Albers the most effective 'primitive' model to help them address these issues. This phenomenon was due first of all to the extensive availability of these textiles in pre-War Germany, and then to pivotal post-War publications in which these textiles were highlighted and analyzed.

There were a number of factors that contributed to the significant pre-World War I German interest in Andean textiles. First of all, the quantity and quality of Andean material available in Germany was extensive and most likely exceeded that of any other fiber tradition. In addition was the fact that the elaborate societies of Pre-Columbian Peru were long extinct. Their extraordinary art products – those that were not destroyed by the Spanish – had only recently been unearthed, primarily by Germans, from burial sites along the coastal deserts of Peru.[1] Germans were able to see these objects romantically, as coming from societies distant in time, very different from the products of the African and Oceanic cultures currently embroiled in Germany's colonization campaigns.[2] Andean textiles were also superbly produced by hand with simple tools; the hand-made process had been implemented by expert weavers to produce works that were considered in both Andean and modern German societies to serve both artistic and utilitarian needs, and thus demonstrated the unity between art, craft, and utility. Unlike the rich carpet traditions of Asia and the Middle East, as well as the European tapestry tradition, Andean weavings did not depict elab-

orate floral or illusionistic scenes, and no evidence existed to suggest that Andean weavings were executed by a weaver according to cartoons made by someone else. Andean textiles were also ancient products that ideally satisfied the growing modern taste and interest in geometric abstraction, particularly in Germany after the Art Nouveau whiplash form fell into disfavor. Finally, the abstract geometric forms employed in Andean textiles could be seen as creating pictographic and ideographic signs, particularly given the absence of writing, as we define it, in Andean society. These characteristics of Andean culture and its textile production suggest that textiles carried a visual sign language, a function that would have interested modern artists seeking universal methods of visual communication.

The example of these textiles was ideal to modern eyes because the art could be perceived in many ways, according to varying tastes, based almost exclusively on the analysis of the textiles themselves. These qualities made Andean textiles ideal 'primitive' models for modern times. Indeed, Andean textiles were collected and studied in pre-World War I Germany with particular zeal, especially in Berlin. While other German cities such as Munich, Dresden, Stuttgart, and Hanover had important collections of Andean material, the collections in Berlin were larger and better documented, and they would be of particular importance to artists and designers at the Bauhaus, including Anni Albers.

The Berlin Museum für Völkerkunde

Paul Klee made the first of his many visits to the Berlin Museum für Völkerkunde in 1906; his fellow member of the Blaue Reiter group Franz Marc visited the museum by 1911, and probably Wassily Kandinsky, August Macke, and many other artists visited it too during the first decades of the century. Indeed young Anni Albers, who lived nearby in the Berlin suburb of Charlottenburg, probably visited often with her family, and may have developed her admiration for Pre-Columbian art there. The sheer quantity and quality of the ethnographic material, due to the intensive acquisition campaign begun by the museum in its founding year, 1873, would have attracted crowds of families and avant-garde artists from throughout Europe by that time.[3] And while the Museum für Völkerkunde owned many non-European items, the Department of American Archaeology was, and continues to be for that matter, the largest department in the museum. Of the nearly 45 000 items in the Andean collection, thousands were textiles, including tunics, panels, cloaks, belts, and fragments from various Andean societies and time periods including the Wari (also spelled

Huari), Tiwanaku (Tiahuanaco) and Pachacamac groups of the Middle Horizon peri-od (500–900 CE), the Ica, Chimu, and Chancay groups from the Late Intermediate period (900–1400 CE), and the Inca society from the Late Horizon period (c. 1438–1534 CE).

The Andean art collection at the Berlin Museum für Völkerkunde reflects the findings from the mainly German-sponsored archaeological sites in Peru, beginning with the important discoveries by Wilhelm Reiss and Alphons Stübel at the coastal necropolis of Ancón in 1879. The Ancón excavation was recorded in their large, three-volume account, *Das Totenfeld von Ancon* (The Necropolis of Ancon in Peru), published in Berlin in 1880–87. This text was very important because it reproduced hundreds of Andean textiles and served as a primary text for further studies in the area of Andean textile design and structure. It should be noted that Stübel was a collaborator with the renowned German archaeologist, Max Uhle, from the Dresden Museum für Völkerkunde, whose major contributions were the excavation at the site of Pachacamac, south of Lima, and the discoveries at Tiwanaco, Bolivia.[4] Together, Stübel and Uhle wrote *Die Ruinenstätte von Tiahuanaco im Hochlande des Alten Perú* (The Ruins of Tiahuanaco in the Highlands of Ancient Peru), published in Breslau in 1892, a large text that also reproduced photographs of textiles.

While substantial acquisitions of Andean materials came to the Berlin museum from Reiss, Stübel, and others between 1879 and the turn of the century, the most important infusion of Andean art came from the enormous collection of a German textile merchant, Wilhelm Gretzer, acquired from 1899 on.[5] Gretzer had lived in Lima from 1871 to 1903, during which time he financed his own crew of workers to search for attractive items at ancient burial sites. As Corinna Raddatz stated, the fact that Gretzer was a textile merchant may explain why he 'was the first [collector of Pre-Columbian material] who took serious interest in Pre-Columbian Peruvian textiles'.[6] In 1899, Gretzer sold a large quantity of material to museum patron Arthur Baessler, who promptly donated it to the museum, along with other material, bringing the total Baessler donation to 11 690 items.[7] Finally, in 1907, Gretzer sold 27 254 pieces to the museum. A large exhibition of the Gretzer acquisition was held that year at the Berlin Gewerbemuseum, and Gretzer was invited to assist with the installation and was sub-sequently awarded the Order of the Red Eagle Class Four by Emperor Wilhelm II for his contributions to the museum.[8]

Max Schmidt was employed as a curator at the museum during this period and quickly became an authority on Andean textile techniques and designs. His 1910 arti-

cle, 'Über Altperuanische Gewebe mit Szenenhaften Darstellungen' (On Ancient Peruvian Textiles with Scenic Representations), was published in the journal *Baessler-Archiv*, which Baessler founded in 1910 to promote research related to the museum's collection. Schmidt's 61-page article (with 53 illustrations) dealt specifically with the Baessler and Gretzer material, which came primarily from the coastal Late Intermediate period. This text is important for a number of reasons. It was at the time the most extensive scholarly investigation devoted to Andean textiles in the world, and it served as the basis for Schmidt's major 1929 publication *Kunst und Kultur von Peru* (Art and Culture of Peru), which Anni Albers owned and studied. Citing Uhle, Reiss, Stübel, and Koch-Grünberg among his sources, Schmidt analyzed weaves, looms, styles, and subject matter, features of Andean textiles and their production that would be useful and fascinating to contemporary weavers.

In his article, Schmidt analyzed and diagrammed the interlocking tapestry technique of several Tiwanaku-style tunics in the museum's collection, pointing out that the geometric designs, as well as the relationships between positive and negative shapes, were related to the structural process of weaving.[9] This information would be highly relevant to members of the Bauhaus Weaving Workshop who initially borrowed only the formal motifs from Andean textiles but, after developing a fuller understanding of the integral relationship between the design and structure of Andean textiles, were able to apply this principle to their own work. Given the topic of his article, scenic representations, Schmidt described and reproduced numerous textiles with figurative representations from the Late Intermediate period, such as a painted textile fragment depicting a staff-bearer figure, and the lively, slit-tapestry panel (Figure 2.1) that he described as follows:

> It is a typical example of developed scenes depicting four-footed animals, fish, bird-snares, and corn plants protected by field guards … The slit tapestry runs diagonally around the outline of the figural forms. The colors of the figures change arbitrarily with different gradations of brown, deep blue, white and yellow, with yellow as the main color emphasized by specifically dyed cotton strands.[10]

The task of describing a fundamentally readable image such as this was probably a less complicated one for Schmidt to undertake than to decipher the far more austere and iconographically inaccessible woven textiles from the earlier Wari and later Inca cultures, which he did not attempt. That these geometrically stylized figures of the Late Intermediate period were not only available but also accessible in their formal charac-

ter may explain why members of the early Weimar Bauhaus Weaving Workshop were, like Schmidt, initially drawn to them.

In 1911 the Berlin Museum für Völkerkunde published a museum catalogue of which an entire section was devoted to the Andean collection. From this catalogue, one learns that there were several display cases of Andean textiles of various techniques, designs, and functions. The techniques included tapestry, painted cloth, and 'lace-like weaves'; the designs included geometric depictions of figures and regularly repeated patterns; and the functions ranged from tunics and cloth samples to feather attire and *quipus* (Andean knotted-cord recording devices).[11] This collection, along with the accompanying scholarly analysis, would serve as source material for later scholarship in the field of Andean textiles and for artistic investigations by members of the Bauhaus.

Small, private collections of Andean material were also being assembled in Berlin by various individuals. Eduard Gaffron, for example, had an extraordinary collection of Andean textiles; much of it was published in Walter Lehmann's *Kunstgeschichte des Alten Peru* (The Art of Old Peru), before being dispersed. One German private collection of particular importance to this study is the collection of non-European art assembled by Nell Walden, wife of Herwarth Walden, the director of the Gallery Der Sturm and editor and publisher of the journal *Der Sturm*. She began the Nell Walden Collection (Sammlung Nell Walden) in 1914, and by 1924 it contained 39 examples of ancient Peruvian textiles, the whereabouts of which are at present unknown.[12] Vintage photographs and catalogue entries reveal that most of the pieces were from the Late Intermediate period, specifically from the burial sites of Pachacamac and Lima (see Figure 2.3).[13] She restored and backed many of the pieces so that they could be framed, Western-style, like small paintings. The large group of avant-garde and Expressionist artists associated with Der Sturm, including Kandinsky, Klee, Marc, Macke, and, later, Laszlo Moholy-Nagy and other Bauhaus members, had access to this collection twice a week from 1917 on, which they would have seen exhibited and juxtaposed with modern works, including their own.[14]

The practice of exhibiting Andean textiles within the context of formal universalism and modern artistic trends continued throughout the next few decades, both in Germany and internationally. For example, a 1923 exhibition at the Städtische Kunsthalle Mannheim, 'Urformen der Kunst' (Original Forms of Art), later called 'View of the Primitive Formworld', included ancient Peruvian weavings among the profuse ethnographic material from collections by individuals including the Waldens

and the writers Wilhelm Hausenstein and Ernst Fuhrmann.[15] The originator of the exhibition, Gustav Hartlaub, explained his goals for the project in a 1923 letter:

> It should show that primitive man everywhere and independently of one another came up with certain elemental forms of ornament, pottery, drawing, and sculpture; and how the fundamental motifs of folktales are spread throughout all peoples.[16]

Like Alois Riegl, Hartlaub sought to locate the foundations of ornamental design by comparing as many different kinds of visual expression as he could. Hartlaub's range was wider; he included art of the insane and children, and the art of ancient America, along with African and Oceanic art.

A similar exhibition, in which the modern was juxtaposed with the ancient, took place in Berlin in 1924 at Herwarth Walden's Gallery Der Sturm. Thirty-three works by the Bauhaus Master Laszlo Moholy-Nagy were exhibited alongside 39 ancient Peruvian textiles from the Nell Walden Collection in an attempt to illustrate and connect the universality of their abstract visual forms.[17] Each of Walden's textiles was categorized in the accompanying catalogue by its primary figure, such as 'fish', 'bird motif', 'war motif', 'mythological scene', 'chieftain head', and 'cat', figurative fragments that were perceived as connected to Moholy-Nagy's abstract compositions. Certainly, this exhibit would have been known and visited by members of the Bauhaus, many of whom were represented by Gallery Der Sturm.[18]

Andean source material at the Bauhaus, 1920–23

By the 1920s in Germany, Andean art was viewed and analyzed with increasing frequency. Between 1920 and 1923, three popular German books that addressed Andean textiles within the context of 'primitive' art, and one book specifically on Andean art, were published. The books on 'primitive' art under discussion, which were available to members of the Bauhaus, include Wilhelm Hausenstein's 1922 *Barbaren und Klassiker: ein Buch von der Bildnerei exotischer Völker* (Barbarian and Classic: a Book on the Works of Exotic Peoples); Eckart von Sydow's 1923 *Die Kunst der Naturvölker und der Vorzeit* (The Art of Indigenous and Ancient Peoples); and Herbert Kühn's 1923 *Die Kunst der Primitiven* (Primitive Art); the other book is Ernst Fuhrmann's 1922 *Reich der Inka* (The Inca Empire).[19] An interesting link between these four books is that they were all written by proponents of Expressionism with strong Marxist leanings who saw parallels between ancient Peru and modern Germany.

2.1 Slit-tapestry panel, Pachacamac, c. 900–1400, Museum für Völkerkunde, Berlin, Gretzer Collection (1907) (reproduced in Max Schmidt, 'Über Altperuanische Gewebe mit Szenenhaften Darstellungen', in *Baessler-Archiv Beiträge zur Völkerkunde*, Vol. 1, 1910, p. 52)

Aus Nell Walden-Heimanns Heim

2.2 Flechtheim Gallery catalogue, Düsseldorf, 1927, no page number

2.4 Tapestry fragment, Ancón, 7.3 cm wide, Museum für Völkerkunde, Berlin (reproduced in Eckart von Sydow, *Die Kunst der Naturvölker und der Vorzeit*, Berlin: Propyläen-Verlag, 1923, p. 412)

Hausenstein, a popular writer who had in 1920 written a monograph on Klee, was well known at the Bauhaus; indeed, a copy of *Barbaren und Klassiker* is still at the Anna Amalia Bibliotek in Weimar, the public library frequented by Bauhaus students; Klee, too, owned a copy. Von Sydow was a Leipzig art historian and critic who also knew Klee by 1919, and had recently finished *Die Deutsche Expressionistische Kultur und Malerei* in 1920. His 1923 text was part of the sixteen-volume Ullstein-Verlag series on world art, the Propyläen-Kunstgeschichte, that would later include Max Schmidt's important *Kunst und Kultur von Peru*, of 1929.[20] Not surprisingly, Albers was aware of this and other great editions published by her mother's prominent Ullstein publishing family.[21] Art historian Kühn's 200-page text (with 250 plates) was part of a popular art series published by Delphin-Verlag, Munich.[22] Fuhrmann's *Reich der Inka* was the first volume of the 'Cultures of the World' series published by Karl Osthaus's Folkwang Museum. All four texts had sections dealing with Andean textiles and all reproduced textiles from the Berlin Museum für Völkerkunde collection.[23]

These writers clearly relied on the theories of Worringer, but they added a Marxist gloss. 'Primitive' artists, including weavers, were, according to them, not only spiritually connected to the creative act because of their intuitive, pre-rational state, but they were also valued members of a communal social system. Andean textiles were thus interpreted as being readily adaptable to modern needs and social theories.

Von Sydow paid particular attention to the distinguished position that textiles, as an example of fine craftsmanship, held in ancient Peruvian society. He discussed the collective production processes by which these textiles were made, their high level of technical mastery, and their great and 'tasteful' designs. He wrote,

> The value of Peruvian art rests for us in their ceramics and textile products. At least herein are so many splendid and at the same time tasteful, bold designs, and so successful that the other examples of their talent such as sculpture and architecture recede into the background.[24]

The value, 'for us', von Sydow noted, involved the finely made, boldly designed, and accessible objects that reaffirmed modern notions of design and craftsmanship while simultaneously serving as original 'primitive' sources of fine handicrafts.

Hausenstein, echoing Worringer, noted that Pre-Columbian Peruvian society, before its destruction by the Spanish, was able to maintain the precarious relationship between production and expression, a relationship that modern society desperately needed to balance.[25] Ancient Peru was thus thought of as a kind of Marxist Arcadia

wherein the worker was both an artist and a producer, and could thus serve as an ancient model for modern goals.[26] Kühn thought of ancient Peru as such an Arcadia, where the individual specialist worked in harmony with society. He wrote,

> The handwork was completely refined and properly made; there was weaving done on genuine looms, there were metal specialists, woodworkers, feather workers, sculptors, potters, construction workers. The weavings were so finely made that they were thought to be made of silk in the court of Charles V.[27]

Like other writers and artists, Albers would also use the example of the ancient weaver to emphasize and validate her social and aesthetic theories. In her 1924 article 'Bauhausweberei' (Bauhaus Weaving) for the journal *Junge Menschen*, she suggested that modern weavers at the Bauhaus should model themselves after the ancient weaver who controlled all stages of the weaving process, from the design to the end result, by maintaining the 'inherent properties of handicraft and materials'. Albers's unique twist to this socialist perspective was her ability to adapt it to industry. She wrote,

> Weaving is an ancient handicraft … Earlier, because of the close relationship to loom and material, fabrics were created that were good, because they were woven according to the inherent properties of handicraft and material … The Bauhaus seeks to restore the overall contact with the material. Weaving at the Bauhaus is therefore foremost hand weaving. This technique therefore follows the ancient way of producing the individual piece. At the same time, it reaches into the area of the 'designer' and attempts to transform it: instead of a design pattern, we at the Bauhaus want to submit the fabric itself for mass production, thus determining a new direction for industry from handicraft. Today, the work must be experimental; we have lost too much of the feeling for materials that those in earlier times had. We must attempt anew to learn this feeling. We must thoroughly investigate anew handicraft and technical possibilities … We can then perceive industry – the mechanical handicraft – and work for it, since we comprehend it essentially.[28]

Albers believed that in order to 'restore the overall contact with the material', weavers at the Bauhaus must follow the 'ancient way' of making individual pieces by hand and then submitting those individual pieces to industry as prototypes. Thus, Albers justified the continuation of primitivist concerns, now for new ends, by acknowledging the weaving processes and products of the past. The ancient weaving tradition Albers referred to was probably the Andean one because the qualities she admired in

ancient weavings were those exemplified in Andean textiles, and these textiles were characterized by varieties of patterns and structures that she admired and adapted. As a weaver, she would have known about the great collections of Andean textiles so readily accessible to her and her colleagues at the Bauhaus. No other ancient model available to her could have provided a richer source of inspiration, as she later stated in her books and articles.

Andean textiles served as a reminder of an ancient, 'primitive' time when the relationship between art and society was harmonious, and when fine craftsmanship and design were valued. This occurred before 'civilization' – symbolized by the Spanish in this case – intruded. Fuhrmann made a similar observation in his opening paragraph to *Reich der Inka*:

> The Europeans consider a civilization to be advanced when those people distance themselves from a close identification with their means of existence. And even if this path leads to error, nonetheless we can still recognize the attempt of people to outgrow their past. And it is certain that in Peru and Mexico we see two remarkable attempts of humanity to progress along their own unique path without traveling the well-trodden path of the Old World.[29]

In Fuhrmann's view, the ancient Americans maintained a connection between process and product that the European world had broken. He also noted that Andean textiles were more than just decorative and utilitarian items: they also conveyed information. The Andean knotted textiles, known as *quipus*, he remarked, served as memory aids.[30] These comments are important because they helped to elevate the status of Andean textiles from mere ornamental patterns to carriers of codified meaning.

Interestingly, two Andean textiles were reproduced with frequency in the above texts: a Tiwanaku-style tunic (see Figure **2.3**), in Fuhrmann, in Kühn, and (in color) in von Sydow, and a Late Intermediate period fragment (Figure **2.4**), in von Sydow, Fuhrmann, and Hausenstein. Both textiles were from the Berlin Museum für Völkerkunde collection, and both had already been discussed and reproduced in Reiss and Stübel's *The Necropolis of Ancon*. The textiles are different in technique and function, but are similar in that they both depict highly stylized and geometrized woven figural representations. Reiss and Stübel originally described the small fragment thus:

> Green Gobelins border with yellow pattern. In the upper and lower figures, unmistakable is the large face with its two outstanding ears and side headgear or antlers. The

lower portion of both is formed by the conventional body of a recumbent animal, whose curly tail may be indicated by the small square attached behind. From the head one might suppose a human figure had been intended; but the lower portion must apparently be taken for the body of an animal. Between these two a similar but far more conventionalized figure is introduced in reverse attitude.[31]

Von Sydow similarly described the fragment above as a 'green tapestry border with yellow pattern between two strongly stylized reclining animals in reverse positions'.[32] The writers may have singled out this piece for its fantastic abstract figuration and complex spatial organization for so tiny a piece. Indeed, it was unlike conventional European art, but not so strange as to alienate the viewer.

Similar formal qualities were emphasized in the tunic which, importantly, was shown only in detail in all the twentieth-century texts (see Figure 2.5). The writers may have been aware of the fact that this finely made tapestry was originally the outer adornment of a mummy bundle found and illustrated by Reiss and Stübel. In the full tunic, the 38 staff-bearing figures are almost indiscernible from one another as they interlock in the larger formation of bold vertical bands. Details, however, reveal more clearly two abstracted, fantastic figures, both clad in tunics and displaying the characteristic split eyes. However, the standing figure holds a bow and the bent-legged one a baton or staff. Like the small fragment, the figures here face in different directions by row; on the top portion of what remains of the tunic where the shoulder would have been, the figures are inverted so as to remain upright on the back when worn. Each individual figure is further broken into many colored units outlined by white on a gold ground. This is the remarkable textile that Kühn used as his example when he stated that 'the weavings were so finely made that they were thought to be made of silk in the court of Charles V', even though this particular piece would not have been known in Europe before Reiss and Stübel's excavations.[33] Reiss and Stübel referred to this tunic as the 'Sumptuous Garment of a Mummy', and noted the complex and sophisticated arrangement of the colors and figures:

> A first glance at the confusion of white lines and bright patches of color will not reveal the pictorial representation designed by a wonderful fancy and woven by a practiced hand. The design of each stripe shows the sevenfold recurrence of two human figures, one seated, the other standing, but both conceived in the most original manner, and surrounded with diverse attributes and ornaments.[34]

Perhaps unrecognized by the writers at the time was the fact that this tunic was woven weft-wise, or 'sideways'. This was an Andean weaving technique characteristic of the Middle Horizon and Late Horizon periods whereby the cloth was woven with a short vertical warp and long, pattern-carrying weft threads in the horizontal direction.[35] Two such unusually short but wide units of cloth were then turned and sewn together; thus in the final product the warp runs across the tunic rather than up and down it, as is more typically the case. Relevant here is the orientation of the Andean weaver sideways to the final position of the pattern, a feat that required great mental dexterity.[36] This technical feature is important to note because Anni Albers later used it for her own pictorial weavings in the 1950s. While European tapestries were sometimes woven weft-wise, a point that Albers was most likely aware of, the technique in this case would have had limited appeal for her because of the European practice of weaving from cartoons for narrative pictorial purposes.

In 1924, two major books dealing with Andean textiles were published that had a direct impact on Anni Albers. She was well aware of Walter Lehmann's *Kunstgeschichte des Alten Peru* – indeed, she had slides made of images taken directly from the German edition – as well as Raoul and Marguerite d'Harcourt's *Les Tissus indiens du vieux Pérou* (The Textiles of the Indians of Old Peru), for she owned a copy of the 1934 French edition.[37] Her colleagues were most likely aware of them as well. These books provided specific technical and contextual information about Andean textiles that the previous texts had not fully dealt with, and which would have been of great interest to those in the Weaving Workshop seeking 'new' technical information to apply to their modern needs.

Lehmann reproduced a wide range of textiles of visual styles and techniques primarily from German collections. The selections were focused on the abstract figurative slit tapestries of the Late Intermediate period as well as the strictly geometric textiles from the Wari and Inca periods, and on virtuoso Andean weaving techniques.[38] From this book, Albers and others would have understood four major characteristics of Andean textiles. The first is that the geometric patterns of Andean textiles not only reflected the inherent structure of weaving itself, but also held symbolic meaning related to the Andean natural and conceptual world. Lehmann wrote,

> plaiting, which, with net-making, was a forerunner of weaving, involves the development of linear and primary geometric patterns, which appear of themselves in their simplest form … Nature is represented, not as she is, but as she is conceived. The forms are no longer those of nature, but [primarily] geometrical patterns.[39]

Second, many types of structural techniques were used by Andean weavers with great skill, often within the same piece. Lehmann wrote, 'one should not judge the Peruvian textiles exclusively according to their technique, since different processes exist side by side in the Peruvian culture and are indeed found present in the same piece'.[40] Third, there were distinct links between Andean textiles, architecture, and ceramics. The geometric patterns of the textiles, as basic design elements, supplied most of the patterns for the other media. He wrote, 'the wall patterns in plaster from Chanchan, which recall the [Late Intermediate period] textiles both of Ica and Pachacamac, show that the Ica style must have existed in Chanchan, probably in the form of textiles which were used originally as wall hangings and later imitated in plaster'.[41] Fourth, the geometric forms of Andean textiles expressed a collective visual vocabulary that 'suggest hieroglyphs'. As Lehmann put it,

> The ever active imagination of the man of that period did not see, as we do, in the sober … line-forms merely rectangles, crosses, triangles and so on. He interpreted them differently, poetically … Here we see the natural motives recede before an almost boundless wealth of symbols and attributes, fused into an artistic whole by an admirable inner harmony. Representations of this nature suggest hieroglyphs.[42]

Similarly, the d'Harcourts' text would have provided the weavers with new examples of Andean textile designs and accompanying technical analysis, including discussions of openwork, featherwork, embroidery, double weaves, and piles. D'Harcourt paid particular attention to the Andean dye process and weaving technology. Of the dyeing process he wrote,

> No doubt it is assumed that the ancient [Peruvian] methods of mordançage [using a mordant to fix colors to the fiber] were assimilated into modern procedures; and with the aid of vegetable juices and by using fermentation, the desired results were achieved; the results were particularly remarkable for the indigo and the cochineal dyes.[43]

In addition, the d'Harcourts commented on the expressive element of Andean textiles that they believed was particularly apparent in the unfinished pieces. In these, they suggested, the modern observer can really imagine the ancient weaver at work, 'ready to continue at any moment'.[44]

3. Andean textiles at the Bauhaus

German interest in 'primitive' art continued to grow after World War I, but now for additional reasons. After the devastation of the Great War, artists and writers sought to renew their connections to hand-made 'primitive' art processes in opposition to what they viewed as the destructive and alienating power of the machine. Hermann Bahr's 1916 appeal in *Expressionismus* for an escape 'from a "civilisation" which is out to devour our souls', is worth reviewing because it points to the strong anti-machine sentiments that were embraced at the Bauhaus during its early years, despite the influence of De Stijl.[1] Attitudes toward the machine in post-War, economically depressed Germany were mixed: the destructive potential of the machine was still painfully apparent, but the need to retool was an obvious necessity. Architect Adolf Behne, who, with Bauhaus founder Walter Gropius, was one of the founders of the group *Arbeitsrat für Kunst* (Working Council for Art), wrote in 1919 that Europeans must become 'primitive again' in order to engage once more with 'the world of experience'.[2] Like Bahr, and William Morris before him, Behne believed that the machine had become a weapon against intuition and expression. Therefore, handwork was clearly seen as a way of addressing the conflict between the machine and the human spirit. In this context, the term 'primitive' refers to an intuitive, pre-industrial state, and one that corresponded particularly well to early years of the Bauhaus. Hand-made, 'primitive' textiles served as useful models with which to understand the pre-industrial connection between art and craft, and between spiritual expression and handwork, the very connections members of the Bauhaus sought to achieve for the modern era.

Importantly, hand-weaving remained a vital and ongoing interest at the Bauhaus throughout the entire 14-year period of the school's existence. While recent scholarship has finally focused attention on various aspects of the Bauhaus Weaving Workshop, particularly regarding issues about gender, the important role of 'primitive' art for the formal and technical approaches to weaving there has not been discussed heretofore.[3] The ideological shift that occurred at the Bauhaus around 1923 – when Gropius changed its motto from 'Art and Craft, A New Unity' to 'Art and Industry, A New Unity' – in part denigrated the earlier interest in primitivism and Expressionism at the Bauhaus.

Anni Albers recalled that during the early years of the Bauhaus, they created objects 'possessing often a quite barbaric beauty'.[4] The notion that a hand-made object from the Bauhaus could possess 'barbaric beauty' is a primitivist one that was particularly relevant there during this period, but one that has been obscured, and even denied, by former members of the Weaving Workshop, in order to focus on later and more celebrated Bauhaus developments.[5]

Members of the Bauhaus Weaving Workshop engaged in primitivist discourses particularly focused on Andean textile techniques and forms. At first, members of the workshop valued and borrowed the geometrically abstract motifs of Andean textiles. When attitudes toward production and technology changed at the Bauhaus, they began to look at and apply increasingly complex Andean weaving structures and forms to their own work. Indeed, the Weaving Workshop was a place where numerous formal and production theories were instigated and demonstrated, partly due to its members' increasingly sophisticated knowledge of Andean fiber art.

The first major stage of the Bauhaus Weaving Workshop, from 1919 to roughly 1923, is often referred to as the Expressionist phase of the Bauhaus. It corresponds with Johannes Itten's tenure, and was a period when the Bauhaus as a whole was attempting to build up supplies and staff during a time of economic hardship. Itten's background in art education reform reinforced the emphasis on hand-made processes and experimentation. Anni Albers recalled that 'in the early years there was a dabbling in a kind of romantic handicraft'.[6] This stage was also marked by a gradual shift toward abstraction, partly due to the influence of Worringer, whose *Abstraktion und Einfühlung* appears to have been on the required reading list for incoming Bauhaus students during the early years. Anni Albers, who read it 'with delight', was among this group.[7]

When Itten's tenure ended in 1923 as the pull of International Constructivism strengthened, Gropius was at the same time under pressure by state authorities to provide tangible results of the school's progress in the form of the exhibition and model home which the Bauhaus produced in 1923. It was clear to many members of the Bauhaus that in order to rebuild for the future, students needed to be trained to work in accord with the machine rather than in opposition to it. Handwork came to be regarded as a first step in the production process, rather than an end in itself. These developments were strengthened by the influence of De Stijl and Russian Constructivism, two international movements that encouraged the unity of art and industry. These changes inspired a more sophisticated interest by members of the

Weaving Workshop in weaving materials and their natural properties, natural dyes, and geometric patterning as they began to investigate how this knowledge could be applied to industry. During this period members of the workshop had access to an increasing amount of source material on Andean textiles, and this information clearly informed their work. For this reason, it appears that the weavers looked closely at Andean tunics from the Wari and Tiwanaku societies of the Middle Horizon period (500–900 CE), and other Andean textiles that exhibited complex color and shape patterning.

During the Dessau Bauhaus period (1925–1932) members of the Weaving Workshop, especially Albers, explored complex color and shape patterning in conjunction with complex weaving structures such as multi-layered weaves. There was an increased emphasis on machine-like precision and experimentation with synthetic fibers. This was also the period during which Klee taught courses exclusively to members of the Weaving Workshop, including Anni Albers. It was Albers who most successfully synthesized Klee's lessons with what she was learning from studying actual weaving examples, Andean textiles among them. More than any other ancient example, Andean textiles served as useful counterpoints to Klee's design theories and primitivist practices.

From the later Dessau Bauhaus period, under the direction of architect Hannes Meyer, and from 1930 until the Bauhaus permanently closed in 1933, under the direction of Ludwig Mies van der Rohe, the Weaving Workshop was a place where art was almost exclusively produced according to social needs, due in large part to the school's anti-pictorial and anti-art stance. Interestingly, this was also a period when the hand-woven product was highly valued at the Bauhaus, no longer as an individual Expressionist statement but as an example for production. For this reason, because of the emphasis placed on maintaining the relationship between process and product, the Andean textile paradigm was valued.

Albers played an important role in the Weaving Workshop during most of the Dessau period. Her association with the school continued to the end, partly because Josef continued to teach there until its doors were permanently shut in 1933. Anni Albers received her Bauhaus diploma in February of 1930, but she continued her contact with the Weaving Workshop, serving as Acting Director in 1931. Her important contributions involved her ability to unite a geometrically abstract visual vocabulary with corresponding constructive processes, such as double and triple weaves, and also her creation of innovative weaving constructions, such as open weaves and multi-

weaves, so as to apply them to industry. She synthesized what she had learned from contemporary sources such as De Stijl, Paul Klee, and Constructivism and then applied these lessons to those she was learning from the Andean textiles.

What were the qualities of Andean textiles that inspired such interest? Regarding their formal qualities, for example, archaeologists Reiss and Stübel had as early as 1887 praised the elaborate color and design patterning of ancient Peruvian weavings.[8] The abstract formal vocabulary and lively pictorial scenes found in Andean textiles were qualities that made them particularly popular with twentieth-century scholars and artists searching for 'new' and exciting visual forms and subjects from ancient and non-European sources. Regarding the hand-made process, Andean-art scholar Max Schmidt had noted in 1910 that expert Andean weavers were able to create sophisticated weaving structures on simple hand looms. Scholars would continue this line of thought throughout the 1920s by singling out Andean textiles as the successful pre-industrial 'primitive' handicrafts to serve as models, and reminders of the fundamental properties of the craft of weaving in an increasingly mechanized world. Additionally, in terms of utilitarian value, it was understood in Germany after the discoveries by Reiss and Stübel that textiles were highly valued products of Andean society; they were used for many purposes including uniforms, sacrificial offerings, and mummy wrappings. This utilitarian yet noble functionalism was particularly valued in post-War Germany when ideas about art and utility were often of necessity increasingly intertwined.

The Weimar Bauhaus Weaving Workshop: tradition and innovation

The original Bauhaus textile class was equipped with 17 looms from the former Grand-Ducal School of Arts and Crafts; Helene Börner, who was an instructor there, owned the looms. Börner was hired by Gropius to supervise what was then called the textile class; by 1920, it became the Weaving Workshop.[9] Börner, who taught at the Bauhaus until 1925, and was promoted to Master of Craft status, has remained essentially unrecognized and unknown, even though she was a capable weaver who received outside textile commissions for the workshop.[10] Anni Albers referred to her as 'a very inefficient old lady, sort of the needlework type', without ever mentioning her name.[11] From this kind of statement, and others like it, it appears that Börner was thought of as a craftsperson in the traditional European manner, not as a representative of the avant-garde. She apparently wove from patterns, rather than designing at

the loom, which indicates that she relied on traditional European weaving methods rather than a more spontaneous approach. Many students protested against her methods as well as her interest in decorative surface effects such as lace collars, embroidered scenes on pillows and narrative tapestries.[12] By approaching handcraft merely as a method of labor rather than as a producer of innovation, Börner would have been seen as old-fashioned by the students. As Anja Baumhoff has recently suggested, this traditional academic approach contributed to the secondary status of the Weaving Workshop and of women artists in general at the Bauhaus.[13]

Börner appears to have been disliked by both students and administrators primarily because she did not support the playful experimentation taking place in the Weaving Workshop during the early years. She probably represented the old guard of academic decorative training, and she criticized early Bauhaus weaving products by referring to them as *Phantasiebindungen*, or fantasy weavings.[14] In their recollections, some Bauhaus weavers have gone so far as to exclude Börner's influence almost entirely, because they have not wanted to be associated with the European academic tradition. Most of the students in the Weaving Workshop, including Albers, already had training in art or applied art – some were already trained art teachers – but few members wanted to promote their traditional pasts.[15] They denied their academic backgrounds in order to focus attention on their later and more famous Bauhaus innovations involving utilitarian products.

Later comments by Albers point to the fact that there was a conflict during this time between the academic and the more experimental approaches to fiber art. She recollected in 1938 that during those early years at the Bauhaus traditional textile training was 'useless … [as] many students had felt the sterility of the art academies and their too great detachment from life'.[16] She discussed the pitfalls of narrative tapestry further in *On Weaving*, in which she framed her discussion of narrative tapestry by contrasting the European tapestry tradition with the ancient Peruvian textile tradition:

Along with cave paintings, threads were among the earliest transmitters of meaning. In Peru, where no written language in the generally understood sense had developed even by the time of the Conquest in the sixteenth century, we find – to my mind not in spite of this but because of it – one of the highest textile cultures we have come to know. Other periods in other parts of the world have achieved highly developed textiles, perhaps even technically more intricate ones, but none has preserved the expressive directness throughout its own history by this specific means. In this light we may

reevaluate what we have been made to think of as the high points of the art of weaving: the famous great tapestries of the Gothic, the Renaissance, the Baroque; the precious brocades and damasks from the Far East; the Renaissance fabrics. Tremendous achievements in textile art that they are, they play first of all the role of monumental illustrations or have decorative supporting parts to play. They are responsible, I think, for textiles being relegated to the place of a minor art. But regardless of scale, small fragment or wall-size piece, a fabric can be great art if it retains directness of communication in its specific medium.[17]

While these comments were made long after her Bauhaus days, it is likely that her attitudes regarding the primacy of Andean textiles developed there. Andean textiles would have served as a foil and ideal alternative to the European tapestry tradition that many members of the Bauhaus Weaving Workshop sought to overthrow.

Johannes Itten, as Master of the 'Preliminary Course' from 1919 to 1923, played a significant role in the early Bauhaus period. He may be partly responsible for encouraging student interest in Andean textiles and other non-European textiles, perhaps with the help of weaving student Ida Kerkovius, who was his teacher at the Stuttgart Academy in 1913–1914, where she assisted his mentor, Adolf Hölzel.[18] Itten's pre- and post-Bauhaus writings, and his textile designs from the early 1920s, reveal an understanding of, and borrowing from, Andean textiles. For a 1917 slide lecture, 'On Composition', Itten spoke about the role of 'primitive' art for Picasso and other pre-War artists. He wrote, 'What the Greek works of art signified to the Renaissance artists, the works of art of the exotic peoples of the world – the Negroes, the Mexicans, the Peruvians – signified similarly for the young artists of 1907.'[19] This comment is evidence of Itten's awareness of ancient American art, in the context of primitivist tendencies, by at least 1917. Many years later, in his book *The Art of Color*, of 1961, he presented a more studied analysis of Andean textiles: 'It is interesting to notice that in pre-Columbian Peru, the use of color is symbolic (constructive) in the Tiahuanaco culture, expressional (emotional) in the Paracas, and impressional (visual) in the Chimu.'[20] Since his post-Bauhaus endeavors were devoted primarily to textile instruction, Itten was surely aware by then that the constructive and highly complex color patterning of Tiwanaku textiles was a quality achieved through the tapestry technique; that the lively figurative forms on Paracas textiles were achieved through the embroidery technique, a technique that allows the artist much more freedom to create curvilinear lines and shapes than with the strictly geometric tapestry

technique; and that Chimu textiles were often painted with recognizable subject matter, thus the designs are more visually understandable.

Although he left the Bauhaus in 1923, Itten's later textiles and comments represent a continuation of Bauhaus primitivist concerns. A knotted carpet that he made in 1924 (now lost), for example, emphasized a central stepped-diamond motif. Perhaps Itten adapted this motif, used extensively in Andean textiles, from examples he saw at the Berlin Museum für Völkerkunde or in other Berlin collections. Itten's textiles and textile patterns from the 1920s show his recurrent use of geometrically stylized figures, birds, fish, and plants, framed with borders and registers (Figure 3.1). These motifs and formal devices are ubiquitous in Andean textiles. For example, Itten may have been familiar with two Andean textiles from the Late Intermediate period (900–1400 CE), one depicting walking birds within registers (Figure 3.2) and another with stepped-diamond motifs (Figure 3.3). They belonged to Berlin collector Eduard Gaffron and were reproduced in Walter Lehmann's popular *Kunstgeschichte des Alten Peru*, published in 1924, as we saw earlier.[21] Given the evidence of these distinctly Andean motifs in Itten's work, and the availability of published and exhibited Andean materials, one can safely conclude that Itten was aware of these sources, and appropriated the motifs for his own use.

Itten's textile work also reveals his interest in other types of textile motifs including Asian, Near Eastern, and European folk motifs. Members of the Bauhaus, including Kandinsky, admired European folk motifs, because they served as 'primitive' examples of pure, unadulterated expression. Some of Itten's rugs, which he reproduced exactly from preliminary drawings on graph paper, resemble in color and design the folk embroideries and woven textiles from his native Switzerland and from Germany. Although Itten borrowed motifs from a variety of sources, it is clear that his dependence on preliminary patterns was more aligned with Börner's traditional approach to textile production. For this reason, Itten may have provided the weavers with 'primitive' source material, but not necessarily with a new way of approaching the process of weaving.

However, experimentation was a major part of Itten's 'Preliminary Course', and his encouragement in this area clearly informed the experimentation that took place in the Weaving Workshop. Itten particularly encouraged his students to work with materials and their textural properties; his students often conducted experiments by arranging various materials, shapes, and/or textures side-by-side on a flat surface, somewhat like a Cubist collage. He also had students conduct studies involving the ele-

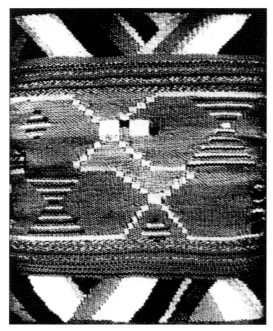

3.1 Johannes Itten, cushion cover, 1924, woven wool, Itten-Archiv, Zürich

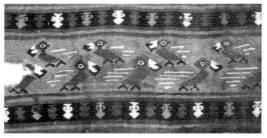

3.2 Kelim textile with fringe, Chancay, 54 × 35 cm (21.6 × 14 in), present location unknown, formerly in the Eduard Gaffron Collection, Schlachtensee (reproduced in Walter Lehmann, *Kunstgeschichte des Alten Peru*, Berlin: Wasmuth, 1924, p. 126)

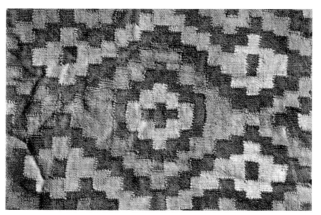

3.3 Ica textile, discontinuous warp and weft, Museum für Völkerkunde, Munich (2185), Museum für Völkerkunde, Munich, formerly in the Eduard Gaffron Collection, Schlachtensee (reproduced in Walter Lehmann, *Kunstgeschichte des Alten Peru*, Berlin: Wasmuth, 1924, p. 113)

mentary shapes of circle, square, and triangle, often in a register format, in order to investigate how texture could be achieved through line and shape, and how rhythmic variations could be created by arranging these elements in repeated and contrasting patterns. Itten's use of grids and registers, formats intrinsic to weaving, as well as his investigations of material properties and world art forms, would thus have provided the weavers with an introduction to weaving principles without the burden of using traditional European textiles as examples.

Itten's role in the Weaving Workshop, like Börner's, has been generally over-looked, however, partly due to the desire by its members subsequently to establish their own creative autonomy. For example, it later became important for weaving student Gunta Stölzl, who was to assume leadership in the Weaving Workshop in 1927, to prove that she started from scratch, so to speak, in order to lay claim to her later innovations. A much quoted recollection by Stölzl in 1969 implies this notion of creative autonomy:

> But how did I come to weaving? The women's class existed. There I discovered a private room with looms, private because it didn't belong to the Bauhaus ... We were about five girls who made a start. Everything technical – how the loom works, the different styles of weaving, how to thread – we could learn only by trial and error; there was a lot of guesswork among us poor self-taught students, and many tears were wept.[22]

Anni Albers likewise downplayed her previous training, both at the Hamburg School of Applied Arts and from Itten, whose 'Preliminary Course' she took in her second semester (1922–23). She often referred retrospectively to the Bauhaus as a 'creative vacuum', where 'you knew nothing, you weren't taught anything, and you really dabbled around until something happened'.[23] For her 1938 article for the Museum of Modern Art exhibition and catalogue, *Bauhaus, 1919–1928*, she wrote,

> In a world as chaotic as the European world after World War I, any exploratory artistic work had to be experimental in a very comprehensive sense. What had existed had proved to be wrong; everything leading up to it seemed to be wrong, too ... At the Bauhaus, those beginning to work in textiles at that time, for example, were fortunate not to have had the traditional training in the craft: it is no easy task to throw useless conventions overboard.[24]

Stölzl, in particular, appears to have disliked making references to outside sources,

including those from the past, from Itten or from folk art. Interestingly, in an unpublished letter to Anni Albers in December of 1964, Stölzl strongly denied any Bauhaus interest in folk art (*Volkskunst*). She wrote,

> I would like to finally come to the point of putting down in writing what my recollections are, up to the time of my departure [from the Bauhaus in September 1931]. And if I can get Otte's [probably Otte Berger] view, that would really give a proper presentation, don't you believe? That folklore [*Volkskunde*] played an important role for us was nonsense; we were far too possessed of our own views. We didn't think about revivifying folk art.[25]

This denial is contradicted by her woven work from the early Weimar period that clearly reveals folk art and primitivist interests. It must be noted that the German word *Volkskunst* (folk art) has a different application than *Völkerkunde* (ethnology). Stölzl's position may have evolved as a response to the growing racist beliefs prevalent in Germany from the twenties through the Nazi period which embraced northern European folk traditions as examples of pure Germanic folk expression. It is also important to note that while he was at the Bauhaus Itten wrote an essay on white superiority.[26] In light of his beliefs that elevated the white man above all others, he probably valued Germanic folk culture for its Aryan associations as much as he valued the geometric patterning. This may have been one reason that Stölzl disassociated herself from all folk sources, by denying any influence of them in her own work.

The early years of the Weimar Bauhaus Weaving Workshop were characterized by an underlying confusion and ambivalence due to difficulties in reconciling traditional and avant-garde approaches to fiber art. Indeed, it was a time of experimentation, as weavers and teachers sought to absorb and apply various pedagogies to the idiom of weaving and textile design under limited economic conditions. For this reason, they turned to fixed, non-European textile models, Andean textiles, which could provide them with useful information related to the formal and technical qualities of textiles.

With such sources to guide them, members of the Bauhaus Weaving Workshop made numerous woven products that reflected their awareness of Andean textiles. For example, Margarete Bittkow-Köhler directly borrowed Andean woven motifs for her large woven wall hanging of about 1920 (Figure **3.4**). She appears to have understood and adapted a fundamental Andean design device of interlocking positive and negative shapes to create figure/ground relationships, which is apparent in the lower-reg-

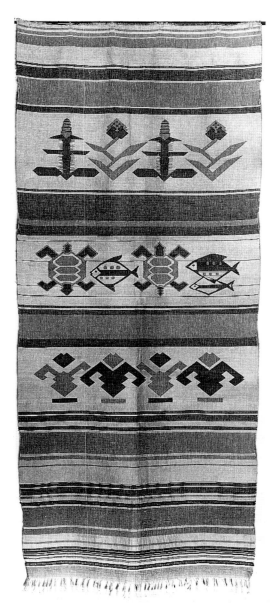

3.4 Margarete Bittkow-Köhler, wall hanging, c. 1920, linen, 258 × 104.2 cm (103.2 × 41.7 in), Busch-Reisinger Museum, Harvard University

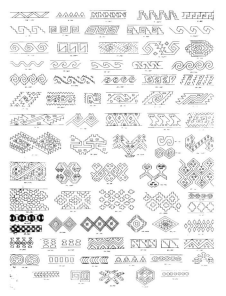

3.5 Andean textile motifs, 'Geometrical Figures and Ornaments Derived from Them' (reproduced in W. Reiss and A. Stübel, *The Necropolis of Ancon in Peru*, trans. A.H. Keane, Vol. 2, Berlin: Asher & Co. 1880–87, plate 104)

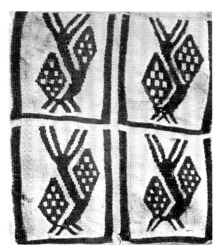

3.6 Ica, detail of textile with maize plant, wool and cotton, Museum für Völkerkunde, Berlin (reproduced in Max Schmidt, *Kunst und Kultur von Peru*, Berlin: Propyläen-Verlag, 1929, p. 485)

ister figures. The four crescent-shaped forms, as well as the fish and plant figures, are references to Andean Late Intermediate period textile motifs that were available to her and others. Indeed, she may have copied motifs from three plates in Reiss and Stübel's text for which 238 plant, human and animal motifs were isolated and diagrammed.[27] For example, motif no. 77 on the bottom of their plate 104 (Figure **3.5**) is an inverted pyramidal shape and crescent-shaped top piece similar to the lower-register figures of Bittkow-Köhler's weaving. In addition, Bittkow-Köhler may have seen many examples of the stylized plant and fish motifs, a nearly ubiquitous feature of Andean textiles, at the Berlin Museum für Völkerkunde, such as the stylized maize plant pattern shown in Figure **3.6**.

Similar in theme is a small slit tapestry by Margarete Willers, of 1922 (see Figure **3.7**). The slit-tapestry technique that Willers utilized, whereby the outline of the shape is created by the empty space between weft colors, was commonly used for Andean Late Intermediate period textiles, and was frequently used for early Bauhaus weavings. Lehmann had referred to the slit-tapestry technique as kelim technique, a technique that he stated 'allows a much freer artistic activity, like painting in weaving, [and] shows scenes positively like picture-writing, as Max Schmidt has illustrated with splendid examples in the Baessler Archive'.[28] Willers's central symmetrical form is a composite tree/fish form not unlike many Andean motifs that metamorphose from one animal, plant, or figure into another. Like Bittkow-Köhler, Willers appears to have been looking at specifically Andean motifs for inspiration. Centralized 'fish' forms, as well as repeating fish patterns, are ubiquitous in Andean textile art. Indeed, Albers would eventually own numerous versions of it, including the small, fully finished, woven panel with cuttlefish motifs arranged in a grid shown in Figure **3.8**. The Andean weaver often depicted stylized fish from multiple points of view, such as frontal and aerial orientations at once, which is the orientation that Willers adapted. Importantly, the Willers piece is similar in size and technique to many Andean textile fragments, and particularly similar to the Andean panels that were woven as complete pieces. This similarity implies that she was looking at Andean textiles for their pictorial qualities and borrowing the motifs and formats for her own purposes.

Likewise, Ida Kerkovius borrowed two extremely common, though not exclusively Andean, textile motifs – the checkerboard and the geometric spiral, or fret – in her lost tapestry of 1920, made of textile remnants (Figure **3.9**).[29] These motifs were extensively reproduced in the texts cited above. For example, Reiss and Stübel reproduced numerous textiles with simple checkerboard patterns, as well as a fret pattern

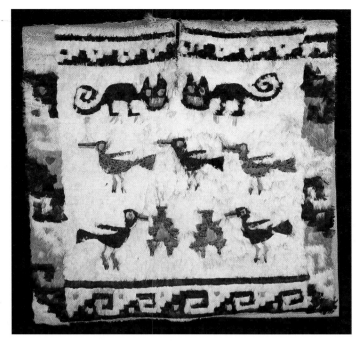

1.5 Tunic, South Coast, Peruvian, Nazca culture, camelid wool, plain weave, embellished by feathers knotted and attached with cotton yarns in overcast stitches, 85.2 × 86 cm (34.1 × 34.4 in), Art Institute of Chicago, formerly in the Eduard Gaffron Collection, Schlachtensee (reproduced in Walter Lehmann, *Kunstgeschichte des Alten Peru*, Berlin: Wasmuth, 1924, plate 12

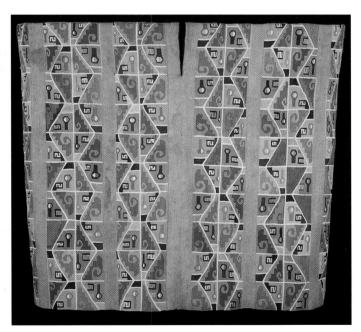

1.6 Tunic, Peruvian, Central Coast, Wari culture, 500–800 CE, camelid wool and cotton, single interlocking tapestry weave, 109.8 × 119.9 cm (43.25 × 47.5 in), Art Institute of Chicago, formerly in the Eduard Gaffron Collection, Schlachtensee (reproduced in Walter Lehmann, *Kunstgeschichte des Alten Peru*, Berlin: Wasmuth, 1924, plate 4

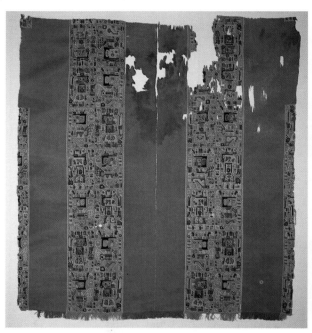

2.3 Tunic, Tiwanaku-style, Ancón, Peru, 104 × 98 cm (41.6 × 39.2 in), Museum für Völkerkunde, Berlin, Reiss and Stübel Collection 1879 (VA7468)

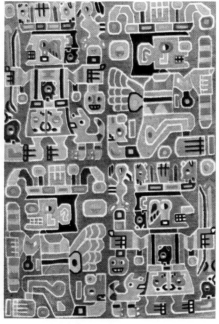

2.5 Detail of Figure **2.3** (reproduced in W. Reiss and A. Stübel, *The Necropolis of Ancon in Peru*, trans. A.H. Keane, Vol. 2, Berlin: Asher & Co., 1880–87, plate 49, and in Eckart von Sydow, *Die Kunst der Naturvölker und der Vorzeit*, Berlin: Propyläen-Verlag, 1923, plate 23)

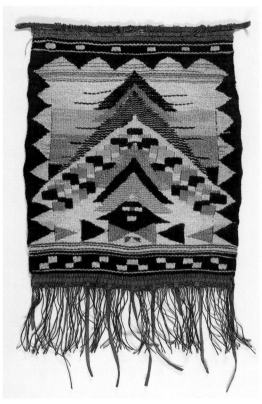

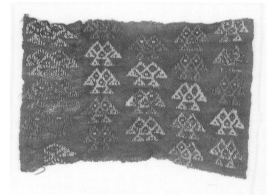

3.8 Chancay textile, fish pattern, cotton and supplementary wool brocade weft, 17.8 × 27.9 cm (7 × 11 in), four selvages, Anni Albers Collection, Josef and Anni Albers Foundation, Bethany, Connecticut

3.7 Margarete Willers, slit tapestry, 1922, linen warp, linen and wool weft, leather ribbons, 39.5 × 32 cm (15.8 × 12.8 in), Bauhaus-Archiv, Berlin

3.11 Max Peiffer-Watenphul, slit tapestry, c. 1921, hemp warp, wool weft, 137 × 76 cm (54.8 × 30.4 in), Bauhaus-Archiv, Berlin

3.12 Tunic, Inca/Early Colonial, Ancón, Peru, tapestry, cotton and camelid, height 84 cm (33.6 in), Museum für Völkerkunde, Berlin, Macedo Collection

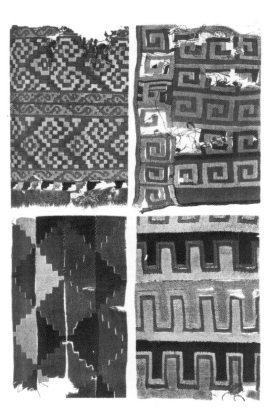

3.10 Andean checkerboard and step-form textile fragments, 'Dress Materials with Geometrical Patterns' (reproduced in W. Reiss and A. Stübel, *The Necropolis of Ancon in Peru*, trans. A.H. Keane, Vol. 2, Berlin: Asher & Co., 1880–87, plate 54)

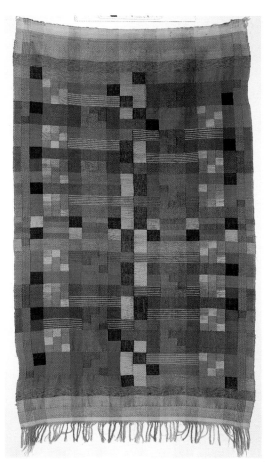

3.17 Benita Koch-Otte, woven wall hanging, 1922–24, wool and cotton tapestry, 214 × 110 cm (85.6 × 44 in), Bauhaus-Archiv, Berlin

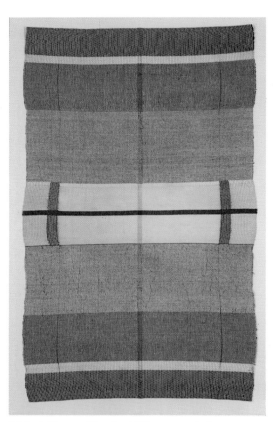

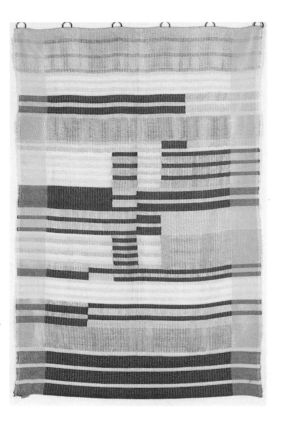

4.1 Anni Albers, wall hanging, 1924, cotton and silk, 169.6 × 100.3 cm (66.8 × 39.5 in), Josef and Anni Albers Foundation, Bethany, Connecticut

4.5 Anni Albers, wall hanging, 1925, silk, cotton, acetate, 145 × 92 cm (58 × 36.8 in), Die Neue Sammlung, Staatliches Museum für angewandte Kunst, Munich

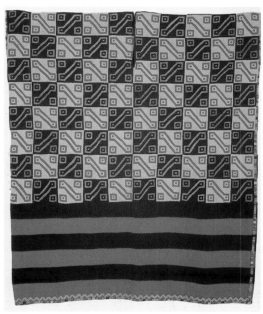

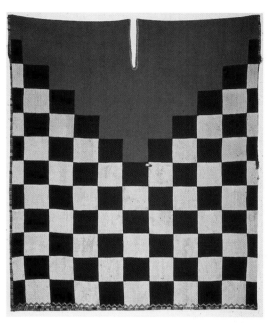

4.3 Tunic, Inca, 'key' pattern, cotton and camelid, 92 × 79.2 cm (36.8 × 31.7 in), Museum für Völkerkunde, Munich

4.12 Tunic, Inca, black and white checkerboard pattern with red yoke, cotton and camelid, with gold beads, 96.5 × 80.5 cm (38.6 × 32.2 in), Museum für Völkerkunde, Munich

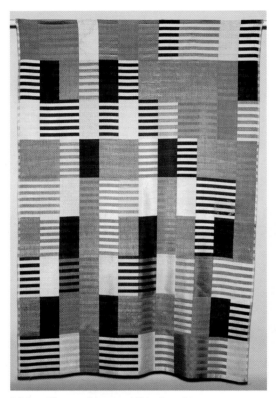

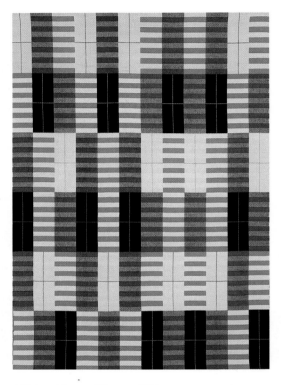

4.7 Anni Albers, wall hanging, 1926, silk, multi-weave, 182.9 × 122 cm (72 × 48 in), Busch-Reisinger Museum, Harvard University

4.10 Anni Albers, wall hanging, 1964 reconstruction of a 1926 original, cotton and silk, triple weave, 175 × 118 cm (70 × 47.2 in), Bauhaus-Archiv, Berlin

made of tiny squares (see Figure 3.10). As noted by Reiss and Stübel, the checkerboard pattern on the top left is itself a variation of the fret pattern on the top right.

The checkerboard was perhaps the most important motif at the Bauhaus. Kerkovius and other members of the Bauhaus would have known about the Andean use of the checkerboard motif from examples in the Berlin Museum für Völkerkunde and those illustrated in Reiss and Stübel. Their experimentation with the checkerboard as a compositional device, and as subject matter, was also influenced by their contact with Itten as well as through their understanding of De Stijl. Klee, too, explored the checkerboard as a constructive formula for composition in the pedagogical exercises that he developed in 1921, his first year at the Bauhaus. But even earlier, the checkerboard was advanced as an ideal visual symbol by De Stijl member Theo van Doesburg who lived in Weimar on and off between 1920 and 1923, and conducted classes there, which he called the Stijl Course, so that he could demonstrate his theories.[30] As numerous scholars have discussed, the presence of van Doesburg in Weimar initiated great change at the Bauhaus.

De Stijl, Constructivism, and the notion of universalism

Universalism was one of the major principles of the movement De Stijl (and the journal of the same name) from its inception in 1917 to its end in 1932. Members of De Stijl such as van Doesburg and Piet Mondrian believed that by abandoning individual expression in favor of a collective and abstract one, universal beauty could be attained. The connection between abstract art and a universal visual language, a connection that had already been investigated by Worringer, was promoted by De Stijl from its beginning. This principle of universalism was to be embraced by members of the Bauhaus as a solution to the problem of entering the machine age. If the universal forms of 'primitive' art – geometric, abstract, elementary – could be adopted in modern art, and if these forms could be produced through both hand-made and machine-made processes, then the crucial link between process and product, as well as that between artist and engineer, could be maintained. The idea that an artist could and should be an engineer, an idea that was shared by members of De Stijl and Constructivism, was clearly in opposition to the Expressionist, anti-machine aesthetic, yet it still allowed the hand-made process to play a role in the practices of design. Indeed Laszlo Moholy-Nagy, who would replace Itten at the Bauhaus in 1923, suggested that at the Bauhaus handicrafts could be 'supplemented', not destroyed, by the machine.[31]

While van Doesburg was in Weimar between 1920 and 1923, De Stijl served as

a magnet for an international group of artists who were also dealing with the relationship between machine production and artistic production. The Russian Constructivist El Lissitzky was a frequent contributor to *De Stijl*. For example, in a 1921 issue, the group calling itself 'the international faction of Constructivists', which included Lissitzky and van Doesburg, issued a succinct definition of the new progressive artist as 'one who denies and opposes the dominant place of subjectivity in art, founding his works not on any basis of poetic arbitrariness but on the principle of new creation, using systematic organization of means to achieve universally intelligible expression'.[32]

For Lissitzky and other Russians, 'universally intelligible expression' involved implementing the materials, construction, and accompanying visual forms of technology in order to make non-objective and non-associational objects for the masses. For De Stijl members, it involved using primary colors and elementary forms as building blocks for unified and hygienic utopian projects.

Not surprisingly, the international call for a universal art was strongly directed toward changing the Bauhaus, because the school was already an established institution where these new ideas could be put to practical use. In late 1922 in Weimar, a Dada-Constructivist meeting was held, where three representatives of International Constructivism – van Doesburg, Lissitzky, and Moholy-Nagy – joined forces. This meeting was followed by the large and widely attended exhibition of Russian art, 'The Erste Russische Kunstausstellung' (The First Russian Art Exhibition), at the Van Dieman Gallery in Berlin, with concurrent shows of Russian art at Gallery Der Sturm, and the Berlin publication of the journal *Object*, edited by Lissitzky and Il'ya Erenburg, that brought many of the theoretical issues of Constructivism to the West.[33]

Constructivism provided the Bauhaus with both a pro-machine ideology, and an abstract, anti-pictorial language that reinforced what Bauhaus members had already absorbed from De Stijl. What Constructivism added was the concept of the artist as a laboratory worker, and an emphasis on the principle of 'faktura', the relationship between the inherent properties of materials, including industrial materials, and their structural arrangement.[34]

The general notion of universalism derived from De Stijl and Constructivism, and subscribed to by members of the Bauhaus, implied that certain forms, namely non-objective forms, exist outside of the limitations and idiosyncrasies of one's cultural domain and personal concerns. In fact, universalism intersected primitivist discourses in so far as universal forms were thought to be primary, abstract, and geo-

metric. Such forms could be used advantageously in industrial design. For Gropius and others at the Bauhaus, the notion of universalism had come to be appreciated because it did not condemn but rather encouraged a new relationship with industry.

The social underpinnings and formal vocabulary of the universalist aesthetic helped members of the Weaving Workshop resolve the conflict between labor-intensive handicraft and labor-efficient industry in the practice of weaving. Andean textile examples helped them understand how universal geometric forms were used within the hand-woven structures of ancient textiles. Additionally, their exposure to Russian Constructivism prompted members of the Bauhaus Weaving Workshop to think of it as a laboratory in which samples and prototypes could be produced. Anni Albers advanced the idea that a textile should reflect in form and in function its inherent structure, and while she adopted the new industrial imperative, she retained the lessons of Andean textiles that demonstrated through hand-made products a range of structures inherent to the medium of weaving.

As Christina Lodder has noted, the technical utopianism of Constructivism did not provide the practical means of integrating art and industry that its members were seeking to achieve.[35] For example, Constructivist textile design never progressed beyond theory and printed fabrics due to the inability of the Russian textile industry to retool. Although mass-production could have been possible after the Revolution, industry was never transformed to meet the Constructivist agenda. Nevertheless, in their printed textiles and clothing designs, Russians such as Liubov Popova and Varvara Stepanova provided an example of modern artists turning away from art toward functional design. Therefore, in the Bauhaus Weaving Workshop, the ideals of Constructivism, rather than its actual accomplishments, were relevant, particularly the goal of the unification of art and industry for the purpose of social welfare. This is important to note because neither De Stijl nor Constructivism provided actual weaving models to support their respective ideologies.[36]

Anni Albers, above all other members of the Weaving Workshop, was able to absorb these international and internal waves of influence, and apply them to her work. Indeed, it is partly through her work and writings that developments in the Weaving Workshop can be understood. For Albers, the solution to the problem of integrating design and utility was to be found in the creation of 'types'. A type, she believed, could be achieved by understanding the essential character of the material as it applied to the function of the product. In her 1924 article, 'Economic Living' for the journal *Neue Frauenkleidung*, Albers wrote,

Economy of living must first be economy of labor … The traditional style of living is an exhausted machine which enslaves the woman to the house … The Bauhaus attempts to find the functional form for the house, as well as for the simplest utensil. It wants things clearly constructed, it wants functional materials, it wants this new beauty. This new beauty is not a style which matches one object with another aesthetically by using similar external forms (façade, motif, ornament). Today, something is beautiful if its form serves its function, if it is well made of well-chosen material. The good chair will then 'match' a good table. The good object can offer only one unambiguous solution: the type.[37]

Within the limited visual repertoire of De Stijl the checkerboard, and variations thereof, was the ideal universal image that could conform to Albers's notion of type, not as a decorative treatment, but as a pattern that echoes the geometric structure of architecture and design and, in her case, weaving. The checkerboard represented a non-objective, non-illusionistic, and impersonal composition that could be translated and interchanged among all media equally. Grid-based compositions by De Stijl artists were reproduced frequently in the journal De Stijl. The type of asymmetrical checkerboard image favored by De Stijl practitioners and others, in which the grid was arranged into different-sized units based on the repetition of a fixed unit, became very popular at the Bauhaus, and was practiced by numerous Bauhaus students in Itten's 'Preliminary Course', under the direct influence of van Doesburg.

De Stijl provided a visual program that was directly linked to the geometric structure of weaving. However, like Itten's investigations with the checkerboard format, De Stijl did not provide a concomitant weaving practice. This was to be found in Andean textile examples, more specifically through the study of Inca and Wari tunics and other Andean textiles with strict grid-based organizations. Because Andean textiles are so visually diverse, the modern weavers could now, as their visual priorities shifted, prefer these more severe styles to the Late Intermediate period ones. By looking at these grid-based Andean weavings, members of the Bauhaus Weaving Workshop could see directly how geometric abstraction could be applied to the fiber medium. From these 'primitive' examples, hand-made on simple tools, the modern weavers could see evidence of a universal visual language involving forms inherent in the weaving structure. This information was then translated by members of the Weaving Workshop in their own work, under the influence of what they were learning from contemporary artistic sources.

A good example of how this intersection of influences was used in the Bauhaus Weaving Workshop is the Kerkovius work previously discussed, and also a c. 1921 wall hanging by Max Peiffer-Watenphul (see Figure **3.11**). The primary geometric forms and primary color schemes derive from the De Stijl formula. Peiffer-Watenphul's use of registers, and the way he filled each register with a different pattern sequence, was a result of Itten's pedagogical exercises. However, the symmetry, floating modules, and central triangle of his composition, used in conjunction with the hand-weaving process, natural fibers, and perhaps hand-dyed fibers, relate this work to Andean textiles. This piece relates visually to the Inca (now thought to be Early Colonial/Neo-Inca) tunic at the Berlin Museum für Völkerkunde, from the 1884 Macedo donation, which Peiffer-Watenphul probably saw (see Figure **3.12**). From the tunic, he could have borrowed and inverted the central triangle, the typical yoke treatment of an Inca tunic. In addition, he could have derived from the tunic the motif of the square within a square or other framed geometric elements now known by the Quechua term *tocapu*. Although the tunic was called pure Inca until very recently, the undertones of European influence, such as the six unframed figures (three on each side), found between the yoke and the waistband on the upper right and left sides of the tunic, might have helped attract Peiffer-Watenphul to it since it is not quite as strict and minimalistic as straight Inca tunics.[38]

In any case, this particular tunic is interesting because the *tocapu* units were used in three different ways: framed squares of quadripartite patterns floating on a solid ground, three rows of patterned modules locked within a horizontal band, and solid units arranged in a checkerboard triangle around the yoke. Peiffer-Watenphul adapted all three types. He divided some of the floating units into quadrants, and used solid units in horizontal checkerboard bands, similar to the Andean example. He seems to have responded to the textual quality of the Andean example in that he used individual design units as a type of visual vocabulary that could be arranged to form a visual sign language, a sign language of primary forms and colors that many members of the Bauhaus, particularly Kandinsky, were investigating.[39]

Peiffer-Watenphul's indebtedness to De Stijl is seen in the primary color scheme and exacting use of primary rectangular forms that defy a three-dimensional spatial reading. Clearly he was trying to move beyond the narrative or pictorial image into a non-referential mode. The Andean model, in tandem with the De Stijl formula, provided him with the visual framework he needed.

Lore Leudesdorff's 1923 weaving (Figure **3.13**) also shows the impact of both

De Stijl and the Andean model. She borrowed an Andean textile motif and a geometric vocabulary for her small, fragment-like, slit tapestry. For example, Leudesdorff incorporated six abstract feather motifs, three on each side of the central quadrant, within the lively shape and color patterning of this small piece.[40] Because feathers were highly prized in the Andes, they were frequently depicted in woven or painted form, such as in an example illustrated in Reiss and Stübel (Figure 3.14).[41] The Andean textile sign for 'feather' was typically a long oval shape divided horizontally by a 'quill'.

Leudesdorff's weaving was to be the last Bauhaus textile that borrowed so directly the motifs from Andean textiles. By 1923, this type of unique, pictorial weaving was denounced by most members of the Bauhaus, as by all members of De Stijl, as 'Expressionist jam', passé and non-essential. Indeed, Stölzl later condemned these early pictorial weavings. In her 1926 article, 'Weiberei am Bauhaus' (Weaving at the Bauhaus), she wrote,

> While at the beginning of our Bauhaus work we started with image precepts – a fabric was, so to speak, a picture made of wool – today we know that a fabric is always an object of use and is predicated equally upon its end use and its origin.[42]

The transition from 'image precepts' to useful objects began to be seen in Bauhaus products as early as 1921, as evidenced by numerous examples. The so-called 'African Chair' of 1921, by Marcel Breuer and Gunta Stölzl (Figure 3.15), was definitely informed by primitivist concerns. Now lost, it was a five-legged, high-backed 'throne'. The wood portions were hand-carved and painted by Breuer and the seat cushion and back were woven by Stölzl. As Stölzl recalled, it was her first opportunity to collaborate on a piece of furniture. She used the wood frame itself as her loom. Rather than weaving separate seat and back cushions, as in the traditional European manner, she 'strung the coarse yarn directly through holes in the painted frame and then wove the pattern in interlocked tapestry style' with fiber remnants.[43] Photographs of this work reveal that the warp was threaded horizontally through drilled holes in the wood frame, then the weft threads were woven from top to bottom, a variation of the 'sideways' technique used in ancient Peru. If one imagines Stölzl straddling the chair, facing her work, this procedure makes sense, but it is not the usual method for any weaving tradition; an alternative method may have involved her weaving from right to left, with the chair, or the back frame, on its side. This chair is the product of artists who were exploring notions of collaboration, the marriage of art and craft, abstraction as a means of expression, and the hand-made process, notions formed in

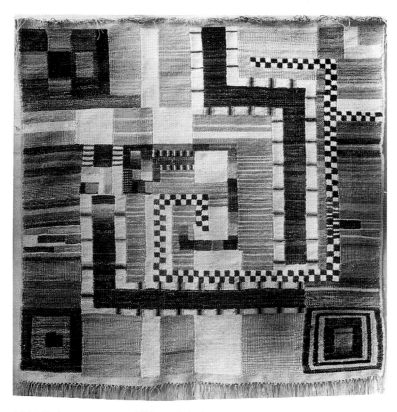

3.9 Ida Kerkovius, tapestry, c. 1920, interlocked tapestry, present location unknown. Photograph courtesy of the Bauhaus-Archiv, Berlin

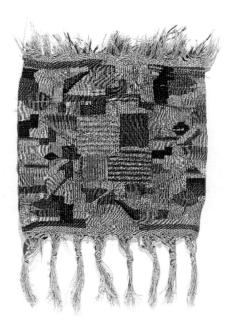

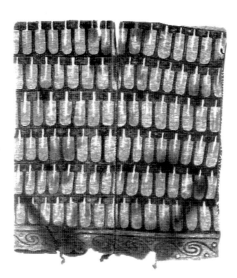

3.14 Andean painted cotton textile with feather motifs, 79 × 88 cm (reproduced in W. Reiss and A. Stübel, *The Necropolis of Ancon in Peru*, trans. A.H. Keane, Vol. 2, Berlin: Asher & Co., 1880–87, plate 39)

3.13 Lore Leudesdorff, 1923, slit tapestry, silk and wool, 18 × 17.5 cm (7.2 × 7 in), Bauhaus-Archiv, Berlin

the pre-War period and kept alive for a short time at the Bauhaus in the Woodworking and Weaving Workshops.

Slightly later in 1921, Breuer and Stölzl collaborated again on a chair that shows a new efficient streamlining of materials and techniques inspired in part by the strict geometry and primary color scheme of De Stijl (Figure 3.16). Again, Breuer provided the frame for Stölzl's weaving, but now the whole is clearly made of parts that could be easily reproduced. Rather than making an abstract pictorial tapestry, Stölzl let the fundamental principle of weaving – that of crossing warp with weft – determine the overall design. The resulting checkerboard of standardized parts, apart from its relationship to De Stijl, has an Andean precedent of which Stölzl may have been aware, particularly through her understanding of Inca tunics. One of the characteristics of Andean textiles is that the primary structure of the fabric itself was often taken as the primary organizing principle for the formal level; for instance, the ubiquitous checkerboard patterns can be seen as essentially a reference to the over-and-under nature of weaving.[44]

The development from spontaneous expression to a more systematically planned product occurred in all of the Bauhaus workshops as standardization was increasingly investigated for its production possibilities and its visual implications. However, this development should not be seen as an end to primitivist concerns at the Bauhaus; when needs and attitudes changed, so too did the 'primitive' model. Andean textile examples, however, withstood the ideological and formal shift that occurred at the Weimar Bauhaus, and continued to serve as a useful 'primitive' source, now translated according to new social and economic needs. Perhaps Frau Börner's criticism of the 'fantasy weavings', or *Phantasiebindungen*, from members of the Weaving Workshop was not so far off the mark, as these early Bauhaus weavings reflect a particular interest in the fantastic motifs of their Andean counterparts.

In 1923, paralleling other developments at the Bauhaus, the Weaving Workshop entered a new phase that emphasized technical factors in weaving and more systematic studies of color and pattern. Already in March 1922, Gunta Stölzl and Benita Koch-Otte had enrolled in a four-week course in dyeing at the Dye-works and Technical School in Krefeld in order to improve their knowledge of dyeing. Stölzl noted that while there, yet acting independently of it, they explored natural dyes, including red cochineal and blue indigo, much to the amazement of their colleagues at Krefeld who were more interested in studying chemical dyes. Indigo blue was not an exclusive Andean dye; cochineal red, however, achieved by mashing the cochineal bug found on

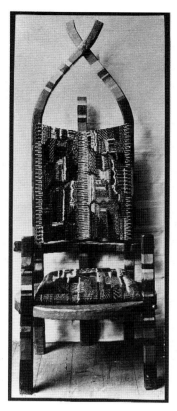

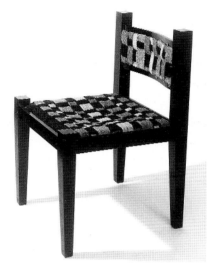

3.15 Marcel Breuer and Gunta Stölzl, 'African Chair', 1921, present location unknown

3.16 Marcel Breuer and Gunta Stölzl, chair, 1921, Kunstsammlungen zu Weimar

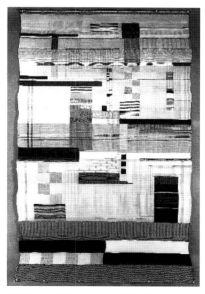

3.18 Gunta Stölzl, tapestry, 1923–24, wool, silk, mercerized cotton, metal thread, 176.5 × 114.3 cm (69.5 × 45 in), Museum of Modern Art, New York

the prickly pear cactus, was an Andean invention. She wrote, 'we were almost laughed out of the Krefeld Academy because in the twentieth century we wanted to use natural dyes, but nevertheless, they gave us the needed support'.[45] That Stölzl and Koch-Otte deliberately chose to focus on these ancient dyes, used extensively in the Andes, is evidence that ancient models were considered relevant to Bauhaus interests regarding the organic properties of color. The women may have been aware, from looking at Andean textiles such as the Tiwanaku-style tunic at the Berlin Museum für Völkerkunde (see Figure 2.3), and reading about them in books, that the range and brilliance of Andean dyes was extraordinary, particularly those involving cochineal and indigo.

By 1923, Stölzl and other weaving students had established a dye facility at the Bauhaus. This enabled members of the Weaving Workshop to investigate and then demonstrate the color theories they were learning from Bauhaus teachers such as Klee and Kandinsky. Simultaneously, they were also exploring the natural colors of various fibers, including synthetic fibers, through Constructivist-based lessons they were learning from Moholy-Nagy.[46] The Andean textile models reinforced these interests and supplied the structural framework with which to apply color theories to the discipline of hand-weaving.

Benita Koch-Otte's 1922–24 wall hanging (see Figure 3.17) reveals that she was investigating the use of chromatic interaction and patterning as they applied to weaving. She had studied with Klee in 1921, and by 1923 she had enough control over the dyeing process that she could implement in thread his classroom exercises involving the arrangements of colors through principles of rotation and reflection, as well as the division and multiplication of modules within a grid framework. Koch-Otte's textile has a highly complex organization of parts that involves reflected and rotated modules. While Klee provided much of the theoretical inspiration to Koch-Otte, it appears as if she was also looking to Andean textile sources. Indeed, Klee's theoretical principles involving color rotation, reflection, and shifting were probably not fully developed until the Dessau period, so she may not have been fully aware of them at this time. For this reason, certain Andean sources involving principles of rotation and swapping would have been crucial to her work.

Koch-Otte's Andean textile models were most likely the Tiwanaku and Wari tunics in Berlin collections such as the Tiwanaku tunic from the Berlin Museum für Völkerkunde (see Figure 2.3) and the Wari tunic from the Eduard Gaffron Collection that she may have been aware of before it was reproduced in color in Lehmann's book

(see Figure 1.6). Both tunics are related in that they are abstracted representations of figures, but the profile head motifs in the latter tunic are so abstract that they are nearly unrecognizable as figures, and thus are read primarily as geometric patterns.[47] The Wari tunic in particular shows how the principles of reflection and color-swapping were handled by expert Andean weavers. Each of the twenty quadrants is subdivided into six triangles of alternating stepped-fret and profile-face motifs. As Rebecca Stone-Miller describes it, the face 'has the typical split eye, "N" or reverse-"N" indication of crossed fangs, a hat or headband, and sometimes a nose'.[48] These motifs are arranged according to shape and color so that various pattern sequences advance or recede from the overall grid-like field. This Andean textile model, and others like it, would have provided Koch-Otte with similar principles of compositional organization to her own; moreover, these principles would have been understood within the framework of hand-weaving.

From these Andean tunics Koch-Otte would have seen how the sequential arrangement of figures and geometric shapes could form abstract patterns, patterns that are further complicated by contrasting color relationships. In both tunics, for example, the flipped version of each figure is diagonally positioned opposite it, with a different color scheme. Koch-Otte divided her panel into quadrants, and organized the whole by rotating the lower right quadrant into the upper left position, and doing the same for the other two quadrants. From looking at Andean textiles such as these tunics, she would have seen how the principles of flipping, inversion, and rotation of small units could be applied to a weaving as a whole. This information differed from the more pictorial interests shown in earlier Weimar Bauhaus weavings, and would lead to an even more extensive investigation of weaving structures and patterns by other members of the workshop.

A 1923–24 wall hanging by Gunta Stölzl also shows a difference in technique and form from earlier Bauhaus textiles (Figure 3.18). From the De Stijl influence, she used elementary forms as building blocks to create a non-associational, universal image. From the Constructivist notion of 'faktura', she made sure that the geometric structure of the weaving was integral to its subject, form, and texture. Additionally, in a move that is not as apparent but is just as significant, she adapted a uniquely Andean weaving technique to achieve her desired results. Stölzl referred to the technique of this work, and similar works that she and Anni Albers developed at the time, as 'inlay' (Einlegen). The 'inlay', or structural panel, was not a Bauhaus invention, Stölzl stated, but was adapted from earlier weaving techniques. She wrote, 'the free way that we did

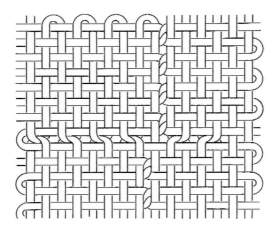

3.19 Anni Albers, illustration from *On Weaving*, plate 63, 'interlocking warp and weft (Peru)'

the "inlay" is actually something that we discovered, [although] it is also evident in folk art but there it is always dependent upon a special pattern of the shafts [warps]'.[49]

Whether Stölzl was using the term 'folk' to refer to Andean textiles remains unclear, but the nature of her subsequent weaving, and the fact that she mentioned the special positioning of the warp thread, implies that she may have been referring to the nearly uniquely Andean weaving technique known today as 'discontinuous warp and weft'.[50] In this laborious and complicated technique, the vertical warp element is not a series of continuous threads but a series of interlocked discontinuous threads held by a scaffold thread system until crossed with the horizontal weft element, also of interlocking, discontinuous threads. Anni Albers later diagrammed this ancient Peruvian technique in her 1965 book *On Weaving* (Figure **3.19**). The appeal of this technique is that it produces areas of intense hue and value in a light-weight fabric, in contrast to the heavier tapestry technique by which strong color results from tightly packing the dyed weft threads over undyed warps so as to obscure them. In addition, the discontinuous warp and weft technique is well suited to strict geometric designs since rectilinear areas require fewer scaffold threads to construct.[51] An excellent example of the Andean discontinuous warp and weft technique that belonged to the Munich Museum für Völkerkunde, was reproduced and described by Lehmann in his 1924 book (see Figure **3.3**) as a textile with 'special warp and special weft'.[52]

The Andean weaver had to connect the warps through a laborious scaffolding system, but Stölzl discovered that she could achieve similar results by applying dyes

directly on the warp threads already stretched on the loom.[53] Thus, for this weaving, Stölzl strung the white silk warp threads and then painted panels directly on the threads. For the weft fiber, she interwove mercerized cotton and unbleached natural sheep wool, ranging from white to black, in much the same way that Andean weavers used natural cotton and camelid fibers to create contrasts.[54] Like Klee, Stölzl was applying tonal values to create gradations and the apparent overlapping of planes. In this case, fiber served as an ideal medium to demonstrate Klee's theories physically, an achievement made possible by Stölzl's much more labor-saving simulation of an Andean weaving technique.

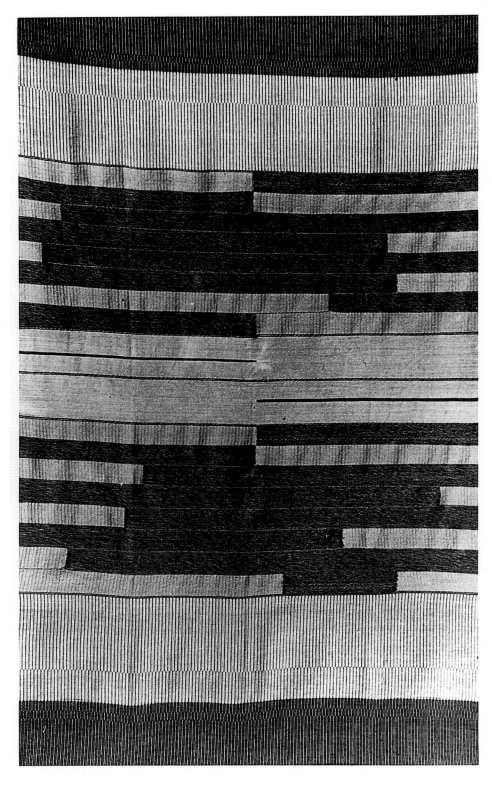

4.2 Anni Albers, wall hanging, 1924, wool, silk, cotton, 120 cm wide (48 in), present location unknown

4. Anni Albers at the Bauhaus

Anni Albers made her first Bauhaus wall hanging in 1924 (see Figure **4.1**). She had joined the Weaving Workshop in 1923, and by her fifth semester, after having assisted in the dye laboratory, she began to create large woven hangings such as this.[1] The work is a plain weave construction, with cotton warp and silk weft.[2] The yarns, black, gray, off-white, and variations thereof, may well have been part of the same undyed yarn lots that Stölzl used.[3] However, Albers did not simulate Andean techniques but rather was attempting to find a weaving structure, used in conjunction with the natural hues of the materials, that defined the pattern itself; in other words, she was exploring the notion of the self-referential textile that displayed the nature of its construction in its form.[4]

Even in her first weaving, one sees elements of both contemporary and Andean sources. For example, Albers's wall hanging is roughly the size and proportion of later Andean tunics in an opened-out format, approximately 169.6 × 100.3 cm (5.5 by 3 feet).[5] It is tempting to read in the symmetry of her work references to center and shoulder fold lines such as these indicated in the tunics she would have seen displayed at the Berlin Museum für Völkerkunde. Albers's use of registers, modular units, and tonal gradations through color crossing (crossing different colored wefts with warps) points to the influence of Klee and De Stijl.

Unlike Stölzl, she did not employ the 'inlay' technique for a now-lost wall hanging from 1924 (Figure **4.2**), but rather relied on the constructive process to create patterns. In it she investigated complex patterns involving horizontal and vertical symmetry achieved by reflecting, rotating, and staggering various segments and bars of the overall piece. She utilized at least three rotation points, one of which is in the center. In addition, this weaving shows that she was experimenting with certain mathematical arrangements and progressions that she may have understood through her contact with Andean textiles. Like Koch-Otte, she may have been aware that many Wari and Inca tunics had geometrical underpinnings involving principles of rotation, reflection, and repetition, and these ancient textiles would have helped her translate the formal theories she was investigating at the time. For example, Albers may have known about the Inca 'key' tunics in the Munich and Berlin museums (see Figure **4.3**) that are composed of bars and reflected key motifs within a checkerboard. These

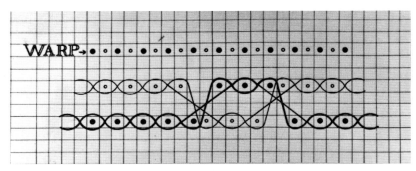

4.4 Anni Albers, illustration from *On Weaving*, plate 23, 'cross section of double cloth in contrasting colors, interlocked for pattern effect'

tunics in particular reveal the self-referential nature of Andean textiles in two ways: the under-and-over process of weaving is reflected in the checkerboard patterning, and the interweaving of the key shapes around the dots is a reference to a weaving in cross-section, which can be seen in Albers's diagram of it (Figure **4.4**) as well as Klee's (Figure **4.17**).[6]

It is clear that Albers was not interested in borrowing motifs from 'primitive' sources, as members of the Weaving Workshop had done during the earlier stage. She was much more concerned with developing a universal language of non-objective form as it was generated directly from the structure of the weaving. This motivation came from many directions: from her understanding of Klee's constructive systems of design, from the geometric abstractions and universalist theories of De Stijl, from the industrially directed products and ideology of Constructivism, and from her understanding of Andean textiles, which involved investigation of weaving structures as a way to arrive at formal designs.

In 1925, the Bauhaus moved from Weimar to the industrial city of Dessau. During the transition period, George Muche purchased Jacquard looms for the Weaving Workshop, a move that points to the increased technological and mechanical direction of the Dessau Bauhaus.[7] With this semi-mechanical loom, the weavers were able to manipulate warp threads through pre-perforated pattern cards in order to make very precise lines and minimize labor. Albers used the Jacquard loom to produce the dazzling 1925 wall hanging shown in Figure **4.5**. This weaving is important because it is the first known work in which she incorporated synthetic material, in this case acetate, along with natural fibers, silk and cotton, to create physical and visual texture due to different fiber thicknesses. The apparent textural three-dimensionality lent

by various levels of threads in a layered format was further intensified by formal choices that create the illusion of bars overlapping a continuous ground.

At this time, partly due to this new technical development, Albers began to experiment with the complex color systems and accompanying multi-weave constructions that are features of her most famous works. A multi-weave construction is produced when multiple planes of cloth are woven simultaneously, each with its own set of warps and wefts, yet threads are exchanged among the layers when needed.[8] With this interlocked sandwich effect, intense color, as well as a stronger cloth, can be made with a fine and light-weight fiber, such as silk. Double, triple, and even quadruple weaves were explored in many periods and styles of Andean textiles with such skill that, as Rebecca Stone-Miller has said, an Andean weaver could 'simultaneously coordinate three distinct planes of cloth, forming three different patterns in two different color schemes'.[9] Albers herself later explained and diagrammed (Figure **4.4**) the multi-weave construction within the context of Andean textiles:

> In ancient Peru, double weaves in complicated designs were made, and triple weaves have been found, as well as a small quadruple piece. If a highly intelligent people with no written language, no graph paper, and no pencils could manage such inventions, we should be able – easily I hope – to repeat at least these structures.[10]

Albers's experiments with color crossing and color locking through structural weaving constructions occurred simultaneously with those of her husband, Josef. As Clark Poling has discussed, Josef Albers in particular was interested in how the illusion of transparency from color crossing and gradations could be achieved literally, physically, and conceptually according to the degree of contrast between the figure and the ground, which Josef later referred to as the degree of 'pronouncement'.[11] Anni's so-called thermometer-stripe patterned weavings, and Josef's thermometer-stripe patterned sandblasted glass pieces such as *Upward* from 1926 (Figure **4.6**), developed from these shared investigations. The 'thermometer stripe' is a term used to describe the alternating horizontally striped bars inside rectangular modules that both Josef and Anni Albers used during the Dessau Bauhaus period.[12] However, it was through Anni's multi-weaves that the phenomenon of 'pronouncement' was best demonstrated because she could achieve it both two-dimensionally and three-dimensionally by physically crossing one set of threads (the weft) with another (the warp).

For example, for her untitled 1926 silk multi-weave wall hanging (see Figure **4.7**), Anni Albers utilized a standardized visual vocabulary of modular units differen-

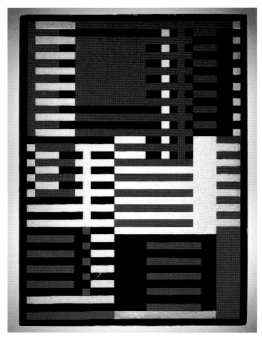

4.6 Josef Albers, *Upward*, c. 1926, sandblasted glass,
44.4 × 31.9 cm (17.75 × 12.75 in), Josef and Anni Albers
Foundation, Bethany, Connecticut

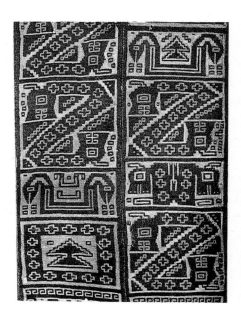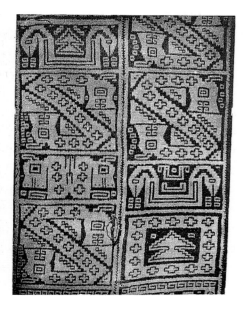

4.8 Tunic, Pachacamac, double weave, red and white, 64 × 55 cm (25.6 × 22 in), views of both sides, Museum für
Völkerkunde, Berlin (reproduced in Walter Lehmann, *Kunstgeschichte des Alten Peru*, Berlin: Wasmuth, 1924, p. 117)

tiated from one another by the various combinations of individual bar colors within each rectangular unit. There are 108 units, and six colors: black, white, gold, light gold (gold + white), gray (black + white), and gray-green (gold + gray), arranged in 13 different thermometer-stripe bar combinations.[13] In Albers's weaving, the intensity of the color, and the contrast of value, for each individual unit depended on both the constituent colors with which it was woven and the color of the unit to which it was adjacent. This she would have learned from Klee, and also from the nineteenth-century theories that M.E. Chevreul had developed for the Gobelins tapestry factory in Paris. The geometric framework was based partly on the De Stijl model. Yet she was also interested in finding the optimum relationship between material properties, structural methods, and the overall visual form and texture of the weaving. It was under this set of preconditions that Albers looked to the Andean model for further and more specific information related strictly to weaving. Here she found both the structural and the formal models she needed.

This is one of an assortment of the first of Albers's many wall hangings of double- and triple-weave constructions. She would have seen many fine Andean examples of multi-weave constructions at the Berlin Museum für Völkerkunde, such as the outstanding reversible, red and white double-weave tunic that was woven with the reverse color combination on either side (Figure **4.8**). Albers realized that the multi-weave construction was the ideal method by which to create the color relationships she was investigating. In addition, she could make a strong fabric whose formal patterning was a direct result of the constructive process. For example, assuming the warp threads were separate layers of white, black, and gold, she could create an intense gold by pulling up only the gold warp web while crossing it with a gold weft thread. By switching the warp layer to white, for example, and maintaining the gold weft, an ivory mixture would result. She chose not to cross the gold with black (which would have made a brown), but she was otherwise able to create six colors and 13 combinations from only three original fiber colors. Far from a flat abstract image, this textile is sculptural in that pouching occurs in certain areas. It could also serve as a functional product; indeed, the ring stains indicate that it may have been used as a tablecloth. Interestingly, Albers referred at the time to this, and her other multi-weave pieces, as a *Flügeldecke*, a term that implies a functional use as a piano throw.[14]

Albers's multi-weaves and modular unit weavings typically involved patterns based on multiples of three and four. For example, the 1926 multi-weave just discussed (Figure **4.7**), is twelve units wide by nine units long, for a total of 108 units.

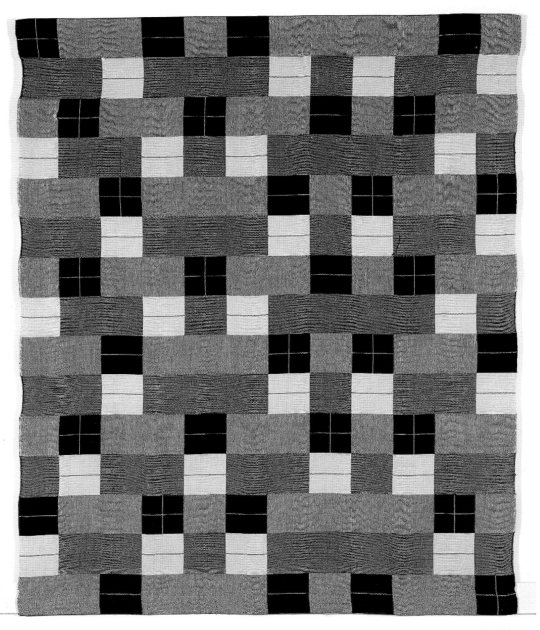

4.9 Anni Albers, wall hanging, 1964 reconstruction of a 1927 original, cotton and silk double weave, 147 × 118 cm (58.8 × 47.2 in), Bauhaus-Archiv, Berlin

Her 1927 silk double-weave wall hanging (Figure **4.9**), is fifteen units long by twelve units wide for a total of 180 units of four color variations and four modular variations: single, double, triple and quadruple. Similarly, her 1926 silk triple-weave wall hanging (see Figure **4.10**), is twelve units wide by six units long for a total of 72 units of four variations. In the latter two works, she added a new motif, the solid unit divided into quadrants. In her black, white, and orange wall hanging, and the similar black, white, and red wall hanging, both from 1927, four rectangular modules, divided into quadrants, appear in each of the six horizontal rows. The overall patterning of this weaving is more methodical, and is based on the sequential repetition of every fourth row, except that for every repeat of shape, a color exchange occurs. For example, white is exchanged for black, black for white, orange and white bars for dark orange and gray bars, and dark orange and gray for orange and white. In this particular weaving, Albers may have been demonstrating a version of the 'Bezold Effect', a color theory that Josef Albers was investigating whereby red (or orange in this case) appears lighter and brighter next to white than to black.[15]

Besides admiring the multi-weave construction of Andean tunics, Albers would have also responded to a common Andean design feature that incorporates interlocked modular design units enclosing symmetrically organized design elements. These design units – framed, with repeated geometrically abstract designs, and implying a visual vocabulary that may have served a linguistic function – are referred to as *tocapu* squares, typically used on high-status Inca tunics. *Tocapu* units functioned on a variety of levels: as design elements for the purpose of creating spectacular visual images and as abstract signs that had ideographic meaning.

Among the Andean *tocapu* tunics in German and American collections that Albers most likely knew was the example with *tocapu* motifs that Lehmann reproduced from the American Museum of Natural History in his 1924 book (Figure **4.11**). This Late Inca/Early Colonial tunic is made up of over 150 individual units of 14 variations, not including the two rows of figures on the lower registers. Within the corpus of Andean textiles, Inca tunics are the most standardized in design and production; they constitute some of the finest weaves, the brightest dyes, and the most spectacular all-over checkerboard formats of any Andean textiles.[16] This information Albers would have known from seeing the Inca tunics at both the Berlin and the Munich Museum für Völkerkunde, and in various publications. The most common designs among surviving Inca tunics are the black, white, and red checkerboard designs that were most likely used as military garments (see Figure **4.12**); this example could be seen at the

Munich museum. The most elaborate Inca tunics are the royal *tocapu* tunics, such as the stunning example from the Bliss Collection at Dumbarton Oaks, Washington, DC (see Figure **4.13**), which may not have been known in the 1920s but is shown here as a superior example of the *tocapu* format.

Typically, in Inca tunics, the more complex the individual *tocapu* square, the more complex the chromatic and design relationships and the calculated placement of the units within the overall field. For example, the starkly bold checkerboard tunics are always composed of alternating black and white squares, with red yokes. The Inca 'key' tunics, such as the example at the Munich Museum für Völkerkunde (see Figure **4.3**), utilize more complicated color relationships such as a red key on a yellow ground alternating with a gold key on a purple ground. Lively and optically charged figure/ground relationships occur in both types of tunics. The all-over *tocapu* tunic, as well as many tunics with rows of *tocapu* squares, continue to mystify modern viewers as to the calculated placement of the squares.

Clearly Albers was aware of the characteristics of Inca tunics, in which standardized units were arranged in various combinations, including seemingly random ones, and she may have adapted some of their design and chromatic features for her own work. The black, white, and red color combination is an obvious example. The checkerboard format was one that she used within the context of the Bauhaus and De Stijl, but the fact that she combined this formation with multi-weave constructions is evidence that she was looking to the Andean model, and combining different Andean examples, for a textile interpretation of the checkerboard. Indeed, her use of module units, the tunic-size format, and the hand-weaving process make her weavings modern versions of the *tocapu* textile. In this way, Albers was participating in and enhancing the discourse of universalism within the context of primitivism.

Paul Klee and the Bauhaus Weaving Workshop

Paul Klee occupied a significant position in relation to the Bauhaus Weaving Workshop throughout his decade-long tenure there from 1921 to 1931. His influence was made primarily through his Bauhaus lessons, which were integrally connected to his own artistic explorations and fundamentally aligned to developments that took place in the Weaving Workshop.[17] Importantly, Klee taught theoretical courses to weaving students, including Anni Albers, for over two years, from 1927 to 1929, a period of great progress and success for both Klee and his students, some of whom had already taken his 'Theory of Form' class. Most of the students at least knew his work through pub-

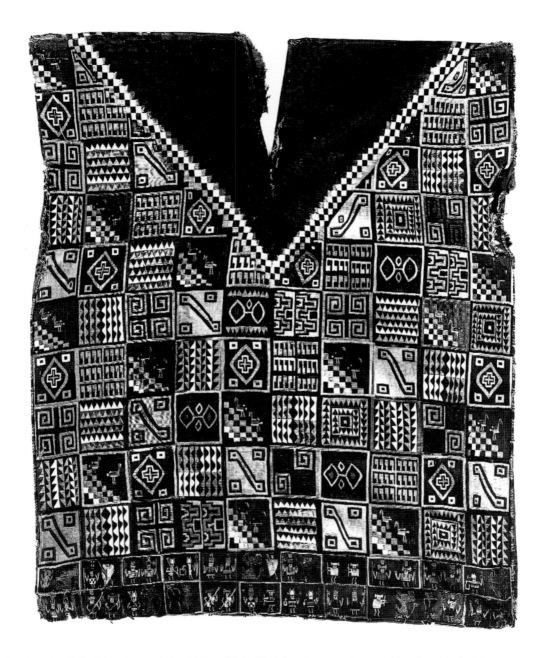

4.11 Tunic, Inca/Early Colonial, *tocapu*, 96.3 × 92.5 cm (38.5 × 37 in), found in stone chest near Moro-Kato, Island of Titicaca, now in the American Museum of Natural History, New York, Garces Collection

lications of his classroom lectures, and through exhibitions and publications of his by then internationally recognized art.[18] Albers owned a copy of Bauhaus Book Two from 1925, which highlighted his pedagogical sketchbooks. 'We were so full of admiration for Klee', Anni Albers later recalled; and elsewhere she said, 'he was my god at the time'.[19]

This reciprocal and highly creative relationship can now be understood more completely by analyzing student notebooks and papers from Klee's Bauhaus courses. The notebooks and material in the collections of the Getty Research Institute and the Metropolitan Museum of Art have not been included in Klee scholarship until now; taken as a whole, with material from the Paul-Klee-Stiftung in Bern and the Bauhaus-Archiv in Berlin, they provide new insights into Klee's work and his impact on members of the Weaving Workshop.[20]

The student notebooks reveal that Klee in fact consolidated much of his earlier Bauhaus lessons that he developed during his Weimar period from 1921 to 1925, particularly his theoretical lessons dealing with chromatic relationships and constructive approaches to composition. The notebooks also reveal that Klee apparently took this opportunity to review and refine his principles *within the context of weaving*. He left out lessons dealing with plants and nature, with the ligaments, bone structure, and circulatory system of the body, and with organic movement, exemplified by his famous waterwheel diagram. Instead he focused on those lessons relevant to weaving: color crossing (scales), and rhythmic sequences (checkerboard) from his 1921–22 pedagogical notes 'Beiträge zur bildnerischen Formlehre' (Contributions to a Theory of Pictorial Form), structural composition (weaving) from a lecture dated 23 October 1923, overlapping patterns (polyphony) from a lesson after 1922, and compositional schemes (rotation, reflection), most likely created for the weaving course.[21]

It is important to note that Klee produced thousands of pages of notes, not all of which he dated; therefore, it is possible to believe that he developed certain lessons specifically for the weaving students, which would not be surprising considering that he may have taught at least eight sections of the course between 1927 and 1929, constituting a substantial amount of his time.[22] Indeed, these courses seem to have served as an important juncture for both Klee and many members of the Weaving Workshop as they developed a deeper understanding of the possibilities of textiles as simultaneously structures, processes, subject matter, and utilitarian products.

Klee's work at the Bauhaus involved linking two often opposing approaches to making art: (1) exploration of intuitive thought processes and expressions, and (2)

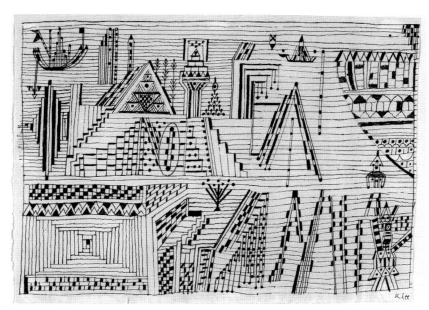

4.14 Paul Klee, *Beride (Wasserstadt)* (Beride (Town by the Sea)), 1927, 51 (01), pen on paper on cardboard, 16.3 × 22.1 cm (6.5 × 8.75 in), Paul-Klee-Stiftung, Kunstmuseum Bern

objective investigation of visual phenomena.[23] Through this approach that joined the subjective and the objective, Klee found a union between thinking and seeing, and between imaginative and objective realities. It is interesting to note that Klee's 1928 essay, 'Exact Experiments in the Realm of Art', in which he described his pedagogical philosophy as a cross between science and art, was completed during the period of his greatest contact with the Weaving Workshop.[24] Klee's increased access to weaving at this time may have inspired him to ponder his own relationship with artistic freedom and limitations, for he would have been regularly reminded of the highly restrictive nature of weaving that can easily limit creativity.

Perhaps more than any other non-textile artist working at the time, Klee's use of textile metaphors and references was extensive, both informing his lectures and extending into the realm of his own work, particularly during his Bauhaus tenure. He frequently used networks of lines to create patterns that resemble those found in tapestries, carpets, embroideries, braids, batik, printed cloth, and lace.[25] For example, portions of Klee's 1927 *Beride (Wasserstadt)* (Beride (Town by the Sea)) (Figure 4.14) seem to be built up from an open network of lace-like threads, while the lower left corner is clearly a pattern derived from the interlocking threads of a weaving. The hor-

izontal registers hold the image together like weft threads on a loom. Klee was fascinated by the grid; he experimented extensively with complex networks of squares: those in regular grid formation as in *Farbtafel (auf Majoren Grau)* (Color Table (on Major Gray)), of 1930 (see Figure **4.15**), and those organized according to the multiplication and division of units within the grid. He frequently painted on loosely woven cloth, such as gauze or burlap, instead of canvas, so that the texture of the woven threads would become an integral part of the work, forming, in effect, a textile. In addition, Klee frequently turned and inverted his compositions before arriving at a final orientation. The notion of turning and folding a work of art is directly related to the flexible nature of textiles and carpets, which are not always governed by a specific viewing direction or orientation. Anni Albers would later do the same for her own weavings in the 1950s.

Based on a general knowledge of Klee's own work – rigorous and academic in technique, meaningful and keenly observant in content – one immediately gathers that his course given to weaving students fulfilled the technical side of his pedagogical approach. The student notebooks are surprisingly uniform, filled with methodical notes and diagrams (some, such as Albers's, are even typed, indicating rewriting outside of class). One envisions a rather cool and exacting classroom environment, judging from the absence of personal flourishes in the notebooks. Yet for members of the Weaving Workshop, who were already discovering the inextricable link between weaving content and weaving technique, his lessons proved to impart both method and meaning.

Decades after having taken Klee's class Anni Albers recalled some of the challenges that Klee presented:

> He would walk into the room, go up to the blackboard, turn his back to the class, and start to explain something that he probably thought was of concern to those listening to him. But he probably didn't know at all where each of us there was in his own development, in his own concern, in his own searching ... On the other hand, I find that he probably had more influence on my work and my thinking by [my] just looking at what he did with a line or a dot or a brush stroke, and I tried in a way to find my way in my own material and my own craft discipline.[26]

It was Klee's routine to be totally prepared for each course, as he explained to his wife Lily in 1921: 'The lecture went quite smoothly yesterday, I was prepared to the last word; this way I don't have to be afraid of saying something that is in any way irre-

sponsible.'[27] Moreover, professors at the Bauhaus most likely did not promote the type of informal, nurturing atmosphere that one finds in today's classrooms. Klee was, after all, the Master, and his students were primarily female; one can assume that certain conventional classroom roles were maintained. However, Klee's curriculum did include class critiques, which may have balanced some of the lecture formalities. Student Lena Meyer-Bergner stated, 'In his course he dealt with the law of surface itself, as well as the relationships between forms and colors … In addition to formal instruction, the weavers gathered for occasional meetings at which, under Klee's leadership, the fabrics were critically analysed.'[28]

This is confirmed by Klee himself who remarked that 'there was some criticism of weaving materials; an eminent number of new ideas were introduced, some particularly good'.[29] Thus, within the formal confines of the course, mutual affinities between weaver, artist, and teacher ultimately contributed to its overall success.

The notebooks and classroom material kept by students Hilde Reindl, Margarete Willers, Gertrud Preiswerk, Eric Comeriner, Anni Albers, Eric Mrosek, and Lena Meyer-Bergner are not exactly the same, which indicates that they were produced during different semesters and/or sections. Not all of the material is dated either, yet the notebooks do follow a general format, beginning briefly with proportions, ratios, and the golden section, and proceeding to color, line, structure, rhythm, and finally to polyphony.

Klee was well aware that weaving could serve as an ideal medium with which to demonstrate his theories.[30] It is not surprising to learn that he owned at least two Bauhaus weavings, an untitled braid-pattern weaving by Ida Kerkovius and a piano cover by Otte Berger.[31] His working notes from the Weimar Bauhaus reveal that his concept of structural composition was developed with weaving in mind, as evidenced by his devotion to the checkerboard, a perfect visual metaphor for the under-and-over structure of weaving. For example, when discussing the elements of line, Klee had students connect points by lines or waves to create rigid or fluid rhythmic sequences through strokes. Certainly line, in this case, could be thought of as a metaphor for thread. Interestingly, as can be seen in some of the students' notebooks, Klee linked the lesson on running threads directly to a discussion of structural composition: the regularly threaded line is a checkerboard in cross-section.

Composition at its most 'primitive' and 'pure', Klee explained in his 1922 lecture notes, occurs through the repetition of a single line or unit in parallel sequence, such as a stripe or row of squares.[32] The greater the unit is manipulated through mul-

tiplication, division, under- and overlapping, and displacement, the more complex and dynamic the composition becomes, producing variations of the checkerboard, and generating systems and structures within a grid format. A page from Anni Albers's neatly organized notebook illustrates how a pattern can vary through the shifting and deferral of a framed unit (Figure **4.16**).

During subsequent semesters at the Bauhaus Klee refined his theories of composition, again using the weaving metaphor to explain them. For example, as can be seen in his 23 October 1923 lesson, 'Constructive Approaches to Composition' (Figure **4.17**), he diagrammed the warp and weft construction of plain weave, basket weave, and braid constructions, along with two cross-section views, in order to explain that the checkerboard structure is the inherent structure of weaving, and that the grid can be envisioned as a weaving structure. This particular theoretical point may have helped members of the Weaving Workshop to more fully understand the ubiquitous checkerboard in Andean textiles, and may have inspired them to seek out the most explicit examples of it from Inca textiles.

For his lessons dealing with color, Klee analyzed the weight, intensity, and contrast of chromatic relationships according to a series of scales, shapes, mixtures, and placements, again of great interest to weavers who were investigating the chromatic properties of fiber when crossed with identical, opposing, or analogous colors.[33] As his lessons on color and structure continued, becoming more complex and sophisticated, color was discussed as a structural element, leading to another of Klee's lessons that resonated strongly with his weaving students. An important page from Klee's undated notes illustrates his theories regarding the arrangement of colors according to the principles of reflection (placing sets of colors into a reflective position on the grid) and reversal (swapping out opposite colors on the grid) (see Figure **4.18**).[34] Here he dealt with both principles: the diagram at the top of the page shows a composition that has been divided according to a 180-degree rotation of color modules, and the diagram at the bottom shows a composition arranged according to swapped complementary colors.

It was within the context of both decorative and structural patterning that Klee explained principles of shifting, displacement, and irregularity, or 'mixing up' the pattern through the apparently random arrangement of color modules on the grid.[35] One can see this principle in Klee's grid paintings from 1927 and after, such as *Color Table* from 1930 (see Figure **4.15**), all of which reveal a strong relationship to weaving: flat, all-over, grid-based compositions that can be turned and read from any side like a tex-

4.16 Anni Albers, page 13 from a notebook for Paul Klee's course, 'Gebiet der Vermehrung' (Area of the Increase), c. 1927, pencil and typing on tracing paper, 29.6 × 21.1 cm (11.8 × 8.4 in), Bauhaus-Archiv, Berlin

4.17 Paul Klee, 'Pädagogischer Nachlass (Principielle Ordnung)', 23 October 1923, pencil on paper, pp. 2 and 3, 22 × 28.7 cm (8.8 × 11.5 in), Paul-Klee-Stiftung, Kunstmuseum Bern

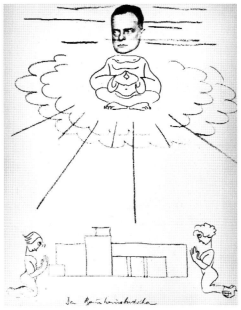

4.20 Ernst Kallai, Paul Klee as 'The Bauhaus Buddha', 1929, photo-collage, Bauhaus-Archiv, Berlin

tile panel. In Klee's abbreviated syllabus for 17 September 1928 he wrote, 'Rotation, irregularity by use of varying threads'.[36] This heading, while rather cryptic, is important for it implies that Klee perceived the principle of rotation, and the accompanying principle of irregularity, within the context of weaving. Benita Koch-Otte and Anni Albers both utilized principles of rotation and swapping for their lively wall hangings, indicating that Klee may have played a part in synthesizing these developments. In turn, the weaving students may have helped Klee to solidify his own theories.[37]

Since a primary goal in the Weaving Workshop was to create weavings that displayed a truth to materials while showing how they were made, Klee's explanations of structural composition were highly relevant on a theoretical level, and the Andean textile model would be highly relevant on a practical level. For example, a Chancay textile fragment from Anni Albers's own collection (see Figure **4.19**) looks similar to the page from her notebook: a grid-based composition of shifted and deferred units! Albers, more than any of the other weavers, was profoundly affected by this synesthetic relationship between the ancient past and the modern present. Klee's teaching clearly had relevance to most of the weavers of the Bauhaus. Indeed, they saw him as a kind of guru, floating well above the increasingly utilitarian direction of the school (Figure **4.20**). His impact on Bauhaus weaving students extended well beyond the Bauhaus period.[38] Anni Albers in particular found that Klee's unique contribution to her art intensified after decades of reflection.

Like his colleague Klee, Bauhaus Master Kandinsky also dealt with and used geometric forms, including the grid, in ways that could be translated by weaving students as early as 1922. Anni Albers took Kandinsky's 'Theory of Form' course during the 1925–26 semester.[39] Certainly before this time, however, she would have been aware of his ongoing extensive investigations into the physical (objective) and emotional (subjective) qualities of color and shape, which he conducted in both systematic and intuitive ways, often utilizing a grid format.[40] She would also have been aware of his earlier Blaue Reiter efforts to locate links between 'primitive' art, including textiles, and modern art. 'For all the intellectuality of his analysis, with its careful building up from smaller elements to a diversified superstructure', wrote Robert Goldwater, Kandinsky's intention was primarily to 'appeal to fundamental elements in human nature and to appeal to them in their undeveloped, undifferentiated form'.[41] Kandinsky's concern with universalist primitivism as a means to explore the universal roots of visual language, a concern fully developed during the Blaue Reiter period, continued to inform his work and pedagogy at the Bauhaus.

While Klee's system-based lessons coincided with and reinforced Albers's work in thread, it is interesting to note that at the same time in Dessau, Anni and Josef, who had become friends and neighbors of the Klees, also admired the poetic character of Klee's art. Michael Baumgartner has recently discussed the creative relationship between Josef Albers and Paul Klee, pointing out the formal concerns that the two masters shared.[42] Baumgartner observes that, based upon the pictures by Klee that Anni and Josef eventually owned, the Alberses were particularly interested in Klee's expressive and spontaneous images.[43] This is a significant point because while Anni's Bauhaus weavings reflect a preoccupation with systems and structures, her work after moving to the United States in 1933 reflects a poetic and playful character that she would credit both to Klee and to Andean weavers. It is really quite amazing how she was able to connect Klee to the weavers of ancient Peru; the connection was already forming at the Bauhaus and would take on new shape over the next four decades.

Years after her Bauhaus period Albers defined art as something that could be 'turned to again and again and that might possibly last for centuries as some ancient Peruvian things have'.[44] Of Klee, she stated, 'I come always back to Klee as my great hero', because 'his art is lasting, and that is what interests me: the lasting things, and not [the] quick passing things'.[45] It is significant that Albers linked her great teachers, the Andean weavers, to her great hero, Klee, by way of her concept of artistic permanence.

Utilitarian textiles at the Bauhaus

As the Bauhaus became more utilitarian in practice and ideology under the direction of Hannes Meyer, Anni Albers continued to emphasize the value of the hand-woven textile as a first step toward mechanical production, and so she looked to Andean textiles, rather than machine-made products, for solutions in the constructive process of weaving. Meyer, a Swiss architect who began teaching architecture at the Bauhaus in 1927, was appointed Director in 1928 upon Gropius's resignation and recommendation. The socialist stance taken by Meyer, who served as Director until August 1930, contributed to the growing emphasis on utility and economy at the Bauhaus. Many of his practical ideas involving the rejection of 'art' in favor of function took tangible form in the Weaving Workshop. As he stated in 1927, 'The fundamental direction of my teaching will be absolutely towards the functional-collectivist-constructive.'[46] As Magdalena Droste has noted, students in the Weaving Workshop during this time 'were coming to terms with Meyer's new social aims; [for example] instead of "carpets",

the idea was now to produce "floor coverings", with the emphasis on "utility materials"'.[47]

As the emphasis on utility superseded pictorial concerns, Anni Albers began to seek structural solutions to the problem of making textiles for a new era. She did this by experimenting with innovative textile constructions and well-chosen, now often synthetic, materials. Although not in terms of natural fibers, the Andean textile example again provided a tangible answer for her in a new technical realm, that of open-weave constructions. During this period, Albers began a thorough investigation of open-weave constructions based on Andean archetypes, an investigation that was to continue throughout her weaving career.[48] Open-weave techniques generally involve either periodically leaving areas unwoven or twisting and pulling aside the taut warp threads so that open spaces are created and held apart by the weft threads. Gauze, the latter type of open weave, involves diverting either warp or weft threads to create open spaces in the web. Variegated textures and all-over patterns were achieved by expert Andean weavers using open-weave techniques, creating a variety of light-weight, sheer, and lace-like cloths. Numerous examples of Andean open-weave constructions were illustrated and discussed in Reiss and Stübel's *The Necropolis of Ancon*, among others, in which it was noted that open-weave structures can be very strong and elastic depending on the strength of the fiber and the degree of twisting.[49] The d'Harcourts, too, illustrated open-weave constructions in their 1924 book *Les Tissus indiens du vieux Pérou*, such as a cotton piece that incorporates figures with feline heads, and another in which a plain-weave step form is alternated with an open-weave checkerboard (Figure **4.21**).

Albers may have become interested in open-weave constructions as a continuation of her seemingly systematic investigation of increasingly more complex Andean textile techniques. Open-weave constructions may have been particularly attractive because of the relative ease with which they could be produced by the machine, as opposed to more complicated multi-weave and discontinuous warp and weft constructions. In addition, the open weave allowed her to develop light and open textiles, qualities that were now in demand for the modern household and work place. Albers discussed open-weave structures, which she called the modern leno weave, in a 1985 interview. She remarked that she had not in fact invented such constructions, as was commonly thought, but that the full range of weaving constructions, including open weaves, had already been invented by Andean weavers long ago. She said,

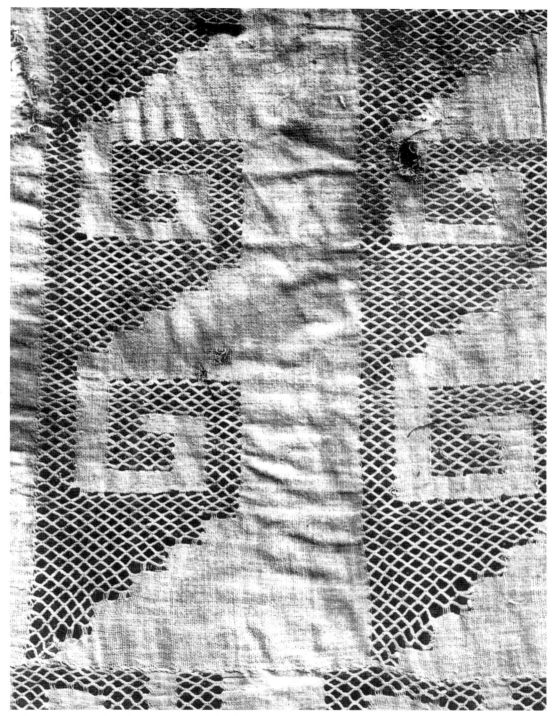

4.21 Open-weave textile with stepped fret (reproduced in R. and M. d'Harcourt, *Les Tissus indiens du vieux Pérou*, Paris: Albert Morancé, 1924, plate 29)

You are quite wrong [to think that I had invented the open weave]. This was done already, three thousand years ago. It's true. There are early Peruvian weavings that have that. But, still, there is sometimes a great need to have heroes. And I was lucky to be thought, in some way, as one of the lights at one point.[50]

One of Albers's numerous undated open-weave constructions was probably created as a prototype for industry (Figure 4.22). The overall pattern is formed by the open and regular checkerboard sequences of yarn. Like her ancient predecessors, Albers always wove her prototypes by hand so that she could understand and manipulate the essential character of the material. What Albers added to the ancient model was an enthusiasm for synthetic fiber and an acceptance of the machine for its labor-saving function. Yet she maintained that hand-weaving was essential for the development of an idea so that the weaver could maintain control over the textural, structural, and material form of the weaving, whatever its final production method might be. In this way, the designer was also the producer, just as the 'primitive' weaver was. This was to be a very important link between her work and Andean textiles, inspired partly by the Constructivist notion of the artist as laboratory worker, and partly by her continued interest in Andean material.

Albers continually framed her discussions of these issues within the context of Andean textiles. In a 1946 article, 'Constructing Textiles', she tried to imagine what the ancient Peruvian weaver would have thought of modern weaving techniques and designs. She suggested that the ancient Peruvian weaver would be pleased with the speed of mass-production, the uniformity and accuracy of threads, and new synthetic yarns, dyes, and finish treatments. But the ancient expert would be disappointed at seeing the monotonous weaving techniques and constructions of today's industrially produced textiles. She suggested that if industry was to improve, and reach a point where materials and constructions worked in harmony with one another, as in ancient Peru, then industry needed to 'incorporate hand-weavers as laboratory workers [and by doing so] our ancient Peruvian colleague might lose his puzzled expression, seeing us thus set for adventures with threads, adventures that we suspect had been his passion'.[51]

These comments, although written twenty years after her first experiments with woven prototypes for mass-production, point to her ongoing indebtedness to Andean textiles as models for her own investigations. They provided her with fundamental formal, technical and social information to apply to her modern needs. When,

4.22 Anni Albers, open-weave textile, no date, Josef and Anni Albers Foundation, Bethany, Connecticut

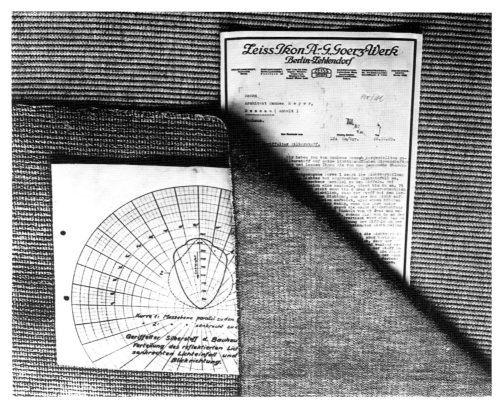

4.23 Anni Albers, Zeiss Ikon analysis of wall-covering material for the auditorium of the Allgemeinen Deutschen Gewerkschaftsbundesschule (General German Trades Union School), Bernau, Germany, 1929, cotton, chenille, and cellophane, 22.9 × 12.7 cm (9 × 5 in), Museum of Modern Art, New York

in 1924, Albers wrote, 'We must investigate anew handicraft and technical possibilities [that] those in earlier times had', it seems certain that she was referring to the Andean model.[52] It is also important to remember Albers's later remark that her interest in Pre-Columbian art began in Germany at the ethnographic museums.[53] These later comments help to put her earlier ones into a more specific context.

Albers continued to investigate new structural possibilities with open-and multi-weave constructions, and she continued to investigate the material possibilities of synthetic yarns. Thinking more about the function cloth played in the architectural context, and adapting her work to the more socially utilitarian focus at the Bauhaus, Albers shifted from making wall hangings to drapery samples. Again, Andean examples would have verified to her that textiles played a role in architecture; this was pointed out by Lehmann, as mentioned in Chapter Two, above. The actual draperies she designed, for a theater café in Dessau, in 1927, and a theater in Oppeln, in 1928, no longer exist, but her preliminary designs and woven samples show that she planned for varying color combinations, gradations, and textures within a large underlying grid format, using multi-weaves and synthetic fibers.[54]

In 1929, Anni Albers designed the wall fabric and curtains for the auditorium of the Allgemeinen Deutschen Gewerkschaftsbundesschule (General German Trades Union School), designed by Hannes Meyer, Hans Wittwer, and the Dessau Bauhaus from 1928 to 1930. She developed an innovative solution to the challenge of creating a sound-absorbing and light-reflecting fabric by employing a clever, and totally modern, version of the double weave. The fabric face had a cellophane weft crossing a cotton warp for a light-reflective surface; the back had a chenille weft and cotton warp for a sound-absorbing cushion (Figure 4.23). The fabric is extremely light-weight yet incredibly sturdy; using her hand-woven sample, these qualities, particularly involving light reflection, were tested, analyzed and quantified in 1929 by the Zeiss Ikon engineering firm in Berlin. For this work she was awarded her Bauhaus diploma by Meyer in 1930. It may be the most perfect union of Andean and Bauhaus values ever created, for she was able to visualize the final product – a machine-made, synthetic, utilitarian product – with the purest of means – the hand-made, double-woven sample. As is implied in her later writings, she probably felt a certain camaraderie at that point with her ancient Peruvian counterpart.

Anni Albers maintained close contact with the Bauhaus after graduating because her husband taught there until it was permanently closed in 1933. Indeed, she served as Acting Head of the Weaving Workshop during the autumn of 1931 until Lily Reich

took over, and she provided ongoing technical assistance to Weaving Workshop students. It appears that she did not produce any large wall hangings during this period, nor did any of her prototypes become mass-produced at this time. Yet the work that she had in her possession in 1932, when Philip Johnson met her and Josef in Berlin, was enough to help guarantee them a passage out of Germany to the United States, despite the fact that it was Josef's work and teaching that Johnson had sought out. With Johnson's help, Anni and Josef Albers were given teaching posts at Black Mountain College, North Carolina. She called these weaving samples her 'passport to America'.[55]

5. Anni Albers in the United States and Mexico

From her Bauhaus years through the period of her work in the United States, Anni Albers believed that for most modern innovations in the field of textiles, other than those involving the power loom and synthetic fibers, an Andean precedent could be advanced, and so she framed her discussions of modern fiber arts, just as she approached her own work, in the terms of her understanding of the Andean textile tradition. One of the primary reasons for which she valued Andean textiles was that they were examples of technically proficient products produced by hand on simple looms. Albers was aware that the ancient hand-weaving process had not fundamentally changed over time. She considered the power loom primarily as a time- and labor-saving device, and yet she believed that the machine threatened to destroy the fundamental relationship that had for centuries existed between weaver and weaving materials. Therefore, she maintained that industrial prototypes needed to be presented as hand-woven samples instead of designs or written instructions. She wanted to restore the vital link between process and product, particularly as she herself adapted to the machine age, while continuing to draw inspiration through her continual investigations and applications of ancient Andean textile designs and techniques. These beliefs concerning the value of hand-weaving in the modern age were strengthened and refined after she emigrated from Germany to the United States in 1933 and became increasingly familiar with Andean textile specimens and scholarship.

Albers would ultimately become an enthusiastic spokesperson for the recognition of Andean textiles. This position was due in part to her increasing contact with, and understanding of, these textiles in the United States and Latin America. She discussed these ancient textiles in her written work; she collected Andean textiles; she used them as examples for pedagogical exercises; and, most importantly, she made direct references to them in her own woven work. These references deepened and became more extensive as her understanding of ancient American art in general broadened to include ancient Mesoamerican art and non-textile media. In nearly all of her endeavors, Albers looked to the Andean textile paradigm for formal, thematic, and technical inspiration.

Anni and Josef traveled extensively in Mexico and Peru. They made at least 14 trips to Latin America during their lifetimes, most in the 1930s and 1940s while they were teachers at Black Mountain College in North Carolina. Anni initiated the first of the trips to Mexico in 1935, and it was then that she bought their first work of ancient American art.[1] Although they both enjoyed collecting and commenting on ancient American art, Anni was the first to make thematic and visual references to it in her work. In light of their shared admiration of ancient American art, this chapter will also investigate Josef Albers's role as a partner in these investigations. It will be shown here that Anni Albers's enthusiasm for ancient American art preceded Josef's, and that he understood and appropriated certain textile principles as a result of her initial inspiration.

The reception of ancient American art in the United States

When Josef and Anni Albers immigrated to the United States to begin teaching at Black Mountain College, a moderate ancient American art revival was already underway in the United States. Such a revival served many purposes – political, social, and aesthetic – and was embraced by a diverse group of people in the United States and in Latin America. In the United States, this revival was part of a new primitivism that focused on the rituals, monuments, and abstract visual language of native and ancient American peoples.[2] This development was in part a continuation of primitivist trends in European art and in part a rejection of them, a rejection whose goal was to separate and distinguish an American style from modern European artistic trends. In Latin America, the revival was part of a political move to re-establish the pre-Conquest identity of nations that had long been controlled by European colonizers.

Various factors contributed to the growing popularity of ancient American art, particularly ancient Mesoamerican art, in the Western Hemisphere after World War I. For example, federal programs that encouraged trade and cultural relations between Mexico and the United States began in the early 1920s after the Mexican Revolution, and by the 1930s Franklin Roosevelt had established the Good Neighbor Policy for the purpose of solidifying this relationship. In addition, many formal archaeological campaigns were mounted by private, institutional, and governmental parties, such as the Department of Pre-Hispanic Monuments, in Mexico, and the Carnegie Institute, in Washington, DC, with the hope of not only gathering new material but also fostering national and international awareness of pre-Conquest achievements. Publications and exhibitions of ancient American art helped to launch a popular interest in this art.[3] The

Pre-Columbian art revival was also fueled by many Latin American artists, such as Diego Rivera, who were actively engaged in a primitivist discourse, now referred to as 'Indigenism', that idealized and appropriated forms from the ancient American past.[4]

The 'Mayan Revival' that took place in the 1920s was not just a phenomenon in the United States. In Mexico, for example, tourists visiting the ancient site of Chichén Itzá, or artists involved with the artists-in-residence program there, could stay in neo-Maya suites at the Mayaland Hotel nearby.[5] Certainly, Anni Albers would have seen tourist brochures and copies of *National Geographic* and other popular journals that contained articles and photographs of the latest discoveries in Mexico. She may have seen articles with photographs that described and reproduced objects from the Sacred Cenote well at Chichén Itzá or the temples at the recently excavated site of Teotihuacan.[6] Indeed, as she later remarked, information about ancient sites was so readily available that she was able to pick up maps of ancient Mesoamerican sites at Mexican gas stations.[7]

Popular journals also carried articles about archaeological excavations that took place in Peru during the early twentieth century, particularly those conducted by Julio C. Tello at Paracas in the 1920s and 1930s, and Hiram Bingham at Machu Picchu in 1911 and after. However, as Elizabeth Boone has recently pointed out, Peru did not develop the political and scholarly infrastructure to deal with its Pre-Columbian past to the same extent as did Mexico.[8] As discussed earlier in this study, many of Peru's valuable textiles ended up in the Berlin Museum für Völkerkunde rather than in Peruvian or North American institutions. For this reason, Albers may have had a more developed knowledge of Andean textiles by the 1930s than her counterparts in the Western Hemisphere.

One interesting set of events can serve to exemplify the range of sources available to the Alberses upon their arrival in the United States. In 1932, the Mexican archaeologist Alfonso Caso, who had been conducting fieldwork at the Oaxacan site of Monte Albán since 1930, discovered a fully intact tomb filled with spectacular objects and mummies. The discovery of 'Tomb 7' was highly publicized; indeed, the discovery was compared with the recent excavation of Tutankhamun's tomb. Almost immediately, the objects from 'Tomb 7' were put on tour.[9] In 1933, the year the Alberses arrived in New York from Germany, the 'Tomb 7' exhibition was on display there in Pennsylvania Station, while across town, in the lobby of the RCA building at Rockefeller Center, the Mexican muralist Diego Rivera was at work painting his con-

troversial frescoes that were soon to be demolished in reaction to the Communist references they contained. Nearby, at the Museum of Modern Art, the exhibition 'American Sources of Modern Art', a thematic exhibition of nearly 200 pieces of ancient American and modern art, had just completed a two-month run; a popular catalogue accompanied the exhibition.[10]

'American Sources of Modern Art'

The exhibition 'American Sources of Modern Art' was organized by Holger Cahill, a curator at the Museum of Modern Art who went on to become Director of the Federal Art Project of the Works Progress Administration from 1935 to 1943.[11] The exhibition would have reminded the Alberses of similar exhibitions held in Germany, where modern art was juxtaposed with non-European art in order to illustrate their supposed affinities. Indeed, Cahill's thesis was strikingly similar to Gustav Hartlaub's primitivist undertaking a decade earlier at the Mannheim Kunsthalle, and to Herwarth Walden's efforts at Gallery Der Sturm in Berlin, as discussed earlier here. Cahill wrote that the exhibition was intended to 'show the high quality of ancient American art, and to indicate that its influence is present in modern art in the work of painters and sculptors, some of whom have been unconscious of its influence, while others have accepted or sought it quite consciously'.[12]

The specificity of theme, the venue in which the exhibition was held, and the scholarly approach to the material helped establish a new context in which to gain a meaningful understanding of ancient American art. Cahill's intention was to draw attention specifically to ancient American art, rather than to a broad spectrum of 'primitive' art, as a source for modernist developments. Indeed, he made it clear that this ancient art was decidedly *not* 'primitive' at all, but archaic. That is, according to Cahill, the art of ancient America was produced by highly sophisticated artists, whose only link to the 'primitive' was their 'primitive' methods of technological production. He wrote,

> During the past 30 years ... connoisseurs [have made] serious investigations into ancient American art for its own sake ... While the growth of popular appreciation has come about through the general interest in primitive peoples, ancient American art cannot, in its best periods, be called primitive ... [even though] all these works were made with the implements of primitive man.[13]

Josef Albers, a few years later, made a similar remark regarding ancient American art:

'I cannot agree with historians who insist on calling this art primitive. In my opinion such plastic work shows not only a highly developed psychological understanding of human nature, it also shows besides an extremely strong visionary power a very cultivated artistic discipline.'[14]

If the Alberses visited the exhibition, which is not known for certain, they would have seen many objects that were similar to those available to them in Germany, such as Andean textiles, ceramics, and metal work. They would have been very pleased with the quantity and quality of the exhibits, including 145 Mesoamerican and 87 Andean objects, of which 16 were textiles, and 32 works by an international group of modern artists including Ben Benn, Jean Charlot, John Flannagan, Raoul Hague, Carlos Merida, Ann Morris, Diego Rivera, David Alfaro Siqueiros, Marion Walton, Max Weber, Harold Weston, and William Zorach.

Just as important to the exhibition was the catalogue itself, with 54 reproductions of the ancient American pieces. Cahill's essay clarified the general chronology and stylistic categories of ancient American art while simultaneously enlarging on the primitivist discourse. One of the most striking of Cahill's remarks was one that linked Peruvian textiles with German applied arts. He wrote that, by the 1920s, 'the influence of ancient Peruvian textile and ceramic design had been registered in German decorative art'.[15] This remark clearly indicates that Cahill was aware of the discernible and significant role Andean textiles played as a part of primitivist trends in Europe. Of Andean textiles Cahill wrote,

> The glory of ancient Peru is in her textiles … The tendency to convention and abstraction already present in the highly imaginative art of Nazca was developed by Tiahuanaco to an unprecedented degree. The style of the highland people runs to grandeur and solemnity as against the liveliness and dramatic sense of the coast … Tiahuanaco textile design is controlled by a severe geometry. The color is rich and the technique excellent … There are many beautiful Nazca and Chimu textiles, especially the kelim textiles, tapestries with slits.[16]

That Cahill spoke of these textiles as art, and described them as such, is evidence of a formalist approach toward ancient American art, as opposed to an iconographic approach, that was used by critics, curators, and artists in the United States. Indeed, Josef Albers admired Mesoamerican sculptors precisely because, as he stated, 'they did their work primarily for art's sake … They did l'art pour l'art.'[17] Anni Albers approached ancient American art along more technical lines; she understood the iconography pri-

marily as it related to the craft of weaving. 'Their personages, animals, plants, step-forms, zigzags, whatever it is they show', she wrote, 'are all conceived within the weaver's idiom.'[18] Yet she was fully aware of the multiple levels of meaning imbedded in ancient American art.

'American Sources of Modern Art' was the first of what would be a continuous stream of cross-cultural exhibitions at the Museum of Modern Art for the next two decades. The Alberses, who had close ties to the museum through Philip Johnson and Edgar Kaufmann, both of whom were involved with the Department of Design there in the 1930s and 1940s, were no doubt aware of the museum's exhibition schedules. For example, after it mounted the huge 'Twenty Centuries of Mexican Art' exhibition in 1940, Josef Albers requested a copy of the catalogue for the Black Mountain College library.[19] That exhibition, organized by the Mexican archaeologist Alfonso Caso, had over 5000 pieces of art divided into four categories: Pre-Spanish, Colonial, Folk, and Modern.[20] Miguel Covarrubius, with whom the Alberses were familiar from their travels to Mexico and from their contact with Diego Rivera, wrote the essay on modern art.[21] In 1941, the museum mounted 'Indian Art of the United States', organized by the Austrian scholar of ancient American art René d'Harnoncourt. D'Harnoncourt, who had spent many years in Mexico, organized exhibitions for the American Federation of the Arts.[22] The quantity and diversity of these exhibitions and their accompanying texts points to the ongoing popularity of ancient American art in the United States. The cumulative result of these events was that they served to bring about a greater awareness of the contexts and forms of this art.

Visits by Josef and Anni Albers to Latin America

The Alberses quickly took advantage of their newly established proximity to Mexico by making almost annual trips there between 1935 and 1952.[23] They were in Cuba twice and in Chile and Peru twice in the 1950s, and they visited New Mexico numerous times. Their last trip to Mexico was in 1967 when Josef was 79 years old, and Anni was 68. Josef Albers took many black and white photographs during their travels and, although he did not date them, they now serve as important documentary evidence regarding their itineraries. These photographs help to clarify what they saw and what they felt was important to record. The exact itineraries of their trips to Latin America remain somewhat sketchy, but their written correspondence, mainly to the Secretary at Black Mountain College, and the photographic records help to fill in the sketch. In addition, Anni's mother made meticulous travel notes on the trips she took with them

in 1937 and 1939, and so more is known about their travels for those years.[24] Later, the Alberses' trips became longer in duration, so that by the 1946–47 academic year they arranged to spend most of their sabbatical year in Mexico and New Mexico. As they made more contacts with dealers and scholars in both countries, they acquired more and more objects for their personal and college art collections. There is no doubt that their trips to Mexico and South America and contact with ancient American art were instrumental in their development as artists and theorists.

During the summer of 1935, the Alberses made their first trip to Mexico. They were in Mexico City and the state of Oaxaca, where they probably visited the ancient sites of Monte Albán and Mitla.[25] At that time, Anni bought the first of many ancient Mesoamerican pieces, an Olmec jade head.[26] Their collection of ancient American art would ultimately include over a thousand pieces of Mesoamerican and Andean art, including ceramics, stone, jade, and textile objects.[27] She bought the piece from a boy who approached her while she waited in the car. Clearly she was aware of the possibility that it was fake: 'I couldn't imagine that there was anything like that piece still available', she said.[28] And clearly she knew enough to know that if it was authentic, which it was, then it had value; she brought it to be authenticated by archaeologist George Vaillant, who was excavating near Mexico City.[29] This incident is significant because it indicates that already by 1935 Anni Albers was familiar enough with ancient American art not only to initiate a trip to Mexico to see it, but also to purchase it, and to seek advice regarding such purchases from scholars in the field.

The Alberses adored Mexico. During the summers of 1936, 1937, and 1939 and the fall of 1940, they drove again to Mexico on the recently opened Pan-American Highway that ran from Laredo, Texas, to Mexico City. In an August 1936 letter to Wassily Kandinsky, written in Mexico, Anni Albers wrote:

> [Mexico] is a country made for art, unlike any other. Marvelous ancient art, much of which has just been discovered, much of which has only just now seen the light of day. Pyramids, temples, ancient sculptures, the whole country is full of these. In addition, there is a lively folk art scene, and of good quality, and there is also much new art, especially frescoes: you of course know Rivera, Orozco, and the others, including Mérida, the talented abstract painter, Crespo – art is today the most important thing in the country, just imagine that.
>
> Near the pyramids, young Indians sell for pennies marvelous little objects that have been excavated, most appear to be genuine, such as the tiny beautiful terracotta

heads, and almost nobody is interested in them. Rivera is one of the few who has a splendid collection of them. There is a very beautiful museum here but unfortunately it is poorly maintained, but with beautiful things. We have gone there many times, we can't go back there enough. Albers has spent entire days photographing there ... [30]

According to Toni Ullstein Fleischmann, Anni's mother, the family spent June and July of 1937 traveling from Veracruz to Mexico City, where they saw Rivera's frescoes at the Ministry of Education, and then to the ancient sites of Teotihuacan, Tlaxcala, Puebla, Mitla, and Monte Albán, a trip that involved traversing the entire country.[31] In 1939, they spent over two months in Mexico because Josef Albers was invited to teach a course at Gobers College in Tlalpan, Mexico.[32] In 1940 and 1941 they were again in Mexico City and La Luz, New Mexico.[33] During their extended trip to Mexico and La Luz in 1946 and 1947, Anni Albers collected hundreds of ancient and modern Latin American textiles for her personal collection and for a newly established collection at Black Mountain College, the Harriett Englehardt Memorial Collection of Textiles, which will be discussed below.

It was probably during the late 1930s and early 1940s that the Alberses visited Diego Rivera. They saw him at his home in San Angel, and later in Coyoacon, and at his museum/studio, Anahuacalli, where they saw his extensive ancient American art collection.[34] Rivera had seriously begun to collect Pre-Columbian art in the 1930s; his collection ultimately numbered nearly 60 000 objects.[35] The Alberses saw his collection and shared with him the excitement of collecting ancient objects recently unearthed after centuries underground. Of Rivera, Anni Albers recalled, 'We were among the privileged few "gringos" to see, many years ago, the Rivera collection ... We felt that Rivera had an oversized appetite for all that came to light and was brought to him by the natives from many parts of the country.'[36]

In the 1930s, numerous Mesoamerican shaft tombs were rediscovered by archaeologists and grave-diggers; Rivera and his friend Miguel Covarrubius frequented the site of Tlatilco, where an ancient cemetery had been unearthed in 1936.[37] The objects therein quickly entered the antiquities market, if they had not already been scooped up on site by tourists and collectors. Indeed, Josef and Anni Albers visited Tlatilco, and from Anni's later comments, one senses the exhilaration of discovery that these early collectors must have felt there. She recalled, 'The children would come up to us with their latest mud-covered findings. Only at home, after we had washed the

5.1 Josef Albers, 'Teotihuacan Museum, etc.', no date, contact prints mounted on cardboard, 26.3 × 20.3 cm, Josef and Anni Albers Foundation, Bethany, Connecticut

5.2 Josef Albers, 'Santo Thomas, Oaxaca', no date, contact prints mounted on cardboard, 20 × 30.2 cm (8 × 12.1 in), Josef and Anni Albers Foundation, Bethany, Connecticut

pieces, would we be sure that what had looked vaguely promising was as beautiful as we had hoped it would be.'[38]

The Alberses saw how Rivera clearly and continually appropriated ancient American images, from all media, for his own art and ideology. His activities as an artist and collector must have inspired the Alberses to conduct similar activities in spite of the great difference between their artistic approaches and his.

The photographs that Josef Albers took during their trips in the 1930s and 1940s show that they visited numerous museums of ancient art in Mexico. For example, an undated assemblage of his photographs includes an assortment of pictures of objects on display at different museums, including a clay sculpture from Classic-period Monte Albán; a close-up of a textile with stepped-diamond and meander patterns; four looms, including backstrap looms; and women's traditional dresses from modern Mexico (Figure 5.1). These photographs suggest that Josef and Anni Albers were seriously studying the art forms and tools of Mexico, both ancient and modern, even though their access to scholarly material, at least to non-textile media, was somewhat limited at first. Anni Albers recalled,

> For us, as amateurs in the true sense of the word and mainly visually oriented, the old anthropology museum housed in an ancient *palacio* [now the Museo Nacional de Antropología in Mexico City] was the main source of information. Here, the pieces were simply placed side by side in old-fashioned glass cases, often crowded together with no attempt at showing them to any advantage. They were regarded merely as specimens. But they afforded us a chance to compare, and, by comparison, to distinguish and to learn, however sketchily.[39]

It is interesting that she referred to herself and Josef as 'visually oriented', because that is primarily how she approached ancient American art, how she dealt with it as a teacher, and how she applied it as an artist. Of the ancient and modern Latin American clothing she saw, she was mainly interested in the construction process with which weavers shaped the article directly on the loom. She wrote in her book *On Weaving*,

> There are ancient Pre-Columbian shirts that are, by adding or dropping warp threads, woven wider at the shoulders than at the waist (the Pre-Conquest version of our padded-shoulder look). There are shirts from present-day Guatemala that are woven with wider-spaced wefts at the waist, to make them fold more easily under a belt.[40]

Another series of undated photographs taken by Josef Albers in Santo Tomas,

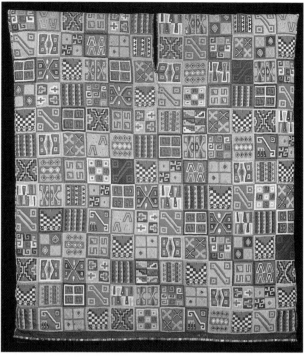

4.13 Tunic, 'Royal Tunic', Inca, cotton and camelid, 71 × 76.5 cm (28.4 × 30.6 in), Bliss Collection, Research Library and Collection, Dumbarton Oaks, Washington, DC

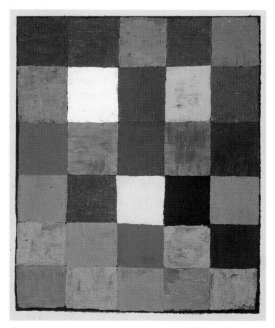

4.15 Paul Klee, *Farbtafel (auf Majorem Grau)* (Color Table, on Major Gray), 1930.83 (R3), pastel on paper mounted on board, 37.7 × 30.4 cm (15.1 × 12.2 in), Paul-Klee-Stiftung, Kunstmuseum Bern

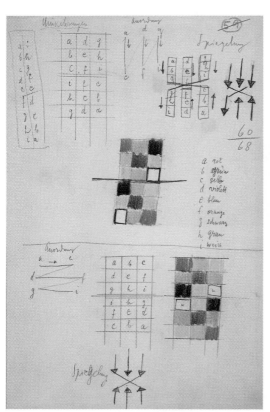

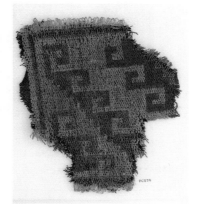

4.19 Textile fragment, Chancay, plain cotton ground with discontinuous complementary wool warp pattern, 13.3 × 15.2 cm (5.25 × 6 in), Anni Albers Collection (PC079), Josef and Anni Albers Foundation, Bethany, Connecticut

4.18 Paul Klee, 'Pädagogischer Nachlass (Specielle Ordnung)', no date, colored pencil and lead pencil on paper, 33 × 21 cm (13.2 × 8.4 in), Paul-Klee-Stiftung, Kunstmuseum Bern

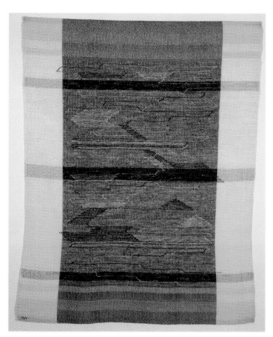

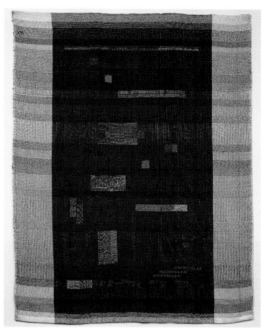

5.5 Anni Albers, *Monte Alban*, 1936, 143.8 × 111.3 cm (57.5 × 44.5 in), Busch-Reisinger Museum, Harvard University

5.6 Anni Albers, *Ancient Writing*, 1936, woven rayon and cotton, 147.5 × 109.4 cm (59 × 43.75 in), Smithsonian American Art Museum, Washington, DC

5.11 Textile fragment, Nazca, cotton, double-faced double weave, 8.6 × 9.5 cm (3.4 × 3.8 in), Anni Albers Collection (PC069), Josef and Anni Albers Foundation, Bethany, Connecticut

5.12 Anni Albers, *La Luz I*, 1947, sateen weave with discontinuous brocade, linen, metal gimp, 47 × 82.5 cm (19 × 32 in), Josef and Anni Albers Foundation, Bethany, Connecticut

7.1 Anni Albers, *Black-White-Gold I*, 1950, cotton, jute, and metallic ribbon, 63.5 × 48.3 cm (25 × 19 in), Josef and Anni Albers Foundation, Bethany, Connecticut

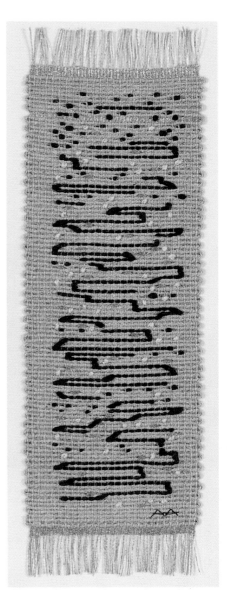

7.3 Anni Albers, *Code*, 1962, 58.4 × 18.4 cm (23 × 7.25 in), Josef and Anni Albers Foundation, Bethany, Connecticut

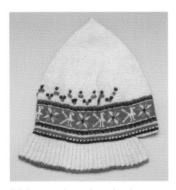

7.2 Peruvian knitted cap, hand-spun wool, 28 × 20.2 cm (11 × 8 in), Harriett Englehardt Memorial Collection, Yale University Art Gallery, New Haven, Connecticut

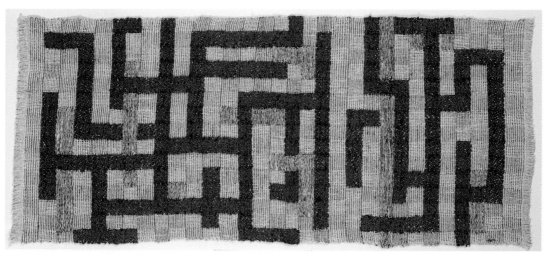

7.4 Anni Albers, *Two*, 1952, cotton, rayon, linen, 45 × 102.5 cm (18 × 41 in), Josef and Anni Albers Foundation, Bethany, Connecticut

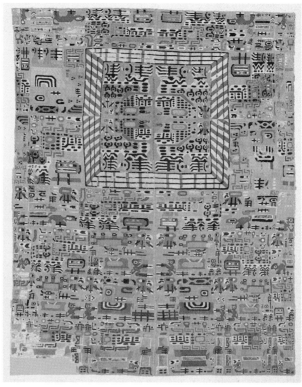

7.7 Section of tunic, Wari, camelid and cotton, tapestry weave,
151.1 × 112.1 cm (60.5 × 45 in), Bliss Collection, Dumbarton Oaks
Research Library and Collection, Washington, DC

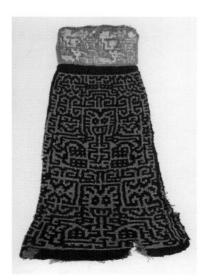

7.8 Bag, Nazca, tubular double weave,
31 × 22 cm (12.4 × 8.8 in), Art Institute of
Chicago, formerly in the Eduard Gaffron
Collection, Schlachtensee (reproduced in
Walter Lehmann, *Kunstgeschichte des Alten
Peru*, Berlin: Wasmuth, 1924, p. 1)

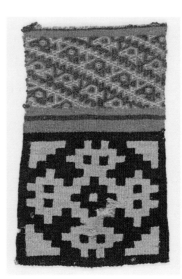

7.9 Textile fragment, Wari or Chancay,
cotton warp, wool weft, tapestry with
supplementary-weft brocade, 18.1 × 10.2
cm (7.13 × 4 in), Anni Albers Collection,
Josef and Anni Albers Foundation,
Bethany, Connecticut

113

7.12 Anni Albers, *Red Meander*, 1954, linen and cotton, 65 × 50.6 cm (26 × 20.25 in), collection of Ruth Agoos Villalovos

7.13 Anni Albers, *Tikal*, 1958, cotton, plain and leno weave, 75 × 57.5 cm (30 × 23 in), American Craft Museum, New York

Oaxaca, shows Anni Albers weaving on a backstrap loom (Figure **5.2**). She appears with a group of Mexican women. One photograph shows a woman weaving on the backstrap loom, one shows a woman spinning yarn, and seven show Anni at the backstrap loom surrounded by the women, one of whom appears to be helping her. This may have been one of her first actual experiences with this loom – although she would have known about it and seen examples of it in Germany and in publications by Max Schmidt – and it is likely that she wove three belts (Figure **5.3**) on a backstrap loom.[41]

By the 1950s, the Alberses were finally able to travel to the Andes. They were in Lima in 1953 where Anni bought an ancient Peruvian textile still attached to a small loom. She recalled,

> I came across one in Lima. A little ball of something that was squeezed together and looked like it had weaving in it … And I bought it, and washed it, and stretched it, and so on, and it turned out to be a whole loom of their kind.[42]

It may have been during this trip, or before, that she also learned about the elaborate Andean knotting and counting implement called a *quipu* (Figure **5.4**), with which threads were knotted according to mathematical formulae. She recalled,

> They [Andean weavers] developed a very tricky mathematics … These instruments were, again, not written. They didn't have writing, as I told you. But what they did was threads … called quipu's, this instrument. And the different things that they had to deliver were designated on each thread. The amount was indicated with different knots and different heights and so on. I knew once, at one time, how to do it.[43]

Although she may have forgotten certain fine points, Albers did make significant discoveries on her trips to Mexico and South America, particularly involving the interrelatedness of thread and text.

Anni Albers's application of ancient American source material at Black Mountain College, 1934–1949

It is clear that these excursions to Mexico during the 1930s and 1940s had a significant impact on Anni Albers as an artist. The dramatic changes that occurred in her woven work immediately after her first visit to Mexico clearly reflect her growing awareness of ancient American art as a continual source of inspiration. Certainly her previous understanding of Andean textiles paved the way for her swiftly to absorb new ancient American sources. The first two wall hangings she made in the United States

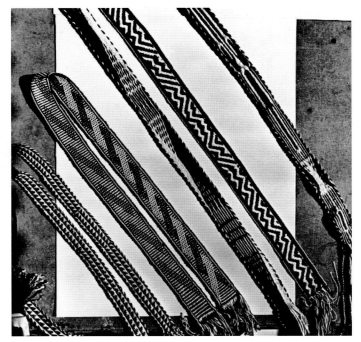

5.3 Anni Albers, woven belts, c. 1944, Josef and Anni Albers Foundation, Bethany, Connecticut

5.4 *Quipu*, from the coastal valley of Chancay, Peru, 120 × 80 cm (48 × 32 in), American Museum of Natural History, New York

were decisively different from her Bauhaus work in a number of important ways. Anni Albers wove *Monte Alban* (see Figure **5.5**) and *Ancient Writing* (see Figure **5.6**) in 1936, most likely as companion pieces, for they are almost identical in size and format.[44] She carried over certain formal elements from her Bauhaus work, including the silken-smooth texture, limited coloration, wall-hanging format, and abstract geometric formal vocabulary. However, she gave *Monte Alban* and *Ancient Writing* referential titles, something she had never done before. This was in contrast to her Bauhaus work, in which she was clearly more interested in finding abstract solutions to technical and utilitarian problems than in making personal poetic references. This departure from her Bauhaus practice was due to her new contact with, and personal response to, ancient American art.

Albers was particularly inspired by the ancient Mesoamerican site of Monte Albán. 'We were aware of layer upon layer of former civilization under the ground', she wrote.[45] Josef photographed Anni there during the 1930s (Figure **5.7**). The site had once been a ritual center, built high on a flat plateau in Oaxaca over the course of twelve centuries; its design was strategically planned so that all movement with the huge open plazas, intimate enclosed areas, and steep, precarious steps could be strictly controled.[46]

In her weaving *Monte Alban*, Albers began to use, for the first time, a weaving technique that she practiced throughout her subsequent weaving career: the supplementary-weft brocade, or 'floating' weft. This supplementary technique is one whereby an extra weft thread is threaded, or floated, above the woven surface. The floating thread can be picked up and looped at will, traversing over woven areas, because it does not serve a structural purpose; in other words, one could pull out all such supplementary wefts and the other wefts would suffice to create a solid textile with the warps. Albers used this technique essentially to 'draw' lines on the surface of the woven structure. This common Andean technique, still widely used in modern Latin America, was one she would have seen in Germany and in publications before 1936. Lehmann, for example, reproduced the front and back of a Nazca bag that has supplementary wefts for the pattern stripes; indeed, Albers owned numerous examples of it, perhaps acquired as early as 1936.[47]

One piece in particular from her collection, a cotton Chancay panel discussed earlier in the book (see Figure **3.8**), is striking because it is one of the few fully finished pieces that she owned; it has four finished edges, or selvages, and although it has become somewhat distorted due to wear, is approximately the size of a standard

5.7 Josef Albers, 'Anni at Monte Albán', photograph, c. 1935, 11.9 × 8.1 cm (4.75 × 3.25 in)

sheet of paper (7 × 11 inches). On it, 25 cuttlefish were woven using the supplementary-weft technique. Albers would have appreciated the completeness of this work and the repetition of the fish in grid formation.

The technique of 'drawing' or 'writing' with thread in this way encouraged Albers to engage in a practice that she had previously avoided, that of making pictorial references. The technique allowed her to devote attention to the surface of the weaving, and while the structure of the overall textile continued to be vitally important, her focus on the inscription was a significant departure from her Bauhaus work. In *Monte Alban* she used the floating weft thread to form layers that refer to the ascending and descending steps, the flat plazas, and the underground chambers of the ancient site. In addition, she arranged the horizontal and vertical stripes of the plain weave structure so that they interlock like masonry walls. Furthermore, Albers also began, with this work, to use color as a referent; in this case, her 'palette' was based on the earthy hues of the site.[48] Her mastery of the fiber medium, and her contact with this ancient American site, inspired her to produce a complex web of textures and layers, a weaving saturated with literal and apparent depth.

In *Ancient Writing*, she used a text format, a title, and abstract visual forms to imply content. Without actually representing particular glyphs or pictures, she evoked the idea of a visual language by grouping differently textured and patterned squares together like words or glyphs, and locking this 'text' within an underlying grid. Ultimately, it appears as if the 'text', set within margins, jumps forward to be 'read' as if on a page.[49]

Like Klee, Albers was very interested in pictographic, calligraphic, and ideographic signs. Like Klee, she sometimes used them simultaneously in her work. She explored the notions of the pictograph – a sign or mark that refers to an external subject – and the calligraph – a beautiful mark that stands for a letter or word – as well as the ideograph – a sign that indicates an idea though not necessarily through pictorial representation – in order to address concerns related to visual language and mark-making. These three semantic and artistic elements – the pictograph, the calligraph, and the ideograph – occupied Albers throughout her career in the United States, and she would continually refer to them in the context of Andean textiles. She was amazed that Andean culture had no apparent writing, and she concluded that the textile medium itself 'was their language … that was their way of speaking about the world'.[50] Clearly, *Ancient Writing* was a response to these ideas about textiles as text, most likely with Andean textiles and her mentor, Klee, in mind.

5.8 Paul Klee, *Zwei Kräfte* (Two Forces), no. 23, 1922, watercolor
and ink on cardboard, 28.4 × 19.2 cm (11.4 × 7.7 in), formerly in
the collection of Anni Albers, now in Die Sammlung Berggruen,
Staatlichen Museen, Berlin

From Klee Albers would have learned that an abstract symbol, such as an arrow,
can be read within the context of a pictorial sign language whereby a sign can refer
to an object (arrow) or an idea (movement). Interestingly, when Albers was a student
at the Weimar Bauhaus, she bought Klee's 1922 watercolor *Zwei Kräfte* (Two Forces), a
page-size work depicting two arrows pointing in different directions, perpendicular
to one another, like the warp and weft of a weaving (Figure **5.8**).[51] Klee used picto-
graphic signs such as arrows in his art, as well as actual calligraphically inscribed let-
ters and numbers. He often arranged these marks and abstract signs within a stratified
format, thereby increasing the allusion both to writing itself and to the overall image
of a text, two concerns that Albers was to deal with. For example, *Monte Alban* is picto-

graphic in the way that it alludes to the external subject matter – the pyramid and plaza shapes – of the site itself. It is calligraphic in the way Albers has used thread to mark or 'write' on the surface. It also refers to the image of a text through the text-like arrangement of horizontal lines and vertical borders.

Ancient Writing, on the other hand, evokes the image of a text in a more ideo-graphic way than *Monte Alban*, most obviously through the title. The geometric units of varying shapes in *Ancient Writing* suggest ideographs in that they are not recognizable as objects: they stand for ideas. The arrangement of these small-scale abstract units, arranged in horizontal rows within the center panel, suggests a text in that they are arranged in a text-like format. In addition, and this she would have learned from Kandinsky, she utilized abstract signs and elements in order to achieve varying layers of expressive and associative meaning, and to create a visual language of forms that could be perceived and read as a composition or arrangement of signs.[52]

Compared to her Bauhaus works, these two works show that her repertory of forms did not change dramatically at this time. For example, she still utilized primary geometric forms derived from the weaving structure itself. What did change was her approach toward content and meaning. Now her forms were created with expressive intent and were endowed with external referents. As she became more engaged with the poetic implications of her work, she employed new weaving techniques and con-structions, facilitated by direct contact through the collecting and studying of ancient American art.

Monte Alban and *Ancient Writing* also signal the beginning of Albers's long explo-ration of what she called 'pictorial weaving'. The term itself is somewhat contradicto-ry in that she never wove recognizable 'pictures' in the traditional Western manner. A more understandable term would be 'abstract pictorial weaving', to distinguish it from figurative pictorial weaving. What is particularly significant about her use of the term 'pictorial weaving' is that she often used it within the context of art in general, as well as Andean art. She seems to have thought of the floating-weft technique as one method by which to achieve a pictorial image in thread. She connected both the notion of pictorial weaving and the notion of textile as text with the floating-weft or warp technique derived from Andean textiles. Of a fragment from the very early North Coast site of Huaca Prieta that she had reproduced in *On Weaving*, she wrote,

> One of the earliest pictorial works made of threads is a weaving in which floating
> warp threads set in a plain-weave field form the design ... It shows a bird which is

thought out in regard to form and structure with superior intelligence. We easily forget the amazing discipline of thinking that man had already achieved four thousand years ago. Wherever meaning has to be conveyed by means of form alone, where, for instance, no written language exists to impart descriptively such meaning, we find a vigor in this direct, formative communication often surpassing that of cultures that have other, additional methods of transmitting information.[53]

Albers hoped to make a lasting aesthetic statement with her art, the type of lasting statement that she believed existed in Andean textiles. She said that with her pictorial weavings she was trying to make works 'that you turn to again and again and that might possibly last for centuries, as some of the ancient Peruvian things have'.[54] By using the term 'pictorial weaving', she was making a distinction between the unique, woven wall hanging, a work of 'art', and the sample fabric for production, a 'prototype'. By making this distinction she was essentially contradicting her later Bauhaus work and ideology, for at the later Bauhaus the whole point had been to make a weaving that was both beautiful and practical, the success of its practicality rendering it beautiful. Now she began to think of herself as an artist *and* a designer, an artist who tried to make profound pictures 'of lasting beauty in the art sense', and a designer who made serving objects with the 'anonymous quality of not really being there'.[55] In this way, she was going back to early Bauhaus practices, particularly those of Klee and Kandinsky, where one worked both intuitively and systematically on the creation of both compositions and constructions.[56] Indeed, she began to sign her initials on the bottom of her pictorial weavings, something she never considered for her industrial samples, and she began to mount and frame the pictorial works.

The distinction that she made between her pictorial weavings and her industrial prototypes allowed her more freedom to approach two notions often seen as incompatible in relation to weaving, those of art and utility. By doing so, she could apply a different set of standards to each. The pictorial weavings were more labor-intensive and personal; the industrial models were more economic and anonymous. However, far from abandoning her Bauhaus philosophy, she continued to emphasize that the quality of any work was dependent on following the inherent laws dictated by the materials and the process. In this way, Albers's pictorial weavings could serve as preliminary investigations for her industrial prototypes, and vice versa, thus partially resolving the conflict. Andean textiles represent the union of art with utility in often extraordinary ways, and while Albers may have ultimately wanted to achieve this

union in her own work, and to create an intermediate category between them, she felt it necessary to make a distinction.

Anni Albers's woven work in the 1940s

During the 1930s and 1940s, when Anni Albers spent time among Mexican weavers in Oaxaca and wove on the backstrap loom, she was also collecting ancient and modern Latin American textiles. One of the prize pieces that she bought in Mexico was a nineteenth-century Mexican serape from Queretaro (Figure 5.9). It is a large black, white, and light blue tapestry of silk weft and white cotton warp with the central slit woven in. The fact that the weft fiber was silk, not an original ancient American fiber, makes this serape unusual. Albers may have been attracted to it for that reason, and also because she had used silk for the majority of her Bauhaus wall hangings.

In addition, she would have been delighted by this finely made tapestry because of its starkly geometric and optically charged design. Albers probably acquired the serape while she was in Mexico during the 1946–47 academic year.[57] In 1946 she wove *With Verticals* (Figure 5.10). The two works are similar in that both involve the optical interplay of black and white with the addition of a single color, red in the Albers piece. Additionally, both textiles involve strong and opposing diagonals, a feature related to twill weaves, commonly used in Andean textiles. Albers had not previously used the diagonal as a major compositional feature in her work. Furthermore, she wove narrow vertical lines throughout the composition using a counter-balanced organization that resembles the dynamic equilibrium of De Stijl. The longest vertical is near the center of the composition in a way that appears to be a response to both the slit-tapestry technique and the neck openings of Latin American tunics. The verticals also function as 'text' in that, as in *Ancient Writing*, the elements are positioned on the composition as a text is positioned on a page. The varying lengths of the verticals seem to represent different signs or notes, and the diagonals extending from them connect the verticals and lock them in place.

In addition to the serape, Albers may have been inspired by a small Andean textile fragment that she purchased, perhaps by 1946, for her personal collection (see Figure 5.11). The vibrant zigzag pattern was produced through an extraordinarily complex double-faced, double-weave technique. Albers would have admired the way a simple pattern – one that reflects the under-and-over structure of weaving itself – could be created by Andean weavers from a complex technique. As with other Andean textile examples, this fragment would have reinforced lessons she learned from Klee

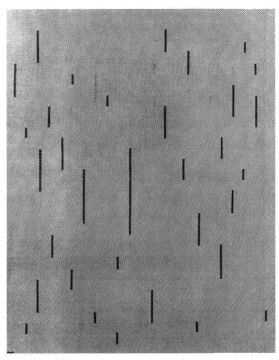

5.9 Serape, Queretaro, Mexico, nineteenth century, woven silk and cotton, 205.7 × 127 cm (81 × 50 in), Harriett Englehardt Memorial Collection, gift of Mrs Paul Moore, Yale University Art Gallery, New Haven, Connecticut

5.10 Anni Albers, *With Verticals*, 1946, 152.5 × 115.6 cm (61 × 46.5 in), collection of Robert Pottinger, Chicago

involving constructive approaches to composition, and served as an example of how these concerns could be applied to weaving.

Albers would have been aware of Klee's many drawings from the mid-to-late 1920s in which he built up the image through a series of parallel and perpendicular lines, a technique that Christian Geelhaar referred to as 'parallel figurations'.[58] For example, Klee used patterns of interlocking lines for many of his works, including *Beride (Town by the Sea)*, from 1927 (see Figure **4.14**). This work is significant because he made it during the year he began teaching the weaving course at the Bauhaus. Albers's interest in drawing and constructing similar 'parallel figurations' with thread is evidence of a relationship of indebtedness to Klee. Indeed, Albers referred to her pictorial weavings as the 'orchestration' of threads in much the same way that Klee and Kandinsky referred to designing as the orchestration and arrangement of elements for a composition.[59]

Her three large weavings *Monte Alban*, *Ancient Writing*, and *With Verticals* signal therefore a continuation of certain early Bauhaus investigations involving the structural and associative arrangement of abstract elements within a composition to achieve meaning. She went back to the wall-hanging format, after having abandoned it during Hannes Meyer's directorship in favor of wall coverings. She went back to the grid as a fundamental structure with which to investigate compositional arrangements. And she began for the first time to investigate the personal and associational aspect of subject matter, particularly in the context of semantics, an aspect of Klee's art that she realized in her own work only after her Bauhaus period. Finally, these three weavings point to an increasingly evident technical and formal indebtedness to ancient American sources through her investigations of supplementary wefts and the diagonal lines of twills as linear elements for expressive ends.

During the 1940s, Anni Albers continued to investigate the differences and similarities between art textiles and utilitarian fabrics. Certainly she was inspired by Andean textiles, which served both aesthetic and utilitarian functions. She produced many drapery fabrics on commission, and she made at least four known pictorial weavings. In 1944, she produced an elegant plain-weave drapery fabric of white plastic, copper-colored aluminum, and black cotton chenille fiber for the Rockefeller townhouse in New York designed by Philip Johnson. As Mary Jane Jacob noted, the fabric sparkled at night and was subdued by day.[60] It was similar to her Bauhaus work, particularly her 1929 drapery fabric for the Bernau auditorium, in that she combined

various types of fiber, both synthetic and natural, in ways that maximized the unique properties of each material.

Three years later, Albers incorporated elements of the Rockefeller drapery fabric into a 1947 pictorial weaving, *La Luz I* (see Figure **5.12**). She used similar black, white, and metallic colors of thread, but for *La Luz I* she manipulated them to form a small, easel-size pictorial composition involving a centralized cruciform shape. For the cross shape, she used a supplementary, discontinuous light-colored weft turned back upon itself so that the cross stands up slightly from the ground, physically and visually. The cross looks as if it were woven on a separate set of warp threads. The title refers to the town in New Mexico where the Alberses stayed for part of their 1946–47 sabbatical year away from Black Mountain College. The cross was chosen both for its universal shape and for its references to the rich history of cultural and historical cross-currents of imported and native visual and religious traditions that make up Latin American society. That she chose a shape so full of associations, including the under-and-over association of weaving itself, shows that she was willing to allow referents to enter into the reading of her pictorial work in order to distinguish it from utilitarian work.

La Luz I also signals the beginning of another significant development for Albers. This was the first of her many small pictorial weavings that resemble in size the Andean fragments and panels that she saw and collected. She was responding to the scale and format of the Andean models, dictated by the width of the backstrap loom. She began to decrease the size of her woven work from large-scale wall hangings to page-size statements precisely at the same time that she was incorporating more ancient American references into her work and purchasing ancient American textiles. Interestingly, at 47 × 82.5 centimeters (19 by 32 inches), *La Luz I* is one of her larger pictorial weavings. The average size of her 34 pictorial weavings, beginning with this work, is approximately 45 × 70 centimeters (18 by 28 inches).

In 1949, Anni Albers had a large exhibition of her work at the Museum of Modern Art, organized by Philip Johnson and Edgar Kaufmann of the Department of Design. This was the first exhibition at the Museum of Modern Art devoted exclusively to textiles, and it subsequently traveled throughout the country for approximately three years.[61] The exhibition highlighted Albers's achievements in the industrial field primarily because of the Design Department's Bauhaus-influenced belief in utilitarian design, and partly because by 1949 she had made few pictorial weavings. The exhibition included 90 items, primarily her post-Bauhaus hand-woven industrial samples

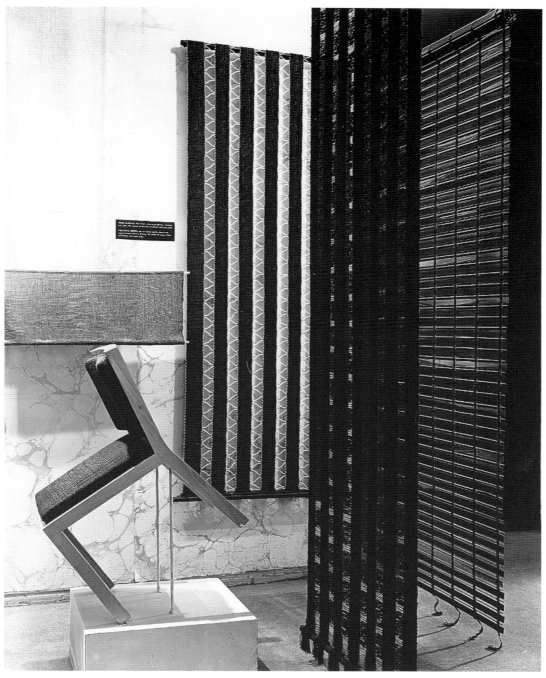

5.13 Installation view of the exhibition 'Anni Albers Textiles', Museum of Modern Art, New York, 14 September 1949 – 6 November 1949

and yardage (51 examples), and four pictorial weavings. Some surviving Bauhaus material was also included, such as watercolors, samples, photographs of her Bauhaus work, and her untitled 1926 multi-weave wall hanging (see Figure **4.**7), which was purchased by the Busch-Reisinger Museum in 1948 for $150.

For the exhibition, Albers wove eight hanging partitions of varying opacities and transparencies (Figure **5.**13), most of which involved leno weaves and synthetic fibers. One of the most extraordinary of her partition materials, the black and white example, is a complex version of the slit-tapestry technique whereby a regularly repeating series of weft threads turn back upon themselves five times before jumping down to the adjacent warp threads to repeat the process. This lyrical textile is also extremely practical in that it is open to light yet patterned enough for privacy. Certainly, Albers's use of fiber for architectural purposes was a continuation of her Bauhaus concerns involving the utilitarian value of textiles.[62] In addition, her investigations of flexible-fiber space-dividers were inspired by her experiences in Mexico, where she saw fiber used for mats and shades, as well as her knowledge that textiles were used in Andean society for shelter and utilitarian purposes.

This exhibition occurred at a pivotal point in Anni Albers's life and career. In 1949 she and Josef had resigned from Black Mountain College and he was teaching at Harvard for the year. Josef then was offered the position of Chair of the Department of Design at Yale University, and Anni would soon begin her most prolific period, the greatest achievement of which involved her pictorial weavings. But first we need to look in more depth at her work while she was at Black Mountain.

6. Anni Albers at Black Mountain College: weaver, teacher, writer, and collector

The aesthetic philosophy that Albers developed at Black Mountain, and which she maintained throughout her career, involved three main themes: one, that the weaver had the potential to be an artist; two, that woven threads could serve as both artistic and utilitarian material; and three, that these goals could only be achieved through hand-weaving and by following the laws inherent to weaving construction, as was done in earlier times. These ideas, demonstrated in her own work and inspired by an ever-increasing understanding of the history of weaving through contact with ancient American sources, are among her greatest contributions to modern art.

Anni Albers used Andean textiles as sources for her teaching as well as for her art and design. She used them in the classroom to discuss both technical and design issues with her students. For example according to the notes of former student Lore Kadden Lindenfeld, Albers required students to analyze and diagram actual Andean textile specimens as well as to study Andean textile dyes such as cochineal (red dye made from the cochineal beetle).[1] For instructional tools Albers also utilized books about and slides of Andean textiles. Don Page, another of her students at Black Mountain during the 1930s, recalled,

> Along with her technical German knowledge of weaving, she had an abiding interest in Pre-Columbian textiles, owning quite a few books (mainly German, I think) with pictures and descriptions of the various types of fabrics that had been woven in South America … If the technique of making any of these sometimes complicated fabrics was not explained or known in the books she would try to discover how they were made herself with the help of us as students. It was a way of teaching fundamentals of weaving as well as making students think creatively … She was always intrigued with the materials used in South American work, i.e. cotton, wool, alpaca, reeds, palm fronds, etc., and she encouraged students to experiment with anything that might be a useful or handsome material.[2]

Most of Albers's students, including Else Regensteiner and Lindenfeld among

them, were also assigned to construct and weave with traditional Andean backstrap looms, 'primitive' looms, as Lindenfeld called them. A photograph from the 1940s shows Black Mountain students weaving on such looms (Figure 6.1). Albers was very familiar with Andean backstrap looms; they were illustrated in Max Schmidt's 1929 *Kunst und Kultur von Peru*, of which she and Page owned copies, and she saw and wove with the loom when she was in Mexico.[3] Albers believed that the backstrap loom 'contained already in principle most of the elements used in industrial looms', and so she employed it as a useful and efficient teaching tool.[4] This assignment was part of an overall pedagogical program that she developed at Black Mountain of starting students 'at the point of zero'.[5] She explained,

> I tried to have them imagine, let's say, they are in a desert in Peru, no clothing, no nothing … And what do you do? … And how do you gradually come to realize what a textile can be? … And gradually then we invented looms out of sticks and so on. And the Peruvian back strap loom.[6]

Interestingly, Albers chose a desert in Peru, where the majority of Andean textiles were preserved because of the arid climate, to serve as her zero point.

Another of Albers's pedagogical developments from the Black Mountain period, this one originating in Johannes Itten's 'Preliminary Course' at the Bauhaus, was non-loom exercises with non-weaving materials.[7] She directed the students to gather materials such as corn, grass, metal shavings, and twisted paper. Then they were asked to arrange them according to an underlying horizontal and vertical structure analogous to that in weaving, such as the studies made of corn and twisted paper that Albers produced (Figure 6.2). The resulting textile-like patterns served to clarify fundamental textile principles, and allowed the students to see quickly that weaving structures and weaving patterns are integrally linked.[8]

Albers's pedagogical techniques reflected her own training at the Bauhaus, and they also reflected her growing understanding of hand-weaving techniques and weaving history, particularly ancient American weaving. Upon her arrival at Black Mountain, Anni Albers herself had essentially to start from zero to build up the college's weaving department. She had to have the college carpenter construct new looms and shelves; she did not have all of her own supplies until her parents brought them from Germany.[9] This back-to-basics situation suited and reinforced her 'point of zero' approach to teaching, somewhat similar to the approach in the Weimar Bauhaus, and gave her the freedom to develop her own weaving pedagogy. Albers recalled, '[Black

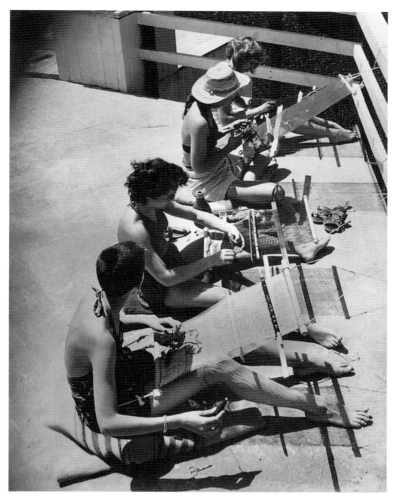

6.1 Black Mountain College students weaving on backstrap looms, 1945

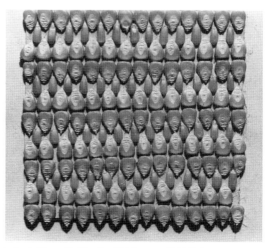

6.2 Anni Albers, studies made with twisted paper and corn, no date, in Anni Albers, *On Weaving*, Middletown, CT: Wesleyan University Press, 1965, plates 34 and 35

Mountain College] turned out to be a very interesting place because it gave us the freedom to build up our own work ... I built up a weaving workshop and got into teaching and developed teaching methods ... that put my students at the point of zero.'[10] She acted as a guide to her students and encouraged them to build ideas and forms directly on the loom through hand-weaving. 'We need [crafts] again [for] their contact with material and their slow process of forming', she wrote in her 1944 article, 'One Aspect of Art Work', implying that this contact had existed earlier, long ago.[11]

At Black Mountain Albers and her students consulted numerous books dealing with Andean textiles. Lindenfeld recalled seeing Raoul d'Harcourt's 1934 *Les Textiles anciens du Pérou et leurs techniques* there, and looking at slides and illustrations of Andean textiles.[12] Tony Landreau, the weaving teacher at the college from 1954 to 1956, verified that d'Harcourt's book 'was definitely in the library'.[13] In addition, there were copies of Schmidt's 1929 *Kunst und Kultur von Peru* at the college by 1938 or 1939, according to former student Don Page.[14] Albers's personal slide collection included various examples from the German edition of Walter Lehmann's 1924 *Kunstgeschichte des Alten Peru*, as well as other Andean textile examples. These are slides that she may have brought from Germany. She also owned a copy of Philip Means's book, *A Study of Peruvian Textiles*, published by the Boston Museum of Fine Arts in 1932, which included many illustrations and diagrams.[15]

Albers reinforced her pedagogical approach to the constructive process by using Andean textiles as examples in her classroom. Of primary consideration to Albers were the structures and forms of these textiles, rather than contextual or chronological data. This point has been noted by numerous former students of hers, including Don Page, and by colleagues such as Tony Landreau and Jack Lenor Larsen.[16] When she used Andean examples in the classroom, Page recalled, 'it was important to her that most of the designs were geometrical and not made up of curves and circles which are not integrally formed by horizontal and vertical threads'.[17] This explains why Albers was not as interested in Andean embroidered and painted textiles, even though these continued to be popular among collectors, as she was in Andean weaving. In any case her knowledge of these ancient textiles served to inspire her students.

Anni Albers's written work at Black Mountain College

As an extension of her pedagogical program, Anni Albers produced didactic essays. Most of the articles that she wrote between 1934 and 1949, three in the 1930s and nine in the 1940s, were ultimately compiled in a book, *On Designing*, published by

Wesleyan Press in 1961. At Black Mountain she developed and clarified her distinct theoretical approach to weaving, which combined structural/constructive principles as a basis for design with an interpretation of Andean aesthetic principles. She promoted hand-weaving, encouraged innovations with weaving materials and structures, and explored the similarities and differences between art and utility. Throughout, she used the example of the ancient weaver to reinforce her basic stance that today's weaver must learn from the past.

Albers's articles, 'Work with Material', of 1937, and 'Art – A Constant', of 1939, were very similar in content; for both articles, she expanded the thesis she had presented over a decade earlier in her 1924 article, 'Bauhausweberei'. In 'Work with Material', she again used the example of 'earlier civilizations' to show how disengaged modern artists had become from the fundamental process of creation. By 'going back to material itself, to its original state', she argued, and by following the laws inherent in a given material, the weaver can make better prototypes for industry and can achieve personal creative satisfaction by ordering and controlling the material itself.[18]

In 'Art – A Constant', Albers presented the thesis that if students understand and work within the 'authority' and limitations of a given artistic discipline, such as weaving, then they are better prepared to innovate and experiment within those limitations. If students are allowed to experiment within this structured framework, they become better equipped to 'build up independent work' that may 'end in producing useful objects, or rise to the level of art'.[19] This belief can be seen as coming directly from her understanding of Andean textiles, many of which – such as those created from discontinuous warp and weft techniques, multi-weave constructions, or sideways patterns – reveal how the expert Andean weaver stretched the limits of the medium to an amazing degree.

The notion of exploring the limits of one's medium also stemmed from the ideas of Wilhelm Worringer, whose work Albers had read while a student at the Bauhaus. She believed that her generation was living in 'bewildering' and 'chaotic times', and thus the need for stability and order was more pronounced.[20] Like Worringer, she believed that 'earlier' insights were simpler, more direct, and more intuitive. 'Layer after layer of civilized life seems to have veiled our directness of seeing', she wrote in 'Art – A Constant'.[21] Like Worringer, Albers made a direct correlation between artistic authenticity and earlier, pre-industrial expressions. In addition, Albers used the ideas stemming from the progressive education tradition that Itten and her husmand Josef represented by arguing that by working with materials, and

'redeveloping' our tactile and perceptual sensibilities, 'we regain the faculty of direct-ly experiencing art'.[22] What Albers contributed to these earlier discourses was a dis-tinctly textile-based point of view that served to elevate textiles, weaving in particular, to the position of exemplar of these ideas, as well as to 'the level of art'.[23] This is a pro-found insight coming at so early a time in modernist developments.

The Bauhaus philosophy that Albers practiced in her own work continued to serve as the basis of her pedagogical philosophy at Black Mountain. Certainly, there were parallels between the two schools. Similar to the early Weimar Bauhaus, Black Mountain in the 1930s had a small group of students, limited supplies, and few indus-trial connections. By the 1940s, it had become a famous art school with an interna-tional staff and an interdisciplinary perspective, just as the Bauhaus had become at Dessau. The similarities between the Bauhaus and Black Mountain allowed Albers to retain and implement many Bauhaus practices and ideas within a new context. The differences between her Bauhaus pedagogy and writing and her Black Mountain ped-agogy involved the development of a more deliberate reliance on the ancient American textile example to validate her theories, and a more vocal belief that the weaver could also be an artist.

Her 1938 article 'Weaving at the Bauhaus' was written for the catalogue of the 1938 exhibition 'Bauhaus, 1919–1928' at the Museum of Modern Art. Her two-page summary on the Bauhaus Weaving Workshop was at the time the most extensive account in English of the workshop, even though the scope of the exhibition ended with Gropius's resignation in 1928. This article advanced Albers's premise that the workshop had evolved into a laboratory-like environment where major innovations took place without the burden or benefit of outside intervention. She wrote,

> At the Bauhaus, those starting to work in weaving or in any other craft were fortunate
> to have had no traditional training … They believed that only manual work could help
> them back to solid ground and put them in touch with the problems of their time.
> They began amateurishly and playfully, but gradually something grew out of their play
> which looked like a new and independent trend. Technique was acquired as it was
> needed and as a foundation for future attempts. Unburdened by any practical consider-
> ations, this play with materials produced amazing results, textiles striking in their nov-
> elty, their fullness of color and texture, and possessing often a quite barbaric beauty.[24]

Of course, this statement contradicts her own reliance on Andean textiles as models, but as discussed earlier, it exemplifies her selective recollection of the Bauhaus

Weaving Workshop. This insular approach allowed her and others, such as Gunta Stölzl, the opportunity to emphasize and take credit for the industrial and economic innovations that were achieved later in the workshop. In her article, Albers credited neither De Stijl nor Constructivism, nor her teachers at the Bauhaus, as stylistic or philosophical sources. Nor did she remark that ancient, non-European, or folk art played a role in the development of the workshop. Conventional European art was significant to this development only as something to be avoided. These omissions helped to perpetuate a view of the workshop as an independent laboratory wherein members arrived at solutions to practical problems first through experimentation with materials and then through 'more systematic training' of their own devising.[25] This autonomous working procedure was one that she encouraged her students at Black Mountain College to engage in also, now with the crucial addition of the acknowledged aid of the Andean model.

Anni Albers wrote nine major pieces in the 1940s.[26] By the late 1940s her references to ancient American art became increasingly numerous as she made further trips to Mexico. Similar to her earlier articulations, these articles explained her belief that hand-weaving must serve as the first step toward both machine production and artistic expression, because it allowed the weaver to maintain the necessary relationship between process and product that earlier civilizations had.[27] While building on her contention that successful design in weaving was dependent on following the inherent laws dictated by structure and materials, she now added that the responsibility of the modern weaver was to invent new combinations of structure and material, rather than follow pre-designed patterns. By such combinations, Albers wrote in her 1941 article, 'Handweaving Today', the weaver could form 'surface contrasts and harmonies, [and] a tactile sensuousness' that can lead to the creation of art.[28]

'The form emerges as the work progresses', Albers continued.[29] This statement is significant because it reveals how completely she had departed from traditional European approaches to weaving.[30] Her rejection of preliminary paper patterns intensified after she came to the United States, learned how to weave on the backstrap loom, and saw weavers in Mexico working in the ancient tradition of designing at the loom. She found it remarkable that ancient American weavers apparently did not use planning devices such as writing and diagrams. This awareness reinforced her ideas that the creation of art through weaving involves an often intuitive, constructive process of forming threads.

In her 1945 article 'Constructing Textiles', Albers finally and directly credited

ancient Peruvian weavers for their achievements and for creating the 'greatest culture in the history of textiles'.[31] In this famous article, published in the *Black Mountain College Summer Art Institute Journal*, and reprinted in the April 1946 issue of *Design* magazine, she imagined what the ancient Peruvian weaver would have thought of contemporary woven products, particularly industrial products. She concluded that the Andean weaver would be amazed and delighted with the new synthetic fibers and the precision that production provides, but he (we have seen that she always used the masculine pronoun for this group, though most of these weavers would have been women) would be disappointed by the lack of imaginative results. She wanted to emphasize how important it was for the modern weaver to learn from 'our ancient Peruvian colleague' at a moment, she implied, when the two civilizations were nearly on equal ground in their achievements. The lesson to be learned involved understanding the ancient Peruvian approach to weaving whereby the integral relationship between process and product was maintained through hand-weaving. 'Modern industry is the new form of the old crafts', she wrote, 'and both industry and the crafts should remember their genealogical relation. Instead of a feud, they should have a family reunion.'[32]

The themes of hand-weaving, construction, and Andean textiles dominated Albers's work from the Black Mountain period. She positioned herself between the ancient past and the machine age in order to emphasize the value of craft for industry and artistic expression. By doing so, and holding fast to this position, strengthened by her knowledge of Andean textiles, she successfully resolved the family feud between art, craft, and industry.

Josef Albers's response to ancient American art

Josef Albers also developed an enthusiasm for ancient American art after emigrating to the United States and subsequently traveling to Mexico. Like Anni, Josef expressed his enthusiasm for this art through his work, through titles derived from specific sites and color relationships associated with the Mexican landscape, and in his writing and his art collecting.[33] With regard to the Alberses' collection of ancient American art, Nicholas Fox Weber noted that one reason Josef Albers was attracted to this art was its persistent serial imagery, consisting of multiple variations on a theme.[34] This observation is applicable to Anni Albers as well. Recent scholarship has focused attention on the significance of ancient American art for Josef Albers's work in sculpture, photography, graphics, and painting, particularly regarding his interest in the abstract monumentality of Mesoamerican architecture.[35] For example, James Oles has remarked that

Albers admired the 'sharp geometric compositions and linear intersections' of the restored Mesoamerican temples, an admiration that was clearly demonstrated by his use of stark figure/ground relationships, and sharp and steep angles.[36] Neal Benezra pointed out that Albers admired Mesoamerican architectural monuments precisely because they served as prime examples of the successful union between sculpture and architecture, a union that he sought to emulate in his own architectural sculptures.[37] In addition, Albers admired post-Conquest Mexican furniture, and made a set of chairs modeled after some he had seen in Mexico from the Colonial period.

Irving Finkelstein was one of the first scholars to note that Albers used design elements such as repeats, meanders, frets, figure/ground relationships, and pattern networks built up from modules, that were derived from ancient American architectural sources.[38] Curiously, Finkelstein did not credit these elements as resulting from textile sources, which they most certainly did, as César Paternosto pointed out.[39] However, the patterns that Albers created with bricks for his wall murals such as *America* (1950), for Harvard University (Figure **6.3**), while very close to the 'thermometer-stripe' works that he and Anni had done at the Bauhaus, clearly resemble the fundamental structure of a woven textile. Clearly Josef was influenced by the sculptural reliefs on many Mesoamerican buildings that he admired, such as those at Mitla (Figure **6.4**) and Uxmal that were derived from textile patterns. He would have been aware of the fundamental relationship that existed between architecture and textiles in ancient America because of the obvious visual similarities, and also because Anni Albers would have alerted him to this relationship, a relationship that she would have been aware of through her reading of Lehmann and Fuhrmann who made this point in the early 1920s.[40]

Some of the responsibilities that Josef Albers had at Black Mountain included recommending faculty candidates, co-ordinating exhibitions for the college art gallery, and ordering books for the library. For example, in February 1937 he organized an exhibition of Maya art, prepared by the Federal Arts Project.[41] Two years later during a 1939 trip to Mexico, he met the Russian-born artist John Graham whom Albers had considered hiring Graham to teach at Black Mountain, but after meeting him in Mexico said that Graham had 'too much theory and not enough practice'.[42] Albers owned a copy of Graham's 1937 book, *System and Dialectics of Art*, a gift from Graham, which was essentially a new take on Worringer's original thesis. Like Worringer, Graham suggested that 'primitive' art in its earliest form was abstract and was the result of a pre-rational unconscious expression. Graham believed that modern

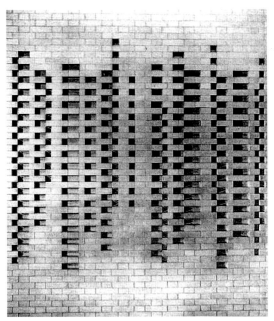

6.3 Josef Albers, *America* (detail), 1950, masonry brick, 330 × 260.6 cm (11 ft × 8 ft 8.25 in), Harkness Graduate Center, Harvard University Law School

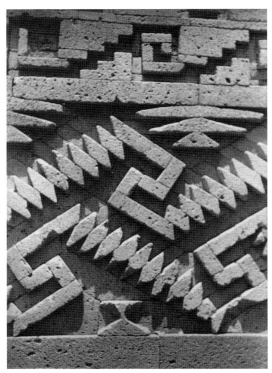

6.4 Josef Albers, no title (Mitla, detail of Palace of the Columns, Oaxaca), no date, 21 × 17.7 cm (8.4 × 7.1 in), Josef and Anni Albers Foundation, Bethany, Connecticut

artists should try to re-establish this link with the 'primitive' unconscious in order to produce pure and authentic artistic expressions. He wrote,

> The purpose of art *in particular* is to re-establish a lost contact with the unconscious (actively by producing works of art), with the primordial racial past and to keep and develop this contact in order to bring to the conscious mind the throbbing events of the unconscious mind.[43]

The Alberses, neither of whom supported Abstract Expressionism or Surrealism, most likely rejected Graham's idea that the unconscious should guide creative action, for they never referred to the unconscious as a source for creative expression. Indeed, Anni Albers once wrote that 'for many today, introspection then becomes the unfiltered and often the sole source material; and thus convulsion is mistaken for revelation'.[44] However, they both would have agreed that modern artists needed to acknowledge the intuitive and spiritual basis of creation that those in earlier times were thought to have achieved more fully. And the Alberses would have generally agreed with Graham's definition of 'primitive' art as 'abstract, awesome, sensuous, direct'.[45] Certainly, notions of the 'primitive' continued to inform much of the art of the 1930s and 1940s, as artists in many countries continued to seek the origins of creative expression. The Americas became an attractive destination to many artists precisely for its ancient past, far removed from the troubles of modern times.

In 1939, Josef Albers presented a slide lecture at Black Mountain entitled 'Truthfulness in Art', devoted almost entirely to the achievements of ancient American artists.[46] Like Anni Albers, Josef used ancient American art to serve as a contrast and exemplary model for modern times, but his interests were more focused toward sculptural pieces, and less toward context. As to the contextual relevance of the work he was discussing, he stated, 'Purposely, I shall not touch the historical side [of this art], but hope that we will realize a near connection of that art work with modern art problems.'[47] Interestingly, the only ancient American slides in his archives all come from Lehmann's 1924 book *Kunstgeschichte des Alten Peru*, so it is most probable that he used these slides for this lecture.

Albers admired ancient American art for its 'truthfulness to conception, and material, [and] truthfulness to art as spiritual creation'.[48] He explained how these qualities were demonstrated in ancient American clay, stone, and textile work. He showed slides of figurative sculpture to discuss the 'psychological proportion' and 'active volume' demonstrated in the works, stating, 'no other period has such a rich

and vital plastic work'.[49] He showed a slide of an ancient American textile to exemplify how ancient American art demonstrates a truthfulness to visual elements of art, regardless of context, particularly involving the figure/ground relationships. 'Art is spirit and has a life of its own', he said, and it is significant that he used ancient American art to express this idea.[50]

While he may have preferred Mesoamerican architecture, the ancient textiles he admired would have been Andean given that no ancient Mesoamerican textiles survive, Josef, unlike Anni, may have tended to merge Mesoamerican and Andean art into one category that combined the diverse Mesoamerican empires of the Olmec, Maya, and Aztec, with the diverse Andean empires of the Charin, Wari, and Inca.

Albers admired Maya art and civilization with such enthusiasm that he even made an analogy between Black Mountain and Maya society. For a 1939 article about Black Mountain's position on the arts, he wrote, 'Black Mountain College is consciously on the side ... of the Mayan Indians who demanded that the king be the most cultivated among them.'[51] This analogy must have persisted, for a former student recollected that her encounter with him at Black Mountain, 'a hillbilly setting, in the Southern Baptist Convention country of the Tarheel State was a little like finding the remnants of an advance civilization in the midst of a jungle'.[52] Albers believed that ancient Americans were 'THE representatives of abstract art', and he used the model of ancient American art to reinforce and validate his own work and ideology; he wrote to Kandinsky that 'Mexico is truly the promised land of abstract art.'[53]

The Josef and Anni Albers Collection of Pre-Columbian Art

By the late 1930s, the Alberses had begun to collect Mesoamerican art seriously, especially miniature ceramic figurines. From the very first of their trips to Mexico, Anni Albers made a point of searching the Mexican markets for antiquities.[54] They were interested in the formal qualities of the pieces rather than in iconographic and historical context, partly due to the lack of information at the time regarding the meaning of Mesoamerican ceramics, and partly due to their own aesthetic preferences. As I stated above, Josef Albers liked to acquire multiples of the same kind of figure, particularly West Mexican ceramic figures, because of their serial implications.[55] Also demonstrating their formal concerns, they collected many mass-produced, mold-made ceramic pieces from Teotihuacan, Veracruz, and West Mexico, as well as clay and ceramic textile and body stamps. Certainly, they were attracted to rather than repelled

6.5 Stamp, Guerrero, Late Post-classic, 1250–1521 CE, ceramic, 7 cm (2.8 in), Peabody Museum of Natural History, New Haven, Connecticut

6.6 Schematic human statuette, possibly Colima, Proto-classic, 100 BCE – 300 CE, gray mottled stone, 4 cm (1.6 in), Peabody Museum of Natural History, New Haven, Connecticut

6.7 Tunic fragment, Wari, South Coast Peru, 700–900 CE, camelid wool over cotton tapestry weave, 15.6 × 60.4 cm (6.5 × 23.75 in), Hobart and Edward Small Moore Memorial Collection, Yale University Art Gallery, New Haven, Connecticut

by these ancient examples of artistic standardization. While standardization represented one of the many types of artistic product within the wide corpus of ancient American art, the Alberses' predilection for repetition in their own art seemed to predispose them to ancient American 'repeats'. Anni Albers wrote,

> It was [the] timeless quality in Pre-Columbian art that first spoke to us, regardless of our ignorance of the special significance [this art] must have had to a contemporary community. We were struck by the astounding variety of its articulation, by the numerous distinct cultures and resultant differing formulations.[56]

Their collection includes a number of pieces related to textiles, including a Nayarit ceramic sculpture that depicts a house, the painted surface of which is a textile pattern. This piece is evidence of the integral role of textiles in ancient American architectural and ceramic patterns because it suggests, as Karl Taube wrote, that Mesoamerican houses such as this were made of 'woven material, such as matting or wattle, that may have covered a wooden framework'.[57] The Alberses also acquired a number of ceramic and stone stamps imitating woven textile patterns that were originally used to block motifs onto a flat surface or to roll motifs onto the body (Figure 6.5). Stamps such as this symmetrical block pattern incorporate the interplay of figure with ground, and the forms used to achieve the designs are decidedly abstract. Anni Albers most likely can be credited with alighting upon the purpose of these stamps, and realizing the textile pattern implications. On their way from Monte Albán to Mexico City in 1937, Toni Ullstein Fleischmann wrote, 'Anni is still sick but is feeling somewhat better, enough so that she has gone out on her search for old things, and with an hour she turned up an old stamp.'[58] The next day, in Mexico City, they visited a modern weaving school housed in a former cloister.[59] Certainly, Anni Albers was informed about various textile-related sites and objects, and because of her knowledge in this area, she was able to guide their excursions and make informed decisions about purchases.

One stone piece from their collection (Figure 6.6) is an abstract representation of the human figure, probably a hand ax, that Albers may have believed was a bobbin on which weft threads were held, in a criss-cross fashion, as they passed between the warp openings of a weaving. The piece is interesting because it may be the one that she referred to in her 1943 article 'Designing'. In this article she discussed the relation of tools to art. She wrote that tools are not usually designed aesthetically, but represent 'form to its barest essentials', with no substantial relationship to art.[60] However,

she wrote, 'some early tools of stone, representations of the human figure, do not show this opposition, since they themselves are sometimes art'.[61]

The Harriett Englehardt Memorial Collection of Textiles and the Anni Albers Collection of Pre-Columbian Textiles

In 1946, Mrs Sam Englehardt from Montgomery, Alabama, wrote to Anni Albers regarding the possibility of establishing a memorial fund in honor of her late daughter, Harriett, who died in 1945 in Germany while working for the Red Cross. Harriett was a former student of Anni Albers at Black Mountain. After speaking to the college administration, Albers proposed that they establish a memorial collection of textiles. By this time, Albers was already collecting textiles for her personal collection, so she most likely had possible sources in mind when she suggested the formation of a textile collection. Albers knew that she would soon be going to Mexico, and was prepared to purchase pieces there. Indeed, she bought most of the textiles in the Englehardt Collection between 1946 and 1947, when they were in Mexico and New Mexico for their sabbatical.[62] She sought out ancient and modern woven products, primarily from the Americas, not necessarily for their utilitarian function (although the items include shawls, hats, vests, belts, and bags), but for their structural techniques and geometric designs.

Upon returning to Black Mountain in 1947, Anni Albers began to organize an exhibition of the Harriett Englehardt Memorial Collection of Textiles to be installed at Black Mountain for April 1948. She had approximately 15 of the pieces framed in Asheville, and she also purchased display cases. It is not surprising that the majority of the framed pieces were Andean, for she considered these to be the prize pieces. The exhibition was so 'popular', Albers stated, that its run was extended to the end of the summer.[63]

Albers continued to augment the Englehardt Collection until she left Black Mountain in 1949. She wanted to build a collection of 'antique' and non-European textiles, rather than European-style items, because they provided the kind of formal and technical examples that she believed would most benefit her students. In an October 1948 letter to Altman Antiques, Los Angeles, she wrote,

> I received your interesting catalog and price list of primitive objects of art and am wondering whether you happen to have antique textiles for sale. I am building up a small textile collection in this college and would be interested in purchasing some old Peruvian specimens.[64]

It is interesting that Albers here used the term 'primitive', which she rarely did, to refer to 'objects', while she used 'antique' and 'old' when referring to textiles. Clearly she was making a distinction between ancient American art, as 'antique', and the art of other times, places, and media, as 'primitive'. She wanted to collect examples of a wide variety of weaving techniques, and knew that she could satisfy this goal by collecting textiles from the Americas, although she did also show an interest in Coptic, South Sea, and African textiles. For example, in a follow-up letter to Altman Antiques in December 1948 she wrote,

> We have in our little collection a number of small samples in different interesting techniques, some quite rare, I believe. My plan was to enlarge this group by adding pieces in techniques not yet represented and to avoid duplication … Should you have any single pieces in gauze, pile fabric, or other unusual techniques, or any piece that seems unusual in its design characteristics, I would be much interested to hear about it.[65]

Interestingly, there are no Northwest Coast or Southwest Indian textiles in this collection. She eventually bought eight Andean pieces from Altman Antiques in early 1949 to add to the four or five Andean pieces already in the collection.

Anni and Josef Albers resigned from Black Mountain in 1949. As she prepared to leave, Albers informed the incoming weaving teacher, Marli Ehrmann, about the collection:

> The Englehardt Memorial Collection comprises one hundred pieces at this time, some of which I know will thrill you, and we have found it quite wonderful illustrative material in classes. The students as well as Trude [Guermonprez] and I get always again excited seeing some of the things, especially the ancient Peruvian specimens. All of this material is labeled and listed.[66]

Between 1954 and 1955, Tony Landreau, the last weaving instructor at Black Mountain, cataloged the collection for the first time.[67] Landreau later recollected that Albers had not cataloged the collection in any systematic way because she was not really concerned with chronological or iconographic data. Rather, he said, the collection reflected her aesthetic tastes.[68]

In 1958 the Englehardt Memorial Collection of Textiles was acquired by Yale as a gift from Mrs Paul Moore, where it remains today.[69] Mrs William H. Moore had earlier in 1937 presented Yale with a collection of Andean textiles including a Wari tunic fragment representing kneeling, staff-bearing figures (Figure **6.7**). Most of the

Englehardt collection is still stored in the two original crates that they were shipped in, and the framed pieces, now with rusted staples and yellowed mat board, are still in the original frames at the time of writing.[70] When the collection was acquired by Yale, the Alberses had been living in Connecticut for eight years. The renowned Yale University scholar of ancient American art, George Kubler, was present during the cataloging, at which time some exchanging of pieces occurred between Albers's personal collection and the Englehardt Collection, with Kubler's help.[71] Indeed, some of the pieces from both collections appear to be from the same textile! It is possible that Albers herself cut up some textiles in order to complete her own collection. The practice of cutting textiles was common among early collectors of Andean work, and, in Albers's case, was a procedure that allowed her to study the textile in cross-section. She wrote, 'Wherever the piece of cloth that is the subject of analysis can be cut, this process of tracing the course of each thread … is greatly simplified [and] by cutting along a filling thread, for instance, the path of the thread can be seen in cross section when looked at from above.'[72]

Like the Englehardt Collection, Albers's personal collection was intended first of all to be a teaching collection. Upon her death in 1994, she owned 113 Andean textiles. This collection is not as fully documented as the Englehardt Collection in terms of provenance. It appears that she purchased Andean textiles as late as the 1960s, although she probably began the collection in the 1930s. Certainly by 1958, when the Englehardt Collection was acquired by Yale, she had enough pieces in her collection to swap certain of hers with theirs, as I have said. As noted recently by Sarah Lowengard, who conducted conservation work on the Anni Albers Collection in 1995, the collection as a whole reflected Albers's continuous interest in complex woven structures and abstract formal designs.[73] As with the Englehardt Collection, Albers did not collect many embroidered or painted pieces, but chose to focus on the more 'structural' techniques of Andean textiles. To serve as teaching tools, the pieces were stored in clear plastic envelopes that she made herself so that they could be handled and analyzed from both sides.

The most important aspect of both textile collections is that numerous examples represent techniques that Albers used in her own work as early as 1924. These include double weaves, open weaves, floating wefts, and knotted wefts; there is even an Andean discontinuous warp and weft piece.[74] This black, green, and yellow cotton piece was certainly a piece she valued, for she had it framed. In addition, many of the pieces she collected are composed of designs that she often used in her own work as

early as 1924. For example, many pieces contain bands, squares, interlocking forms, checkerboards, steps, and braids, frequently organized in bilateral and rotational symmetry. Rarely are there figurative pieces. Furthermore, some of the colors are similar to those she used in her own work. For example, the bright pinks and reds in the modern Mexican shawls are similar to the bright colors that she used in her work in the 1950s. Clearly, both collections provided Albers with a wealth of information to translate and apply for her own needs.

7. Anni Albers: pictorial weavings in the 1950s and 1960s

During the 1950s, after the Alberses had moved near Yale University, Anni Albers had the opportunity to work with two of the leading scholars of ancient American art, George Kubler and Junius B. Bird. In 1952 she attended a course at Yale taught by Professor Kubler, who was to become a friend of the Alberses. As part of the course, Anni wrote a scholarly article on the subject of Andean weaving techniques, 'A Structural Process in Weaving', in which she investigated possible ways that Andean weavers were able to weave large widths of cloth on handlooms; this was a subject that had not been previously addressed.[1] She subsequently revised the article after a lengthy correspondence with Bird, of the American Museum of Natural History, who was the premier scholar of Andean textiles.[2] Albers's innovative conclusion to this perplexing question was that the weavers must have utilized a triple- or even quadruple-layer technique on frame looms. Each plane of warps was thus woven accordion-style so that, when unfolded, it yielded a single web of greater dimensions than the loom itself.[3] Considering that Albers was not herself actually a textile scholar, her solution to this problem was advanced for the time.

Her woven and written works of the 1950s reflect her ongoing and intensified study of Andean textiles and ancient American art, and was dominated by her interest in, and use of, visual sign languages, and the notion of textiles as text.[4] Albers was acutely aware of the semantic function of thread and textiles in the context of art and design. As she did in her Bauhaus work, she continued to emphasize codes and systems, but now her work, her 'pictorial weavings' as she called them, included a poetic content achieved through her method of marking, or drawing, with thread to create visual signs that were both semantic and artistic.

The act of 'drawing' with thread was a primary element that Albers used to distinguish her art from the industrial prototype and to refer to textual themes. Without the calligraphically inscribed threads that run along the surface of her 1950 pictorial weaving *Black-White-Gold I* (see Figure 7.1), one could envision the textile as a sample

for a display fabric. The difference, therefore, is that, with this textual augmentation, Albers effectively changed the content and the context of the work from prototype to art.

The supplementary-weft technique was one that she had already derived, in the 1930s, from Andean examples. In *Black-White-Gold I* she introduced the supplementary *knotted* weft, also derived from a Peruvian source. Indeed, one of the two modern traditional Peruvian knitted caps that Albers bought for the Englehardt Memorial Collection, probably in 1946 or 1947, is striking precisely because it is dotted with brilliantly colored supplementary knots (see Figure **7.2**).[5] Later she included these knots in other works such as *Dotted* (1959), and *Code* (1962) (see Figure **7.3**). Given her understanding of the Andean *quipu* (see Figure **5.4**), the knotted-thread instrument that held codified data, it is not surprising that she found significant meaning in the use of knots for her woven work, for Albers believed that Andean textiles served as carriers of meaning. She wrote,

> Along with cave paintings, threads were among the earliest transmitters of meaning. In Peru, where no written language in the generally understood sense had developed even by the time of the Conquest in the sixteenth century, we find – to my mind not in spite of this but because of it – one of the highest textile cultures we have come to know.[6]

In the light of this belief, she explored the notion of textiles as text within the context of Andean textiles. She was not interested in deciphering or copying particular written languages; rather she explored the *idea* of marks and signs as language distributed across a surface in a way that recalls the structure of a text. In this way, she used calligraphic marks as well as ideographic signs to create text-like images and suggest the constituents of a language.

Albers wove *Two* in 1952 with these thoughts in mind (see Figure **7.4**). She actually wove the work with the short end in the vertical direction; afterwards she turned it horizontally, oriented so that the long axis is horizontal, and signed it on the lower right. This horizontal orientation could be interpreted as text-like, even as scroll-like. The warp threads, two different thicknesses of white cotton yarn, thus run horizontally in the finished piece. For the all-over checkerboard pattern, she raised and lowered units of either the wide or the thin warp threads, to either emphasize or de-emphasize the brown weft. On top of this underlying checkerboard ground, Albers wove heavy brown and beige fibers, using a supplementary technique, so that the dark

shapes seem to lie on the ground like a text. The figure/ground relationship is that of sign and ground.

Two reveals Albers's indebtedness to Klee's numerous graffiti- and script-like paintings from the 1930s that she would have seen at museums, galleries, and in numerous publications about Klee from the 1940s and 1950s. After Klee's death in 1940 a profusion of exhibitions of his work took place in New York, including two large retrospectives at the Museum of Modern Art in 1941 (a copy of this catalogue was in the Black Mountain College library)[7] and 1949, the same year that Albers herself had an exhibition there. There were also several large gallery exhibitions of Klee's work in New York during the 1940s and 1950s that Albers was aware of. Curt Valentin, who ran the Buchholz Gallery and later the Valentin Gallery (both in New York), organized Klee exhibitions in 1940, 1948, 1950, 1951, and 1953. Not surprisingly Albers owned copies of the latter three catalogues which, like the others, highlighted Klee's work from the 1930s, particularly his calligraphically inspired pieces.[8] The installation photograph of the 1948 Buchholz Gallery exhibition in Figure **7.5** documents the quantity of Klee's works shown, many of which are narrow, horizontal compositions that are highly calligraphic in character. Interestingly, as discussed in earlier chapters, Klee painted many of these late works on burlap, a loosely woven, natural fiber cloth. When burlap is painted, the warp-and-weft structure of the cloth is emphasized, particularly when the frayed edges are exposed, as Klee often preferred, resulting in a work that appears to be both a painting and a textile.

Anni Albers's Two is a particularly significant and striking piece because of its clear indebtedness to De Stijl. Albers would have seen copies of De Stijl while she was at the Bauhaus;[9] she and Josef also owned most of the Bauhaus Book series including Book Five, devoted to Mondrian. She is said to have liked van Doesburg's work, and may have met him in Germany before his death in 1932.[10] Albers recognized the way in which these early De Stijl images were essentially distillations of recognizable subject matter such as van Doesburg's famous cow series in Bauhaus Book Six, of 1925. These were clear abstractions that resulted in pictographic representations. However, she was also interested in later De Stijl images that moved beyond this distillation stage toward the ideographic and the non-objective image.

As a modernist artist-designer from the Bauhaus, Albers had maintained her involvement with the De Stijl formal vocabulary after more than three decades, viewing De Stijl in the light of her contact with ancient American art. She saw parallels between De Stijl aesthetic principles and Andean textiles in terms of universal abstract

languages and patterns. Remarkably, in 1952, the year that Albers wove *Two*, the first major exhibition of De Stijl work was presented at the Museum of Modern Art, organized and exhibited in 1951 by the Stedelijk Museum in Amsterdam. The catalogue for both exhibitions was published in 1951 by the Stedelijk. Albers most likely saw the exhibition, because at the time she was traveling from New Haven to New York City to conduct research with Junius B. Bird at the American Museum of Natural History.[11] Indeed, she owned a copy of the Museum of Modern Art bulletin, written by Philip Johnson, documenting the exhibition. The catalogue contained reproductions of De Stijl works and passages from *De Stijl* articles in Dutch, German, French, and English.[12] Van Doesburg's *Composition in Black and White* (1918) (Figure **7.6**), which had earlier been reproduced in Book Six of the Bauhaus Book series in 1925, and later in the last issue of *De Stijl* in 1932, appeared as the frontispiece to the catalogue. Albers would have been drawn to this work; the interwoven 'plus and minus' signs not only link it to the inherent construction of weaving but the black-on-white character of the signs also creates a figure/ground relationship like that of a text on a page. *Two* refers to the overall image of a text; it is calligraphic in that thread is arranged in under- and overlapping bands to suggest writing; and it involves the use of non-objective ideographic signs to suggest ideas. The De Stijl exhibition and catalogue probably renewed Albers's connection to De Stijl and provided her with examples of how linear, geometric forms can be used to suggest linguistic elements.

Like Karl Osthaus's Folkwang Museum, curators at the Museum of Modern Art were instrumental in juxtaposing modern and ancient art, and organizing cross-cultural and cross-historical exhibitions. In 1953 the Museum of Modern Art presented a major exhibition of Andean art, 'Ancient Art of the Andes', curated by Andean art scholar Wendell Bennett of the American Museum of Natural History. Importantly, and not surprisingly, Albers owned the exhibition catalogue. The exhibition included 420 objects and many remarkable textiles, some of which Albers may actually have seen decades earlier in Germany. For example, the Inca checkerboard tunic (see Figure **4.12**) reproduced in the catalogue was from the Munich Museum für Völkerkunde collection; Albers owned a slide of it. Also reproduced in the catalogue were two tunics, the Nazca feather tunic with birds and felines (see Figure **1.5**), and the stepped-fret Wari tunic (see Figure **1.6**), both formerly from the Gaffron collection that Lehmann had reproduced in color in his 1924 *Kunstgeschichte des Alten Peru*. Albers must have taken great pleasure in seeing these great Andean tunics in the same museum where her own work had been exhibited just a few years earlier. In addition to these extraordinary

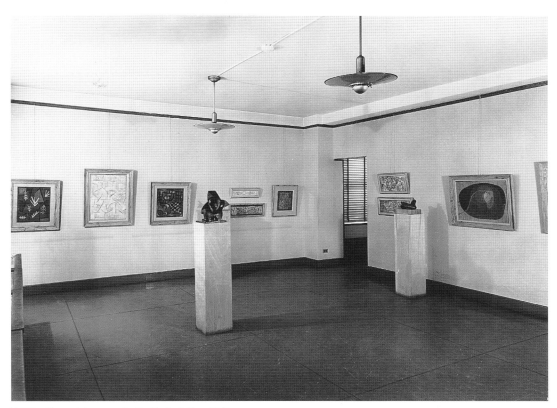

7.5 The Klee exhibition at the Buchholz Gallery, 1948

7.6 Theo van Doesburg, *Composition in Black and White*, 1918, from the catalogue of the De Stijl exhibition, Museum of Modern Art and Stedelijk Museum, 1951

151

pieces, the exhibition also included an incredibly complex Wari tunic from the Robert Woods Bliss Collection at the National Gallery of Art in Washington, DC (see Figure 7.7),[13] which also appears to have served as an inspiration for Albers's *Two*. Even though the exhibition was in 1953, a year after *Two*; perhaps she had previous knowledge of this wonderful textile.

In the exhibition catalogue, Bennett wrote that the Bliss Wari tunic was 'an excellent example of the transformation of representational art into a decorative all-over pattern'.[14] Albers would have responded to this tunic for precisely the same reasons, in addition to admiring the bold figure/ground relationships and the finely executed tapestry technique. The tunic is a highly abstracted representation of felines, human figures, birds, and animals, some of which, the jaguars, appear to be enclosed at the yoke of the tunic. All the figures are governed by bilateral symmetry; the figures change orientation at the shoulder which falls midway horizontally across the yoke (the tunic is missing two-thirds of the back). In addition, there is lateral shape distortion in the form of compression of the figures the closer they are to the side edges of the tunic. As Rebecca Stone-Miller has discussed, this tunic, like other Wari tunics, is so abstracted and the iconography has been so deliberately subverted that the pattern itself has become the focus of attention.[15] Certainly Albers would have appreciated this feature. Like De Stijl paintings; Andean textile examples could be read as both abstract figurative works and as arrangements of ideographic signs. Both types of examples, in which pictorial and linguistic signs merged, were inspirational models for her.

The parallels between De Stijl works and Andean textiles are particularly apparent in those works in which figure/ground relationships are ambiguous, and abstract pictorial signs merge with ideographic ones. For example, the linear patterning in a Nazca bag illustrated in Lehmann's 1924 *Kunstgeschichte des Alten Peru* (see Figure 7.8) reveals this optical dynamism.

Albers owned numerous Andean textiles that contain this visual ambiguity, such as the Chancay or Wari tapestry fragment with supplementary weft shown in Figure 7.9, which she probably purchased in the 1940s. This example is interesting because it was made with two different techniques – the top portion is supplementary-weft brocade, while the lower portion is interlocked tapestry – both of which involve dynamic color and tonal patterning through contrast and repetition. In its stepped lines and figure/ground reversals, the lower portion can clearly be seen as a formal source for *Two*; the upper portion can be seen as a technical source for it. Many addi-

tional sources, such as the Wari textile fragment from the Yale Collection (see Figure 6.7), may have provided Albers with models on which she based her perpendicular forms. Kubler most likely introduced her to this optically charged tunic fragment consisting of five kneeling staff-bearing figures. It serves as a striking parallel to the complex geometry of *Two*. [16]

Soon after Albers wove *Two*, she wove what may have been a companion piece, *Pictographic* (1953) (Figure 7.10), also a long rectangle woven 'sideways'. Blocks of color arranged on a checkerboard ground are 'inscribed' with 41 'X's. As in *Two*, she used line and shape in *Pictographic* to refer both to the image of a text, calligraphic marks, and to the idea of signs as transmitters of meaning (ideographs) and also, as in *Ancient Writing*, the pictograph. The stark contrast between light and dark is not as pronounced as it is in *Two*, and yet the varying degrees of value and intensity between the modules is enough to create levels of contrast and a subtle figure/ground relationship that implies a 'text', or layers of text. While a true pictograph is a sign with figurative references – such as Albers used in her weaving *Monte Alban*, for example – she used the term in a much more general way for *Pictographic*.

Albers was clearly investigating and applying the lessons she had learned from Klee and De Stijl at the same time as she was applying the constructive and visual vocabulary that she learned from Andean textiles. By this time she had surely seen the royal Inca *tocapu* tunic at Dumbarton Oaks in Washington, DC (see Figure 4.13), which at the time was displayed on the wall of the museum, in the same way as she hung her wall hangings (Figure 7.11). Given that she was thinking about the semantic implications of elementary geometric forms, her modules function in much the same way as *tocapu* modules: as collections of signs. However, the signs that Albers used did not carry discrete information about the world, as the Andean textiles did. Rather, her signs were about formal variations, about the nature of mark-making, and about weaving itself. Like much of modernism, and like many Andean textiles, her work was self-referential.

Albers's primitivism was an inventive one that involved studying and appropriating the sign language and craft processes of ancient art, and filtering this information through her understanding of the universalism of Klee, Kandinsky, De Stijl, and International Constructivism, to arrive at a personal visual and constructive language. She applied this language equally well to machine production and artistic expression, but with the latter category the range of information she was dealing with was larger. Unlike De Stijl, and more like Klee, Albers allowed for, indeed encouraged, subjec-

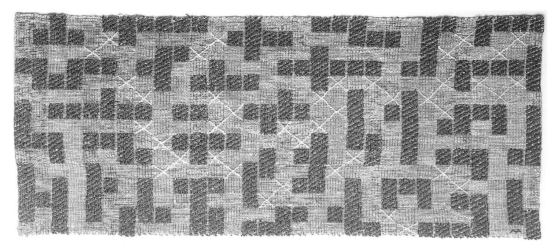

7.10 Anni Albers, *Pictographic*, 1953, cotton with embroidered chenille, 45.7 cm × 103.5 cm (18 × 40.75 in), Detroit Institute of Arts

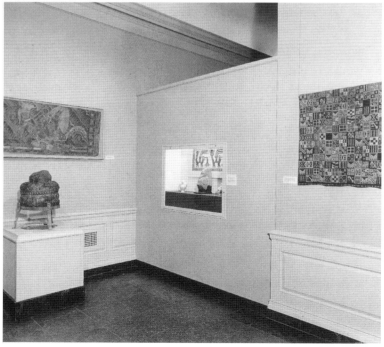

7.11 Photograph of the Robert Woods Bliss Collection at the National Gallery of Art, Washington, DC, taken between 1947 and 1960, of objects acquired in the 1940s, Dumbarton Oaks Research Library and Collection, Washington, DC

tive and arbitrary readings of both figure/ground relationships and content. By combining pictographic, figurative references with non-objective, ideographic signs, she was appealing to both the senses and the intellect.

Albers had a large, traveling retrospective of her pictorial weavings in 1959. The exhibition was organized by the Massachusetts Institute of Technology, and subsequently traveled to the Carnegie Institute of Technology, the Baltimore Museum of Art, and the Yale University Art Gallery. All but 6 of the 27 exhibited shown were produced in the 1950s, and each work was informed in some way by her translation of Andean textiles.

The most striking examples of her pictorial weavings from the 1950s and 1960s can be divided into two main thematic groups: those using imagery derived from ancient American motifs, landscapes or sites, such as *Red Meander* (1954) (see Figure **7.12**), *South of the Border* (1958), and *Tikal* (1958) (see Figure **7.13**); and those evoking linguistic characters and systems through the rectilinear arrangement of ideographic signs, especially those with specific textual references in the title, such as *Variations on a Theme* (1958), *Memo* (1958), *Open Letter* (1958) (Figure **7.14**), and *Jotting* (1959). Both *Haiku* (1961) and *Code* (1962) (see Figure **7.3**) refer to the script-like, or calligraphic, character of woven threads proceeding across and down the 'scroll' in horizontal and vertical directions. In the light of Albers's focus on inscriptions and signs, it is interesting to recall that some of the first pieces of ancient American art that she purchased in Mexico were the ceramic and stone stamps — both flat and roller stamps — used to print and block designs onto surfaces (see Figure **6.5**).[17] These stamps are similar to the press-type once used to compose text in printing in that both require the creation of a figure/ground relationship in order for the image or text to be seen and therefore read. This relationship of image/text to ground was one that Albers delighted in and explored with increasing intensity.

Albers clearly saw parallels between these themes and Andean textiles, for she connected them, and through this connection she was able to form her definition of art. To Albers, meaningful art had to be 'articulate', honestly formed, and a thing in itself. These were characteristics Albers perceived in Andean textiles which she sought to emulate in her own work. She wrote in 1959,

> Though some of the earliest weavings unearthed after thousands of years have the
> magic of things not yet found useful, and later periods have shown us weaving as art,
> thousands of years of establishing and expanding the usefulness of woven materials

have made us see in them first something to be worn, walked on, sat upon, to be cut up, sewn together again, in short, largely something no longer in itself fulfilled. To let threads be articulate again, and find a form for themselves to no other end than their own orchestration, not to be sat on, walked on, only to be looked at, is the *raison d'être* of my pictorial weavings.[18]

With *Open Letter* (Figure **7.14**), for example, Albers once again responded to the format and semantic function of Andean *tocapu* tunics by creating a composition of individual pattern units that, when taken or 'read' as a whole, implies content and meaning through the arrangement of codified visual information, analogous to the way one reads a paragraph composed of letters, words, and sentences.

Many of her pictorial weavings of this period reveal a deliberate effort to maintain a strict rectilinearity of patterns and pattern sequences, and to maintain a high degree of contrast between figure and ground. In *Memo*, for example, she employed a repertoire of sign characters similar to an alphabet that are repeated and varied along horizontal bars. Clearly in these textual weavings the intention was not simply to simulate a page of text, although the viewer's automatic response is to 'read' the 'memo' or 'letter' for information, but to investigate the nature of ideographic signs and the way codified visual information is expressed in thread.

Albers's *Play of Squares* (1955) (Figure **7.15**) also relates significantly to semantics in a way that has generally been overlooked in discussions of her work, that is, the element of play. In *Play of Squares* 69 squares are placed in an apparently random order within a rigid grid format of alternating horizontal bands. As we scan for a code, one system is revealed – every row has either three dark squares or three light squares – but an overall sequential formula does not emerge. In this way, *Play of Squares* is similar to Albers's 1927 wall hanging (see Figure **4.9**), but *Play* is smaller, nubblier in texture, and, when prompted by the title, is seen as more poetic and improvisational. With *Play of Squares* Albers was clearly exploring the notion of play within the context of language. The nonsensical and apparently random arrangement of the squares in a linear format relates visually and conceptually to an ambiguous arrangement of words and letters, a play of words, as well as musical notes, a play of sounds, in a game of meaning and ambiguity. Of course Klee had perfected the art of visual punning by skillfully creating figures, shapes, and texts that could metamorphose from one thing to another depending on one's reading of them. He was a master of word play, of creat-

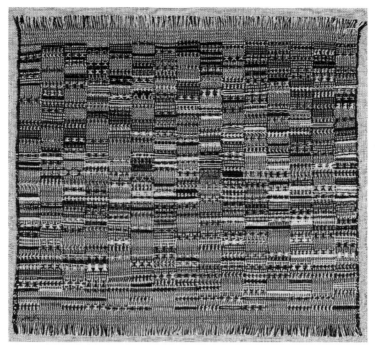

7.14 Anni Albers, *Open Letter*, 1958, 57.5 × 58.8 cm (23 × 23.5 in), Josef and Anni Albers Foundation, Bethany, Connecticut

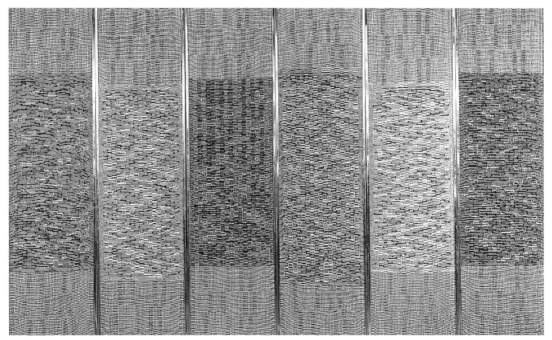

7.16 Anni Albers, *Six Prayers*, 1965–66, cotton, linen, bast, and silver Lurex threads, six panels, 186 × 51 cm (73.06 × 19.69 in) each, Jewish Museum, New York

7.15 Anni Albers, *Play of Squares*, 1955, wool and linen, 87.6 × 62.2 cm (35 × 24.9 in), Currier Gallery of Art, Manchester, New Hampshire

ing shifting signs, and of improvisation. Now Albers achieved a similar mastery of content.

Albers was clearly aware that the strict limitations of the weaving process could easily overwhelm creativity, so she continually advanced the role of improvisation and frequently brought up the subject of play when discussing the creative process. In her 1941 article, 'Handweaving Today', for example, she suggested that designing at the loom should first involve play:

> An elementary approach will be a playful beginning, unresponsive to any demand of usefulness, an enjoyment of colors, forms, surface contrasts and harmonies, a tactile sensuousness. This first and always most important pleasure in the physical qualities of materials needs but the simplest technique and must be sustained through the most complicated one. For just this satisfaction coming from material qualities is part of the satisfaction we get from art.[19]

Through this playful working with materials, Albers believed, the artist can begin to create meaningful form.

Two main efforts dominated Anni Albers's work of the 1960s: large woven murals for public spaces and her book, On Weaving. She produced three woven murals for synagogue ark curtains in Woonsocket, Rhode Island, Silver Spring, Maryland, and Dallas, Texas. These commissions required her to approach text-related issues in yet another way, resulting in powerful ark curtains that both protect and celebrate the Hebrew Scriptures. Nicholas Fox Weber and Kelly Feeney have recently pointed out that Albers's relationship to her Jewish heritage was complex and never fully resolved.[20] Yet Albers produced a significant quantity of Judaica, and these designs and weavings are some of her most powerful work.

Her large Holocaust memorial, Six Prayers (1965–66), for the Jewish Museum, New York (Figure 7.16), is extraordinary. It represents the grand finale of her weaving career, for it is both utilitarian in purpose, in that it could function as an ark curtain, and a powerful artistic statement, 'extraordinarily moving, even wrenching', in its universal emotion, as Nicholas Fox Weber remarked.[21] The woven inscriptions are text-like as overall images – and may also refer to musical scores – as well as ideographic, and they can be seen as collections of signs, as though they were lists of the names of individuals, memorialized in the panels of this work. The supplementary threads also evoke an association with flowing water paths, or tears, making their way downward. As Feeney observed, Six Prayers both elicits prayer and is itself a prayer, like a 'thread-

hieroglyph'.[22] The connection to Andean textiles lies in the way that Albers explored, through the process of weaving and through a use of codified marks, the physical and metaphysical worlds. This was a goal that she sought to achieve throughout her career.

In 1963 she accompanied Josef to the Tamarind Lithography Workshop in Los Angeles, which enabled her to understand the printmaking process that she would soon explore further on her own. After completing her synagogue commissions, and nearing her seventies, she gave away her looms and abandoned weaving entirely, perhaps for health reasons, perhaps due to her newly discovered interest in printmaking, or perhaps because the lessons she had learned from Andean textiles had been so fully and completely absorbed that she no longer felt the need to explore them.

The culmination of her written work was her 1965 book, *On Weaving*, still a standard text in weaving courses today. The dominating theme, as indicated in its dedication, is her devotion to her 'great teachers, the weavers of ancient Peru'.[23] 'There are, of course, many high points in the art of weaving', she wrote in Chapter Nine; 'I will be accused of crass one-sidedness in my feeling of awe for the textile products of Peru, which I advance as the most outstanding examples of textile art.'[24] After nearly half a century of studying these textiles, and translating their lessons in her own art, she had arrived at a point where her focus was clearly centered on them. She articulated her ideas about art and utility, line and shape, objective construction and subjective representation, all of which had already been successfully resolved by the ancient Peruvian weaver. She wrote,

> Works of art, to my mind, are the ancient Peruvian pieces, preserved by an arid climate and excavated after hundreds and even thousands of years. There are those, large or small, of the Tiahuanaco period, for instance – tapestries in the pictorial as well as the technical sense – showing the deities of their Pantheon; or works from other periods, full of the life of their world. There are also the highly intelligent and often intricate inventions of lines or interlocking forms ... Of infinite phantasy within the world of threads, conveying strength or playfulness, mystery or the reality of their surroundings, endlessly varied in presentation and construction, even though bound to a code of basic concepts, these textiles set a standard of achievement that is unsurpassed.[25]

This book, therefore, was her final testament concerning her indebtedness to Andean textiles, and as this quotation indicates, the essays it contains help to put her woven work into a clearer context in relation to her use of Andean textiles as sources.

Albers essentially revived and adapted many of the artistic principles that she

believed were invented by her 'ancient Peruvian colleagues' who created art from threads without the benefit, and burden, of the machine. She saw her role as that of an intermediary between the ancient past and the modern machine age, and therefore her work involved exploring the structures and principles of design that appear in Andean textiles. She thoroughly immersed herself in the art of these textiles as a collector, weaver, artist, teacher, and scholar.

Anni Albers's legacy continues to grow in momentum as her contributions become more fully understood and appreciated. Albers contributed to the modernist discourse in a number of ways. First, she brought textiles to the forefront of design and artistic concerns at a time when educators, theorists, and artists were investigating the role of applied arts in the machine age. She did this by maintaining the value of hand-weaving as a vital step in the production process. By exploring the artistic possibilities of fiber in industry she contributed to the breakdown of distinctions between art and craft, and craft and industry. In addition, she synthesized the formal and the structural concerns of her avant-garde contemporaries within the specific domain of textiles, demonstrating that fiber was a viable material for significant modernist aesthetic statements.

From the early 1920s until well into the 1960s Albers created independent works of art, using weaving techniques and modernist geometry, accomplished in part through her use of ancient Andean textiles as models for technical and formal explorations. She acknowledged the importance of the ancient American products in her woven, written, and pedagogical work; by building on the achievements of her ancient predecessors she created a rich and significant body of work.

Albers's woven and written work have inspired subsequent generations of artists and designers. Her pictorial weavings continue to serve as a standard against which many artists approach their work, and her large wall hangings, because of their three-dimensional qualities, have inspired many weavers to break free of the two-dimensional format into sculptural fiber works. By producing abstract pictorial works by means of weaving she contributed to the breakdown of distinctions between media that was carried through by subsequent artists both inside and outside the crafts world. Her utilitarian and abstract designs for industry have inspired artist-designers not to think of textiles in terms of figurative motifs or surface designs but to work with the appropriate materials and structure to suit the overall utilitarian function of the textile.

In addition, the persistent references in her work and writings to Andean tex-

tile models have served to advance the understanding of these textiles; *On Weaving* has made weavers aware of her indebtedness to her ancient forebears. The thoroughness with which she applied a 'primitive' source to her work and the extent to which this application transformed her work is unique in modern art and design. Her use of Andean textiles for source material was continual and deliberate; they were the ideal models for her modern needs. Through her continual exploration of thread as a carrier of meaning she was able to translate and connect these modern and ancient sources, and by doing so apply what she learned to her own unique vision in thread.

Notes

Introduction

1. Publications on the subject of Anni Albers and Andean textiles by Virginia Gardner Troy include 'Andean Textiles at the Bauhaus: Awareness and Application', *Surface Design Journal*, Vol. 20, No. 2, Winter 1996; 'Anni Albers: the Significance of Ancient American Art for her Woven and Pedagogical Work', Ph.D. dissertation, Emory University, 1997 (reproduced 1997, Ann Arbor, MI: University Micofilms International); 'Anni Albers und die Textilkunst der Anden', in Josef Helfenstein and Henriette Mentha, eds, *Anni und Josef Albers: Europa und Amerika* (exhibition catalogue, Kunstmuseum Bern), Cologne: Dumont, 1998; and 'Thread as Text: The Woven Work of Anni Albers', in Nicholas Fox Weber and Pandora Tabatabai Asbaghi, eds, *Anni Albers* (exhibition catalogue, Solomon R. Guggenheim Museum), New York: Abrams for Guggenheim Museum Publications, 1999.

2. Mary Meigs Atwater in her 1951 edition of the *Shuttle-Craft Book of American Hand-Weaving* (revised edition, New York: Macmillan, 1951 (first published 1928)) did discuss and illustrate some native American, Mexican and Andean weaves based on her interpretation of the Andean weaves in Raoul d'Harcourt's 1934 *Les Textiles anciens du Pérou et leurs techniques*. Albers was well aware of publications dealing with Andean textiles. She owned a copy of d'Harcourt's text, in French, which served as an early encyclopedia of Andean weaves, as well as Philip Ainsworth Means's *A Study of Peruvian Textiles*, Boston: Museum of Fine Arts, 1932.

3. Anni Albers, *On Weaving*, Middletown, CT: Wesleyan University Press, 1965, p. 69.

4. Recent texts dealing with the subject of thread as a social document relevant to ancient American textiles include Jane Schneider, 'The Anthropology of Cloth', *Annual Review of Anthropology*, Vol. 16, 1987, pp. 409–448; Rebecca Stone-Miller, *To Weave for the Sun: Andean Textiles in the Museum of Fine Arts, Boston*, Boston: Museum of Fine Arts, 1992; Elizabeth Hill Boone and Walter Mignolo, eds, *Writing Without Words: Alternative Literacies in Mesoamerica and the Andes*, Durham, NC: Duke University Press, 1994; César Paternosto, *The Stone and the Thread: Andean Roots of Abstract Art*, trans. Esther Allen,

Austin: University of Texas Press, 1996. Mary Jane Jacob, in her essay 'Anni Albers: A Modern Weaver as Artist', in Nicholas Fox Weber, Mary Jane Jacob, and Richard Field, *The Woven and Graphic Art of Anni Albers*, Washington, DC: Smithsonian Institution Press, 1985, was the first to deal with the textual references in Albers's pictorial weavings, and she also briefly mentioned a connection between her open weaves and her contact with Peruvian weaving; see p. 72.

5. Anni Albers, *On Weaving*, pp. 69–70.

6. Recent texts dealing with primitivism in pre-World War I Germany are Donald Gordon, 'German Expressionism', in William Rubin, ed. '*Primitivism' in Twentieth Century Art*, New York: Museum of Modern Art, 1984; Jill Lloyd, *German Expressionism: Primitivism and Modernity*, New Haven: Yale University Press, 1992; Gill Perry, 'Primitivism and the Modern', in *Primitivism, Cubism, Abstraction*, ed. Francis Frascina, Gill Perry and Charles Harrison, New Haven and London: Yale University Press, 1993; and Colin Rhodes, *Primitivism and Modern Art*, London: Thames and Hudson, 1994. For educational theories relevant to Bauhaus pedagogy see J. Abbott Miller, 'Elementary School', in *The ABC's of [Triangle Square Circle]: The Bauhaus and Design Theory*, ed. Ellen Lupton and J. Abbott Miller, New York: Cooper Union, 1991.

7. Wilhelm Worringer, *Abstraction and Empathy*, trans. Michael Bullock, London: Routledge, 1953 (first published as *Abstraktion und Einfühlung*, Munich: Piper-Verlag, 1908), pp. 16–17; Wassily Kandinsky, Franz Marc and August Macke, *Der Blaue Reiter Almanach*, Munich: Piper-Verlag, 1912 (English edition, *The Blaue Reiter Almanac*, London: Thames and Hudson, trans. Henning Falkenstein, introduction by Klaus Lankheit, 1974).

8. Immina von Schuler-Schömig, 'The Central Andean Collections at the Museum für Völkerkunde, Berlin, their Origin and Present Organization', in Anne-Marie Hocquenghem, ed. *Pre-Columbian Collections in European Museums*, Budapest: Akademiai Kiado, 1987, pp. 169–175. Major donations of Andean art to the museum include the Baessler donation of 11 690 items in 1899; the Reiss and Stübel donation of 2000 items in 1879. The museum acquired 2400 items in 1882 from Dr José Mariano Macedo of

Lima, and subsequently the large Centeno Collection, from Cuzco, in 1888, and the Bolivar Collection in 1904. Wilhelm Gretzer sold 27 254 ancient American pieces to the museum in 1907; see Corinna Raddatz, 'Christian Theodor Wilhelm Gretzer and his Pre-Columbian Collection in the Niedersächsisches Landesmuseum of Hannover', in Hocquenghem, *Pre-Columbian Collections*, pp. 163–165.
9. These factors were discussed in two important pre-World War I German publications, W. Reiss and A. Stübel, *Das Totenfeld von Ancon*, Berlin, 1880–87 (English translation by A.H. Keane, *The Necropolis of Ancon in Peru*, London and Berlin: Asher & Co., 1906); and Max Schmidt, 'Über Altperuanische Gewebe mit Szenenhaften Darstellungen', in *Baessler-Archiv Beiträge zur Völkerkunde*, ed. P. Ehrenreich, Vol. 1, Leipzig and Berlin: Teubner-Verlag, 1910 (reprinted by Johnson Reprint Corp., 1968). During the Weimar Bauhaus period, these factors were discussed in Ernst Fuhrmann, *Reich der Inka*, Hagen and Darmstadt: Folkwang Museum, 1922; Wilhelm Hausenstein, *Barbaren und Klassiker: ein Buch von der Bildnerei exotischer Völker*, Munich: Piper Verlag, 1922; Herbert Kühn, *Die Kunst der Primitiven*, Munich: Delphin-Verlag, 1923; Eckart von Sydow, *Die Kunst der Naturvölker und der Vorzeit*, Berlin: Propyläen-Verlag, 1923. These were books that Albers and other members of the Bauhaus were most likely familiar with; see Troy, 'Andean Textiles at the Bauhaus', pp. 37–44 and 65–74.
10. Anni Albers and Nicholas Fox Weber, video interview, 1984, in the Josef and Anni Albers Foundation, Bethany, CT.
11. Anni Albers joined the Bauhaus in early 1922, taking the 'Preliminary Course' with George Muche at that time, and then Itten's course in 1922–23. In 1923, her third semester, she joined the Weaving Workshop. During her fourth semester, 1923–24, she assisted in the dye laboratory, and in her fifth semester, 1924, she most likely completed her first wall hanging. She took Kandinsky's 'Theory of Form' course during the 1925/26 semester; in 1926 and 1927 Klee taught the 'Theory of Form' course to members of the Bauhaus Weaving Workshop, Anni Albers among them. After graduating in 1930 she worked independently and served briefly for the fall of 1931 as Director of the Weaving Workshop. See Magdalena Droste, *Gunta Stölzl*, Berlin: Bauhaus-Archiv, 1987, pp. 143–155.
12. Albers used Schmidt's extensive 1929 book *Kunst und Kultur von Peru* at Black Mountain College according to her former students, Don Page and Lore Kadden Lindenfeld, and colleague Tony Landreau (letters to

the author from Don Page, 4 September 1996; Lore Kadden Lindenfeld, 20 November 1996; Tony Landreau, 25 September 1996). Her personal slide collection, now in the Josef and Anni Albers Foundation, included numerous Andean textile examples.
13. Texts dealing with the Bauhaus Weaving Workshop include Magdalena Droste, ed., *Das Bauhaus Webt*, Berlin: Bauhaus-Archiv, 1998; Anja Baumhoff, 'Gender, Art and Handicraft at the Bauhaus', Ph.D. dissertation, Johns Hopkins University, 1994 (reproduced Ann Arbor, MI: University Micofilms International) Sigrid Wortmann Weltge, *Bauhaus Textiles*, London: Thames and Hudson, 1993; Droste, *Gunta Stölzl*; Petra Maria Jocks, 'Eine Weberin am Bauhaus, Anni Albers, zwischen Kunst und Leben', unpublished Ph.D. dissertation, University of Frankfurt am Main, 1986; Ingrid Radewaldt, 'Bauhaustextilien 1919–1933', unpublished Ph.D. dissertation, University of Hamburg, 1986.
14. A list of their travels is as follows: 1934, Florida, Havana; 1935, Mexico; 1936, Mexico; 1937, Mexico; 1938, Florida; 1939, Mexico; 1940, Mexico; 1941, Mexico; 1946–47, Mexico, New Mexico; 1949, Mexico; 1952, Mexico, Havana; 1953, Chile, Peru; 1956, Mexico, Peru, Chile; 1962, Mexico; 1967, Mexico. This list was compiled from documents at the Josef and Anni Albers Foundation, and in the Black Mountain College Papers, State Archives, Raleigh, NC.
15. Toni Ullstein Fleischmann, 'Souvenir', travel diaries, 1937–39, now in the Josef and Anni Albers Foundation. Anni's mother and father, Toni and Sigfried Fleischmann, met Josef and Anni in Veracruz in 1937 and again in 1939 after fleeing Nazi Germany. The Alberses had three main collections of ancient American art: (1) The Josef and Anni Albers Collection of Pre-Columbian Art, now housed at the Peabody Museum, the Yale University Art Gallery, the Josef and Anni Albers Foundation, and the Josef Albers Museum, Bottrop, Germany (see Karl Taube, *The Albers Collection of Pre-Columbian Art*, New York: Hudson Hill Press, 1988, preface by Nicholas Fox Weber, p. 9, and Anni Albers and Michael Coe, *Pre-Columbian Mexican Miniatures: The Josef and Anni Albers Collection*, New York: Praeger, 1970, p. 4); (2) the Anni Albers Collection of Pre-Columbian Textiles, 113 Andean textiles, now at the Josef and Anni Albers Foundation; and (3) the *Harriett Englehardt Memorial Collection of Textiles*, 92 textiles purchased by Anni Albers for Black Mountain College, now at the Yale University Art Gallery (see Black Mountain College

Papers, State Archives, Raleigh, NC, Vol. II, Box 8; and Troy, 'Andean Textiles at the Bauhaus', pp. 163–169.

Chapter One

1. The term 'non-European', similar to 'non-Western', is used in this study to describe that which was not considered a part of conventional European cultural traditions. While these terms are today considered Eurocentric and Western-centered, they are used here to reflect the distinctions felt by nineteenth- and early-twentieth-century Europeans to exist between their traditions and those of other cultures. The term 'primitive' is also a highly problematic one and has often been used pejoratively to describe that which is perceived as less 'civilized' and/or less developed on the evolutionary ladder than the traditions of those making the designation. It is used here because it describes a category to which Europeans classified most non-European art during the time period discussed in this chapter. 'Primitivism' refers to European attitudes toward non-European cultures and use of their art as source material. The 1984 exhibition '"Primitivism" in Twentieth Century Art: Affinity of the Tribal and the Modern', organized by William Rubin for the Museum of Modern Art, New York, did not include art from the elaborate Mesoamerican and Andean empires. Rubin made a distinction between the 'tribal' art of African and Oceanic societies and the 'archaic' art of ancient American societies. However, I am including a wider range of epochs and cultures in the category of the 'primitive' because that is what the majority of writers discussed here did. The earliest text to deal with the phenomenon of primitivism in modern art is Robert Goldwater's 1938 *Primitivism and Modern Painting*, New York: Random House; the revised edition of his text was published in 1967 and titled *Primitivism in Modern Art*, New York: Vintage, and the enlarged edition, used for this study, was published in 1986, Cambridge, MA: Belknap. A number of recent texts and articles dealing with primitivism were consulted for this study, including the two-volume set edited by William Rubin, *'Primitivism' in Twentieth Century Art: Affinity of the Tribal and the Modern*, New York: Museum of Modern Art, 1984, including essays by Donald Gordon and Jean Laude cited below in this chapter, as well as articles published in response to the exhibition such as Thomas McEviley, 'Doctor Lawyer Indian Chief', *Artforum*, February/May 1985, and James Clifford, 'Histories of the Tribal and Modern', *Art in America*, April 1985. See also Perry, 'Primitivism and the Modern'; Lloyd, *German*

Expressionism; and Rhodes, *Primitivism and Modern Art*.

2. Gillian Naylor, *The Arts and Crafts Movement*, London: Trefoil Publications, 1990 [1971], pp. 98–99. See Marcel Franciscono, *Walter Gropius and the Creation of the Bauhaus in Weimar*, Urbana: University of Illinois Press, 1971, p. 26, for a summary of German primitivist tendencies that grew from the theories and practices of Morris and Ruskin in London during the nineteenth century. See also Walther Scheidig, *Crafts of the Weimar Bauhaus*, New York: Reinhold, 1967.

3. William Morris, 'Textiles', in *Arts and Crafts Essays*, London: Rivington, Percival and Co., 1893, p. 37, cited in Naylor, *The Arts and Crafts Movement*, pp. 104–105.

4. Nikolaus Pevsner, *Pioneers of Modern Design*, London: Penguin, 1991 (first published 1936), p. 49; Gabriele Fahr-Becker, *Art Nouveau*, Cologne: Könemann Verlag, 1997, p. 39.

5. Jon Thompson, *Oriental Carpets*, New York: Dutton, 1988, pp. 35–38.

6. Kathryn Bloom Hiesinger, *Art Nouveau in Munich*, Munich: Prestel-Verlag, 1988, p. 83. Also see Linda Parry, 'The New Textiles', in *Art Nouveau 1890–1914*, London: V&A Publications, 2000, pp. 179–191.

7. August Endell, from an article in the *Berliner Architekturwelt*, 1902, cited in Hiesinger, *Art Nouveau in Munich*, p. 20, n. 61.

8. Hiesinger, *Art Nouveau in Munich*, pp. 53–54.

9. The Deutscher Werkbund, founded in Berlin by Hermann Muthesius in 1907, did not execute textile products until after the War. Josef Hoffman and Koloman Moser founded the Wiener Werkstätte in Vienna in 1903. See Mary Schoeser, *Fabrics and Wallpapers*, New York: Dutton, 1986, p. 34.

10. See Alois Riegl, *Problems of Style, Foundations for a History of Ornament*, trans. Evelyn Kain, introduction by David Castriota, Princeton: Princeton University Press, 1992, pp. 3–13. Also see Margaret Iverson, *Alois Riegl: Art History and Theory*, Cambridge, MA: MIT Press, 1993.

11. Riegl, *Problems*, p. 6. Also see Margaret Olin, *Forms of Representation in Alois Riegl's Theory of Art*, University Park: Pennsylvania State University Press, 1992, pp. 30–31.

12. See Christian Feest, 'Survey of the Pre-Columbian Collections from the Andean Highlands in the Museum für Völkerkunde, Vienna', pp. 71–76; J.C.H. King, 'The North American Archaeology and Ethnography at the Museum of Mankind, London'; and George Bankes, 'The Pre-Columbian Collections at the Manchester Museum', in Hocquenghem, ed., *Pre-Columbian Collections*.

13. Riegl, *Problems*, pp. 46 and 28. To buttress his argument Riegl noted that Semper's theory could not explain the curvilinearity and sculptural representations of Stone Age art, some of the earliest artistic expression known, where line was used apart from any reference to textiles. Riegl suggested instead that such expression was motivated by an *imitative* impulse, which eventually gave way to an abstract and decorative use of line as in, for example, the zigzag, which eventually progressed toward more curvilinear decorative forms. The *geometric* impulse therefore, according to Riegl, exemplifies the earliest stage of *ornamental* design after the 'response to the imitative impulse [exemplified by the] semi-cannibal cave dwellers' had been overcome.

14. Hermann Bahr, *Expressionismus*, Munich, 1916, p. 70 (translation mine). Portions of the text appear in Francis Frascina and Charles Harrison, eds, *Modern Art and Modernism*, New York: Harper and Row, 1982.

15. Bahr, quoted in Frascina and Harrison, eds, *Modern Art and Modernism*, p. 169.

16. Worringer, *Abstraction and Empathy*, pp. 136–137.

17. Riegl, *Problems*, pp. 137, 273.

18. Worringer believed that cave painting was not the result of a true art impulse; see *Abstraction and Empathy*, pp. 17, 42.

19. Ibid., p. 16. For information regarding Worringer's impact on the Brücke and Blaue Reiter groups see Peter Selz, *German Expressionist Painting*, Berkeley: University of California Press, 1974 (first published 1957), p. 184; Magdalena Bushart, 'Changing Times, Changing Styles: Wilhelm Worringer and the Art of His Epoch', in Neil Donahue, ed., *Invisible Cathedrals: the Expressionist Art History of Wilhelm Worringer*, University Park: Pennsylvania State University Press, 1995, p. 80.

20. Worringer, *Abstraction and Empathy*, p. 17. Worringer was not specific about who or what constituted the 'primitive', except that it occupied a place outside of the Western tradition from the Renaissance on. He used the term 'primitive' in a general way rather than attributing it to a limited range of cultures, and connected the category of the 'primitive' to the condition of precognition. His references to ancient American art were few and cryptic. He spoke of 'the glittering veil of the Maya' as that which conceals the objective world from the 'primitive' mind, suggesting that he considered Maya art, and presumably all ancient American art, within the category of the 'primitive', pp. 16, 18, 129.

21. Eckart von Sydow, *Die Deutsche Expressionistische Kultur und Malerei*, Berlin: Furche-Verlag, 1920, p.18.

22. Paul Klee, diary entry 951, 1915, translated by O.K. Werckmeister in *The Making of Paul Klee's Career, 1914–1920*, Chicago: University of Chicago Press, 1989, pp. 41, 45.

23. Franciscono, *Walter Gropius*, pp. 183–190; Magdalena Droste, *Bauhaus, 1919–1933*, Berlin: Bauhaus-Archiv, 1990, p. 13.

24. Selz, *German Expressionist Painting*, p. 288; Stuart MacDonald, *The History and Philosophy of Art Education*, London: University of London Press, 1970, p. 330.

25. MacDonald, *History and Philosophy*, p. 330.

26. As Jean Laude noted in his essay 'Paul Klee', in Rubin, 'Primitivism', pp. 487–488, Klee owned a copy of Levinstein's text.

27. MacDonald, *History and Philosophy*, p. 329.

28. Theodor Koch-Grünberg, *Anfänge der Kunst im Urwald*, Berlin: Wasmuth, 1905, pp. vii, x, p. 34.

29. MacDonald, *History and Philosophy*, pp. 335–340.

30. J. Abbott Miller, 'Elementary School', pp. 4–21; see also Anita Cross, 'The Educational Background to the Bauhaus', in *Design Studies*, Vol. 4, No. 1, January 1983; Frederick Logan, 'Kindergarten and Bauhaus', *College Art Journal*, pp. 37–39.

31. Franciscono, *Walter Gropius*, p. 180.

32. Miller, 'Elementary School', pp. 16–18. Itten was a student of art educator Franz Cizek and his colleague in Stuttgart, Adolf Hölzel.

33. Franciscono, *Walter Gropius*, pp. 180–182.

34. Peg Weiss, *Kandinsky in Munich, the Formative Jugendstil Years*, Princeton: Princeton University Press, 1979, p. 23.

35. Ibid., pp. 28–30.

36. Ibid., pp. 28–30, 121–122; see Baumhoff, 'Gender, Art and Handicraft', for a fuller investigation into Bauhaus co-educational policy.

37. Cross, 'Educational Background', p. 49.

38. See Lloyd, *German Expressionism*, pp. 8–9, 61, 92; also see Carmen Stonge, 'Karl Ernst Osthaus: The Folkwang Museum and the Dissemination of International Modernism', Ph.D. dissertation, City University of New York, 1993, and Herta Hesse-Frielinghaus, *Karl Ernst Osthaus*, Recklinghausen: Bongers, 1971, for discussions regarding exhibitions at the Folkwang Museum. Osthaus attended Riegl's lectures in Vienna in the mid-1890s, shortly after the publication of the latter's *Stilfragen*. See Stonge, 'Karl Ernst Osthaus', p. 69, for a discussion of Osthaus's anti-Semitism. Unfortunately, some racial investigations and primitivist theories were appropriated by supporters of cultural nationalism and in some cases even motivated by it.

39. Hesse-Frielinghaus, *Karl Ernst Osthaus*, p. 511;

Lloyd, *German Expressionism*, p. 8. Gropius worked in Behrens's office from 1908 to 1910.

40. Jill Lloyd, 'Emil Nolde's "Ethnographic" Still Lifes: Primitivism, Tradition, and Modernity', in Susan Hiller, ed., *The Myth of Primitivism*, London: Routledge, 1991, pp. 96–102.

41. Franciscono, *Walter Gropius*, pp. 262–274.

42. Stonge, 'Karl Ernst Osthaus', p. 57.

43. Kandinsky, Marc, and Macke, eds, *Blaue Reiter Almanach*, pp. 27–28. Osthaus was later removed from the patron list. Osthaus's 1918 dissertation, *Grundzüge der Stilentwicklung* (Characteristics of the Development of Style), testifies to his continued interest in the supposed universal characteristics of art and the use of historical art works as teaching models. The text is essentially a brief history of art from the point of view that, as Osthaus stated, 'We believe in the unity of all earlier art' (translation mine). By 1918, this was not a new observation, as Osthaus himself admitted, but it is further evidence of the ongoing attempts by members of German art circles to make links between the art of diverse cultures; see Karl Ernst Osthaus, *Grundzüge der Stilentwicklung*, Hagen: Folkwang Verlag, 1919 (dissertation, 1918, from Julius-Maximilians-Universität, Würzburg), pp. 5–7.

44. Irving Leonard Finkelstein, 'The Life and Art of Josef Albers', Ph.D. dissertation, New York City University, 1968 (reproduced Ann Arbor, MI: University Micofilms International), pp. 8, 25.

45. Hesse-Frielinghaus, *Karl Ernst Osthaus*, pp. 511–516; Lloyd, *German Expressionism*, p. 10. For example, the 'International Textiles' exhibition, held in July 1909, included Javanese batiks, weavings from the Far East, rugs, and calico fabric, as well as eighteenth-century silks and batiks from Persia, Asia Minor, and Turkey. In February 1910, there was an exhibition of Spanish textiles, and in September 1911 an exhibition of modern textiles and wickerwork. A 1914 non-European art exhibition included Japanese, Egyptian, and other new 'exotic' acquisitions, as the catalogue states without explanation, including objects that Osthaus had recently purchased from the Frobenius Expedition to West Africa, which may have included textiles.

46. Lloyd, *German Expressionism*, pp. 23, 34, 44, in Chapter Three, 'The Brücke Studios: a Testing Ground for Primitivism'.

47. Ibid., pp. 59, 60.

48. Lloyd, *German Expressionism*, p. 171.

49. Selz, *German Expressionist Painting*, p. 88; Stonge, 'Karl Ernst Osthaus', p. 205; Lloyd, *German Expressionism*, pp. 8–12.

50. Emil Nolde, 1912, from *Jahre der Kämpfe 1902–1914* (second volume of an autobiography), Berlin: Rembrandt, 1934, pp. 102–108, 172–175, cited in Herschel B. Chipp, *Theories of Modern Art*, Berkeley: University of California Press, 1968, pp. 150–151.

51. Manfred Schneckenburger, in 'Bermerkungen zur "Brücke" und zur "primitiven" Kunst', in Dr Siegfried Wichmann, ed., *Welt Kulturen und Moderne Kunst*, Munich: Verlag Bruckmann, 1972, p. 470, suggested that Nolde's feline model was a feather tunic now at the Linden-Museum, Stuttgart.

52. See Walter Lehmann, *Kunstgeschichte des Alten Peru*, Berlin: Wasmuth, 1924 (English edition, *The Art of Old Peru*, London and New York, 1924), for a reproduction of the feather cloak and Wari tunic. The Kachina figure probably came from the Berlin Museum für Völkerkunde collection; see Schneckenburger, 'Bermeskungen', p. 470.

53. Goldwater, *Primitivism*, Chapter Four, 'Emotional Primitivism: The Brücke', pp. 104–125; Gordon in Rubin, 'Primitivism', p. 381.

54. Wassily Kandinsky, *Über das Geistige in der Kunst*, Munich: Piper, 1912, trans. as *Concerning the Spiritual in Art*, New York: Wittenborn, Schultz, Inc., 1947, pp. 23–24.

55. See Weiss, *Kandinsky in Munich*, for her argument against Worringer's influence on Kandinsky, pp. 158–159, n. 25, in which she states that Kandinsky developed his ideas on abstraction before, and counter to, those of Worringer.

56. Kandinsky, *Concerning the Spiritual*, p. 25. Also see Beeke Sell Tower, *Klee and Kandinsky in Munich and at the Bauhaus*, Ann Arbor, MI: UMI Research Press, 1981, p. 172.

57. See Weiss, *Kandinsky in Munich*, pp. 109, 124–125, for a brief discussion of Kandinsky's textiles, in which she does not make this connection.

58. A second Blaue Reiter exhibition, consisting of 300 items, was held in 1912 at the Hans Goltz Gallery, Munich; see Selz, *German Expressionist Painting*, Chapters 16 and 17.

59. Peg Weiss, *Kandinsky and Old Russia, the Artist as Ethnographer and Shaman*, New Haven: Yale University Press, 1995, pp. 94, 106. Weiss, like Laude before her, noted that Klee might have facilitated Blaue Reiter access to the museum in Bern; see Laude, 'Paul Klee', p. 499. Of the 142 plates, plus eight vignettes and the cover, approximately 35% were examples of European modernist works; 30% were examples of European Gothic and folk art and crafts; 25% were

non-European examples; and 10% were drawings by children and 'amateurs'.

60. Wassily Kandinsky, 'On the Question of Form', in Kandinsky, Marc, and Macke, eds, *The Blaue Reiter Almanac*, p. 173.

61. Donald Gordon, 'German Expressionism', in Rubin, 'Primitivism', p. 373.

62. Gordon Willey and Jeremy Sabloff, *A History of American Archaeology*, New York: Freeman, 1993 (first published 1974), p. 79.

63. In Kandinsky, Marc, and Macke, eds, *Almanac*, p. 88.

64. Laude, 'Paul Klee', pp. 488, 499.

65. Cited in Goldwater, *Primitivism*, p. 199, from the Museum of Modern Art, *Paul Klee*, New York: Museum of Modern Art, 1945, p. 8.

66. Tower, *Klee and Kandinsky*, p. 295, n. 17.

67. Goldwater, *Primitivism*, Chapter Six, 'The Primitivism of the Subconscious', pp. 192–204.

68. James S. Pierce, *Paul Klee and Primitive Art*, New York: Garland, 1976, pp. 4–5.

69. Ibid., pp. 130–131, Klee to Geist, 1930.

70. Paul Klee, *Die Alpin*, January 1912, trans. in Franciscono, *Walter Gropius*, p. 167.

71. Cited in Goldwater, *Primitivism*, p. 201, from a 1909 diary entry in Felix Klee, ed., *The Diaries of Paul Klee 1898–1918*, Berkeley: University of California Press, 1964, p. 237.

72. See Laude, 'Paul Klee', pp. 492–493, for a discussion of Klee's primitivist interest in surface and sign in relation to Bedouin rugs that Klee would have seen in Munich in 1910 and during his 1914 trip to Tunisia with Macke.

73. Pierce, *Paul Klee and Primitive Art*, pp. 60–61. Klee's personal library includes a 1922 edition of Hausenstein's *Barbaren und Klassiker*. Information on Klee's library is courtesy of the Paul Klee Foundation and the Estate of Paul Klee, Bern.

74. The author wishes to thank Mrs H. Hofsteter at the Bernisches Historisches Museum for her help with this project. Klee's interest in non-European and Andean textiles has never been fully documented, but has been noted by numerous writers. For example, in the 1940s, the Surrealist André Masson wrote about the affinity between Klee's work and 'ancient Peruvian fabrics'; see André Masson, 'Homage to Paul Klee', *Partisan Review*, Vol. 14, No. 1, Jan.–Feb. 1947, translation of 'Elegie de Paul Klee', *Fontaine* (Paris), Vol. 10, No. 53, June 1946, reprinted by the Valentin Gallery in 1950, a copy of which the Alberses owned. James Pierce, echoing Will Grohmann's observation from his 1954 monograph on Klee,

linked Klee's work with the muted rich colors and geometric step forms of Peruvian textiles; see Pierce, *Paul Klee and Primitive Art*, pp. 40–50. Klee's work has been discussed by Robert Goldwater and Jean Laud in relation to Oceanic tapa cloth and Islamic carpets because of the similarity of all-over linear surface patterning, while William Rubin linked Klee's late 'pictographic' paintings to painted bark cloth from the Congo for the similarity of bold reductive signs; see Goldwater, *Primitivism*, p. 193; Laud, 'Paul Klee', p. 493, and Rubin, 'Primitivism', p. 59. Marcel Franciscono recently connected Klee's use of contour rivalry, where the outline of one form is shared by another, with Andean textiles from the Chavin period, although these textiles would not have been known by Klee at the time; see Marcel Franciscono, *Paul Klee: His Work and Thoughts*, Chicago: University of Chicago Press, 1991, p. 362.

Chapter Two

1. See Rebecca Stone-Miller, *Art of the Andes*, London: Thames and Hudson, 1995, pp. 216–218, for a summary of the Conquest period.

2. Jean-Louis Paudrat, 'From Africa', in Rubin, 'Primitivism', pp. 125–136.

3. Immina von Schuler-Schömig, 'The Central Andean Collections at the Museum für Völkerkunde, Berlin, their Origin and Present Organization', in Hocquenghem, *Pre-Columbian Collections*, pp. 169–175.

4. Willey and Sabloff, *History*, pp. 75–77.

5. Reiss and Stübel donated 2000 Andean items to the museum in Berlin in 1879. The museum then acquired 2400 items in 1882 from Dr José Mariano Macedo of Lima, and subsequently the large Centeno Collection, from Cuzco, in 1888, and the Bolivar Collection in 1904. See Corinna Raddatz, 'Christian Theodor Wilhelm Gretzer and his Pre-Columbian Collection in the Niedersächsisches Landesmuseum of Hannover', in Hocquenghem, *Pre-Columbian Collections*, pp. 163–165.

6. Ibid., p. 163.

7. Schuler-Schömig, in Hocquenghem, *Pre-Columbian Collections*, p. 172.

8. Raddatz, in Hocquenghem, *Pre-Columbian Collections*, p. 165.

9. Schmidt, 'Über Altperuanische Gewebe', pp. 17–19.

10. Ibid., p. 52.

11. Berlin Museum für Völkerkunde, Staatliche Museen zu Berlin, collection catalogue, Vol. 15, 1911, *Führer durch das Museum für Völkerkunde*, Berlin: Verlag Georg Reimer, pp. 178–179. I am grateful to

Dr Manuela Fischer and Renate Strelow of the Berlin Museum für Völkerkunde for providing information about the museum's collections and for supplying copies of subsequent catalogues including Vol. 16, 1914: *Die Ethnologischen Abteilungen*, Verlag Georg Reimer, Berlin; Vol. 18, 1926: *Vorläufiger Führer*; and Vol. 19, 1929: *Vorläufiger Führer*, the latter two both Verlag Walter de Gruyter & Co., Berlin.

12. Herwarth Walden, *Der Sturm, Hundertachtundzwanzigste Ausstellung: Moholy-Nagy, Hugo Scheiber, Gewebe aus Alt-Peru*, exhibition catalogue, Berlin: Gallery Der Sturm, February 1924. I am grateful to Dr Magdalena Droste for pointing out this source. In her 1963 book, *Herwarth Walden*, Nell Walden wrote that her collection was at one time on loan to the ethnography museum in Geneva before Professor Zeller of the Bernisches Historisches Museum bought some of the pieces. However, I found no Walden provenance among the Andean textiles at the Bern museum. I am grateful to Elisabeth Lundin of the Landskrona Museum for her help.

13. Flechtheim Gallery catalogue, 1927, Bauhaus-Archiv, Berlin; *Der Querschnitt*, 1927, Vol. 7, No. 9; *Der Sturm*, 1927/28, p. 39.

14. Georg Brühl, *Herwarth Walden und 'Der Sturm'*, Cologne: DuMont Buchverlag, 1983, p. 53.

15. I would like to thank Dr Clark Poling for pointing out Gustav Hartlaub's contribution at the museum, and Dr Inge Herold of the Städtische Kunsthalle Mannheim for providing archival information about this exhibition.

16. Karoline Hille, *Spuren der Moderne, Die Mannheimer Kunsthalle von 1919–1933*, Berlin: Akademie Verlag, 1994, p. 345, n. 46 (translation mine).

17. See Walden, *Der Sturm, Hundertachtundzwanzigste Ausstellung*.

18. Hans Wingler, *The Bauhaus*, Cambridge, MA: MIT Press, 1986 (first published 1969), p. 34.

19. See Pierce, *Paul Klee and Primitive Art*, pp. 60–61, for a discussion of Klee's knowledge of and access to these books.

20. The series also included Carl Einstein's *Die Kunst des 20 Jahrhunderts*, of 1926. Albers's copy of Schmidt's 1929 work is at the Josef and Anni Albers Foundation. In a 1938 or 1939 photograph at the North Carolina State Archives, in Raleigh, a copy of it was prominently placed on the table of Black Mountain College student Don Page's studio. According to Page, he and Albers both owned copies of the book (personal communication, September 1996). In addition, Albers cited Schmidt's 1929 text in her 1952 article, 'A Structural Process in Weaving',

reprinted in *On Designing*, Middletown, CT: Wesleyan Press, 1961 (reprinted 1987), p. 80.

21. According to Nicholas Fox Weber, Director of the Josef and Anni Albers Foundation, Albers tried to play down her upper-middle-class upbringing (personal communication, 6 May 1995).

22. Anni Albers read Kühn's work, for she referred to him in her discussion of ancient cave art in her 1961 article, 'Conversations with Artists', in *On Designing*, p. 62.

23. Most of the plates were originally published in Reiss and Stübel's *The Necropolis of Ancon*. The six textile plates in Fuhrmann and von Sydow are identical; see Fuhrmann, *Reich der Inka*, and von Sydow, *Die Kunst der Naturvölker*.

24. Von Sydow, *Die Kunst der Naturvölker*, pp. 57, 62 (translation mine).

25. Hausenstein, *Barbaren und Klassiker*, p. 67.

26. César Paternosto discusses the parallels between Communism and the Andean state mainly with regard to the large building projects that both constructed, and the mutual integration of high art and applied art; see Paternosto, *The Stone and the Thread*, Chapter Ten, 'Constructive Histories', pp. 199–205.

27. Kühn, *Die Kunst der Primitiven*, p. 163 (translation mine).

28. Anni Albers (then Annelise Fleischmann), 'Bauhausweberei', in *Junge Menschen*, 'Bauhaus Weimar Sonderheft der Zeitschrift, Weimar', November 1924, Vol. 5, No. 8, Hamburg; Munich: Kraus Reprint, 1980, p. 188 (translation mine).

29. Fuhrmann, *Reich der Inka*, p. 9 (translation mine).

30. Ibid., p. 11.

31. Reiss and Stübel, *The Necropolis of Ancon*, Plate 69, Fig. 2.

32. Von Sydow, *Die Kunst der Naturvölker*, p. 533.

33. Kühn, *Die Kunst der Primitiven*, p. 163.

34. Reiss and Stübel, *The Necropolis of Ancon*, Plate 49.

35. Junius B. Bird and Milica Skinner, 'The Technical Features of a Middle Horizon Tapestry Shirt from Peru', in *Textile Museum Journal*, December 1974, p. 9. The sideways technique was used primarily for Wari and Tiwanaku tunics.

36. See Stone-Miller, *To Weave for the Sun*, p. 38, for a description of this technique.

37. At the Josef and Anni Albers Foundation, her personal slide collection includes numerous reproductions from the German edition of Lehmann's book. In addition, she owned a 1934 French edition of d'Harcourt's book, *Les Textiles anciens du Pérou et leurs techniques*; the English edition, *The Textiles of Ancient Peru and their Techniques*, was also published that year (Seattle:

University of Washington Press, 1962). Josef Albers also used slides taken from Lehmann's book; these may have illustrated his 'Truthfulness in Art' lecture.
38. Lehmann, *The Art of Old Peru*, p. 64.
39. Ibid., pp. 12–13.
40. Ibid., p. 27.
41. Ibid.; this aspect was also discussed by Hausenstein, Fuhrmann, and von Sydow.
42. Ibid., pp. 14, 15. Kühn and Hausenstein also admired the notion of a collective Andean vision.
43. Raoul and Marguerite d'Harcourt, *Les Tissus indiens du vieux Pérou*, Paris: A. Morancé [c. 1924], p. 12 (translation mine).
44. Ibid., p. 14. Not surprisingly, the d'Harcourts' bibliography included Reiss and Stübel's 1880–87 publication, Schmidt's 1910 publication, and Lehmann's 1924 publication.

Chapter Three
1. See Chapter One for Bahr's statement and note 15 there for its source.
2. Cited in Franciscono, *Walter Gropius*, pp. 111–112.
3. Recent texts dealing with the Bauhaus Weaving Workshop include Droste, *Das Bauhaus Webt*; Baumhoff, 'Gender, Art and Handicraft'; Droste, *Gunta Stölzl*; Petra Maria Jocks, 'Eine Weberin am Bauhaus, Anni Albers, Zwischen Kunst und Leben', unpublished Ph.D. dissertation, University of Frankfurt am Main, 1986; Ingrid Radewaldt, 'Bauhaustextilien 1919–1933', unpublished Ph.D. dissertation, University of Hamburg, 1986; and Weltge, *Bauhaus Textiles*.
4. Anni Albers, 'Weaving at the Bauhaus', in Herbert Bayer, Walter Gropius, and Ise Gropius, eds, *Bauhaus, 1919–1928*, New York: Museum of Modern Art, 1938; 1959 edition, Boston: C.T. Branford, p. 141.
5. The definitive texts on the subject of the Weimar Bauhaus continue to be those by Franciscono, *Walter Gropius*, and Scheidig, *Crafts of the Weimar Bauhaus*. Both here addressed the issue of primitivism at the Weimar Bauhaus but not specifically in relation to the Weaving Workshop. Hans Wingler, in his pivotal book, *The Bauhaus*, did mention that for some Weimar Bauhaus textile designs, 'motifs of folklore were taken up and modified according to the techniques and materials of weaving', p. 335. Also see Clark Poling, *Kandinsky: Russian and Bauhaus Years 1915–1933*, New York: Solomon Guggenheim Foundation, 1983, p. 36, for a discussion of this issue in relation to Kandinsky.
6. Anni Albers and Sevim Fesci, interview for the Archives of American Art, 5 July 1968, transcript at the Josef and Anni Albers Foundation, p. 6.

7. Jocks, 'Ein Weberin am Bauhaus', p. 4; Nicholas Fox Weber, 'Anni Albers to Date', in Weber, Jacob, and Field, *Woven and Graphic Art*, p. 18.
8. For example, see plate 54 in Reiss and Stübel, *The Necropolis of Ancon*. This subject was discussed further in a 1906 article by Charles Mead, 'The Six-Unit Design in Ancient Peruvian Cloth', in *Anthropological Papers: Boas Anniversary Volume*, New York: Stechert and Co., 1906, pp. 193–195, and again by Franz Boas in his *Primitive Art*, Oslo, London, Paris, Leipzig, and Cambridge, MA: Harvard University Press, 1927, pp. 46–52.
9. See Droste, *Bauhaus*, p. 72, and Baumhoff, 'Gender, Art and Handicraft', Chapter Three, for summaries of the work of the Weaving Workshop.
10. In 1925 Börner wove copies of four weavings for the Kunstsammlungen zu Weimar (Weimar Art Museum) and the Bauhaus collection; see Droste, *Gunta Stölzl*, p. 121, for a reference to this, and p. 125 for an example. Börner stayed in Weimar when the Bauhaus moved to Dessau in 1925; see Wingler, *The Bauhaus*, p. 335. See Baumhoff, 'Gender, Art and Handicraft', p. 158, for a discussion of Börner's economic contributions and sacrifices.
11. Anni Albers and Sevim Fesci, interview, the Archives of American Art 1968, p. 1 (transcript in the Josef and Anni Albers Foundation).
12. Wingler, *The Bauhaus*, p. 335; Droste, *Bauhaus*, p. 72.
13. Baumhoff argues that women at the Bauhaus were not considered equal to men there, and that women were, as a general policy, channeled to the Weaving Workshop in order to leave the other workshops open to men; see 'Gender, Art and Handicraft', p. 144.
14. Droste, *Gunta Stölzl*, p. 118; Baumhoff, 'Gender, Art and Handicraft', p. 160. My thanks to Sigrid Weltge for her help with this translation.
15. For example, Anni Albers, Gertrud Arndt, Marli Ehrman, Hilde Reindl, and Gunta Stölzl had previous applied arts training. Otte Berger, Friedl Dicker, Dörte Helm, Margarete Willers, and also Anni Albers, had previous art training. Benita Koch-Otte, Ida Kerkovius, Else Mögelin, and Helene Schmidt-Nonné were trained art teachers. See biographical material by Jeanine Fiedler in Droste, *Gunta Stölzl*, pp. 143–167; also Weltge, *Bauhaus Textiles*, pp. 201–206.
16. Anni Albers, 'Weaving at the Bauhaus', p. 141.
17. Anni Albers, *On Weaving*, p. 69.
18. Droste, *Gunta Stölzl*, p. 155. In 1908, Kerkovius studied with Adolf Mayer in Berlin. Weltge, in *Bauhaus Textiles*, p. 47, notes that Itten kept his sketchbooks from Kerkovius's lessons.
19. Willy Rotzler and Anneliese Itten, *Johannes Itten*,

Werk und Schriften, Zurich: Orell Fussli Verlag, 1972, p. 218. This lecture was presented in Vienna.

20. Johannes Itten, *The Art of Color*, New York: Van Nostrand Reinhold, 1973 (first published 1961), p. 17.

21. Lehmann, *The Art of Old Peru*, p. 64 and plate 126; Lehmann described the discontinuous warp and weft as a textile with 'special warp and special weft'.

22. Translation compiled by Baumhoff, 'Gender, Art and Handicraft', p. 142, from a document by Gunta Stölzl, 'Über das Bauhaus', manuscript written for the radio station Deutschlandfunk, 5 February 1969, pp. 104–105, in the Bauhaus-Archiv; and Droste, *Bauhaus*, p. 72.

23. Anni Albers and Neil Welliver, interview, 'A Conversation with Anni Albers', in *Craft Horizons*, July/August 1965, pp. 21–22. Anni Albers was 23 years old when she was accepted by the Bauhaus, after an unsuccessful first attempt. From 1916 to 1919 she studied art under Martin Brandenburg in Berlin after an unsuccessful attempt to study painting with Oskar Kokoschka; from 1919 to 1920, she studied at the Hamburg School of Applied Arts. See Weber, 'Anni Albers to Date', p. 132.

24. Anni Albers, 'Weaving at the Bauhaus', p. 141. Her first semester at the Bauhaus was spent in George Muche's 'Preliminary Course'; she joined the Weaving Workshop in 1923.

25. Letter at the Josef and Anni Albers Foundation, 22 December 1964 (translation mine). I believe Stölzl may have also been responding to a 1964 exhibition of three American weavers, Sheila Hicks, Lenore Tawney, and Claire Zeisler, at the Kunstgewerbe-museum, Zurich. In the accompanying catalogue, Erika Billeter, perhaps for the first time directly, made the connection between ancient Peruvian textiles and the products of the Bauhaus Weaving Workshop, both of which influenced the three weavers. Stölzl, then living in Switzerland, would have been well aware of this show.

26. Droste, *Bauhaus*, p. 32. It is worth pointing out that Karl Osthaus had similar racist notions.

27. Reiss and Stübel, *The Necropolis of Ancon*, plates 102–104. Also, plate 103, no. 76, illustrates another of the many motifs Bittkow-Köhler may have borrowed for the lower-register figures.

28. Lehmann, *The Art of Old Peru*, p. 27. Willers, who studied art in Munich and Paris before entering the Weaving Workshop in 1921, may have seen the many excellent examples of Andean textiles in those cities, as well as the pieces in Berlin that Schmidt illustrated. See Droste, *Gunta Stölzl*, p. 165. The slit technique

is not exclusively Andean; it is commonly used for Middle Eastern carpets, which members of the Bauhaus were most likely familiar with. However, in this case, Andean models were clearly the superior models due to evidence of their accessibility and also to their abstract, non-representational motifs. See 'Paul Klee und die Kelims der Nomaden' by Hamid Sadighi Neiriz in Droste, ed., *Das Bauhaus Webt*, pp. 120–121 for further discussion of the Islamic carpet in relation to the Bauhaus.

29. Wingler, *The Bauhaus*, p. 338. This was Kerkovius's apprentice work.

30. Van Doesburg was in Weimar from December 1920 to January 1921, and again from April 1921 to spring 1923.

31. Cited in Richard Hertz and Norman Klein, *Twentieth Century Art Theory*, Englewood Cliffs, NJ: Prentice Hall, 1990, p. 66, from Moholy-Nagy's *Malerei, Photographie, Film* (Painting, Photography, Film), Volume Eight of the Bauhaus Book series, published in 1925.

32. Cited in John Willet, *Art and Politics in the Weimar Period*, New York: Pantheon, 1978, p. 77.

33. Ibid., p. 78. See also Christina Lodder, *Russian Constructivism*, New Haven: Yale University Press, 1990 (first published 1983), Chapter Eight, 'Postscript to Russian Constructivism: The Western Dimension', pp. 224–238.

34. Lodder, *Russian Constructivism*, pp. 3–7.

35. Ibid., pp. 62, 117, 148. See also Charlotte Douglas, 'Russian Textile Design 1928–33', in *The Great Utopia: The Russian and Soviet Avant-Garde 1915–1932*, New York: Guggenheim Museum, 1992.

36. Willem van Leusden designed a De Stijl loom in 1925, now at the Central Museum in Utrecht. Also at the museum are two rugs based on designs by van Doesburg and Bart van der Leck. I am unaware of any woven textile examples made by members of De Stijl.

37. Anni Albers, 'Economic Living', as translated in Frank Whitford, *Bauhaus*, London: Thames and Hudson, 1984, pp. 209–210.

38. Rebecca Stone-Miller, personal communication, March 1997.

39. This piece was given to Itten as a farewell present; Wingler, *The Bauhaus*, p. 335. It was also in 1921 that Peiffer-Watenphul signed on with the German art dealer Alfred Flechtheim. Flechtheim, who dealt in modern and 'primitive' art, also published the multi-cultural journal *Der Querschnitt* (The Cross-Section), in which Andean textiles from Nell Walden's collection were reproduced. Peiffer-

Watenphul went to Mexico in 1924, and went on to teach at the Folkwang School in Essen from 1927 to 1931. See Droste, *Gunta Stölzl*, p. 163.

40. I am grateful to Professor Rebecca Stone-Miller for pointing this out to me.

41. Reiss and Stübel, *The Necropolis of Ancon*, plate 39.

42. This article also contained her famous line, 'Weaving is primarily a woman's field of work.' See Wingler, *The Bauhaus*, p. 116, 'Weberei am Bauhaus' from the journal *Offset, Buch- und Werbekunst*, Leipzig, 1926, No. 7 (Bauhaus issue), pp. 405–406.

43. Cited in Droste, *Gunta Stölzl*, p. 41, from a 1968 statement by Stölzl.

44. Mary Frame, 'The Visual Images of Fabric Structures in Ancient Peruvian Art', in Ann P. Rowe, ed., *The Junius B. Bird Conference on Andean Textiles*, April 7th and 8th, 1984, 1984, Washington, DC: Textile Museum, pp. 47–80.

45. Quoted in Droste, *Gunta Stölzl*, p. 112, from a 1968 Stölzl document.

46. Clark Poling discusses this approach throughout his book *Bauhaus Color*, Atlanta: High Museum of Art, 1976.

47. See Stone-Miller, *Art of the Andes*, pp. 146–148, for a discussion of this piece and other Wari tunics.

48. Ibid., p. 147.

49. Droste, *Gunta Stölzl*, p. 50, from a 1958 statement by Stölzl.

50. See Stone-Miller, *To Weave for the Sun*, p. 263, for a summary of this technique.

51. Ibid., pp. 18–22. Stone-Miller discusses many labor-intensive Andean weaving techniques in the context of 'technical transcendence', in that technical limits were routinely pushed way beyond what was functionally and economically sufficient in order to infuse the product with material, labor, and artistic intensity.

52. Lehmann, *The Art of Old Peru*, p. 64. Anni Albers had this image made into a slide for her personal slide collection, now at the Josef and Anni Albers Foundation.

53. Droste, *Gunta Stölzl*, p. 50; Wingler, *The Bauhaus*, p. 336.

54. 'Camelid' refers to the wool of the South American cousins of the camel: the llama, alpaca, guanaco, and vicuña.

Chapter Four

1. Droste, *Gunta Stölzl*, p. 143.

2. The Josef and Anni Albers Foundation, which owns the piece, provided me with this information (25 May 1995).

3. Chemical analysis has not been conducted on this piece.

4. Dr Magdalena Droste, in a letter to the author (30 December 1996), remarked that it is very unlikely that Anni Albers colored her warps as Stölzl did.

5. See John Rowe, 'Standardization in Inca Tapestry Tunics', in Ann P. Rowe, ed., *The Junius B. Bird Conference on Andean Textiles*. The average size of an Inca tunic ranged from lengths between 70 and 84 inches and widths between 29 and 30 inches. Tunics from other Andean periods had different, and not as standardized, dimensions.

6. Mary Frame also made this observation in 'The Visual Images of Fabric Structures in Ancient Peruvian Art', in Ann P. Rowe, ed., *The Junius B. Bird Conference on Andean Textiles*, p. 55.

7. Weltge, *Bauhaus Textiles*, p. 90.

8. Stone-Miller, *To Weave for the Sun*, p. 265.

9. Ibid., p. 71.

10. Anni Albers, *On Weaving*, p. 50. She also wrote about Andean multi-weaves in 'A Structural Process in Weaving', of 1952, in *On Designing*, pp. 69–70.

11. Poling, *Bauhaus Color*, p. 32. As Dr Poling mentioned in a personal communication to me, the 'theory' wasn't articulated until Josef's American period, so far as scholars know from publications.

12. See ibid., p. 34, for a discussion of the thermometer stripe. Also see Finkelstein, 'The Life and Art of Josef Albers', for a similar suggestion as to the importance of weaving for Josef Albers's Bauhaus work. Finkelstein noted that weaving was particularly relevant to Josef Albers's Bauhaus interests regarding the interplay of figure/ground relationships and the illusion of volumetric movement; see pp. 68–71.

13. The 13 color pairs are as follows: black/black, black/white, black/light gold/, black/gray, black/green, white/white, white/gold, light gold/light gold, light gold/gold, light gold/gray, gray/green, gold/gold, gray/gray; there are no pairs of black/gold, white/light gold, white/gray, light gold/green, or gray/gold. A recent structural analysis of this weaving, conducted by Jane Eisenstein, reveals that Albers's weaving is in fact a double weave, not a triple weave as was previously thought. See http://www.softweave.com/.

14. In the listing of Albers's Bauhaus works, prepared when she received her diploma in 1930, this work was noted as a *Flügeldecke*; for her 1926 triple weave, *Yellow-Black-Gold*, now known only through the edition woven in Gunta Stölzl's workshop in Zurich in 1965 and from an old photograph at the Josef and Anni Albers Foundation, the word *Flügeldecke* is

crossed out and replaced with the word *Behang*, hanging. This information is courtesy of Dr Magdalena Droste, Bauhaus-Archiv, Berlin. Thanks to Sigrid Weltge for her help with the translations.

15. Poling, *Bauhaus Color*, p. 29.

16. See John Rowe, 'Standardization', pp. 239–264. Also see Susan Niles, 'Artist and Empire in Inca and Colonial Textiles', in Stone-Miller, *To Weave for the Sun*, pp. 50–65.

17. Clark Poling's important *Bauhaus Color* provides significant information regarding Klee's pedagogical practices at the Bauhaus, including a discussion of the Weaving Workshop. Magdalena Droste, in *Bauhaus 1919–1933*, pp. 62–65 and 144–145, also provides an account of Klee's teaching at the Weimar and Dessau Bauhaus. Sigrid Wortmann Weltge, in *Bauhaus Textiles*, mentions Klee (pp. 60, 109). See Jenny Anger, 'Klee's Unterricht in der Webereiwerkstatt des Bauhaus', in Droste, ed., *Das Bauhaus Webt*, for a compelling discussion of Klee's role in the Weaving Workshop. For a discussion of Klee's impact on Albers see Troy, 'Thread as Text', which partly informed my presentation, 'Paul Klee and the Bauhaus Weaving Workshop', at the 1998 Southeastern College Art Conference in Miami.

18. Students who took courses with Klee before 1927 include Helene Schmidt-Nonné, Benita Koch-Otte, Gunta Stölzl, and Gertrud Arndt; see Droste, ed., *Das Bauhaus Webt* and Droste, *Gunta Stölzl*, appendix. Klee's publications during his Bauhaus tenure include 'Wege des Naturstudiums' (Ways of Nature Study), 1923, in the *Bauhaus Report*, published for the 1923 Bauhaus exhibition; the Jena lecture, 'On Modern Art', 1924; *Pädagogisches Skizzenbuch*, published as the second of the 14 Bauhaus Books in 1925; and 'Exakte Versuche im Bereiche der Kunst', 1928 (see note 24, below). Major Klee exhibitions that Bauhaus students had access to include those at the Goltz Gallery, Munich, 1920 (362 works); First Bauhaus Exhibition, Weimar, 1923; Kunstverein, Jena, 1924; and Galerie Flechtheim, Berlin, 1929 (a large fiftieth-birthday exhibition). See Christian Rümelin, 'Klee und der Kunsthandel', unpublished manuscript in the Paul-Klee-Stiftung, Bern (1999).

19. See Anni Albers's interview with Neil Welliver, 'A Conversation with Anni Albers', p. 15; and Weber, 'Anni Albers to Date', in Weber, Jacob, and Field, *Woven and Graphic Art*, p.19.

20. At the present time, it is known that these students took Klee's course: Eric Comeriner, Hilde Reindl, Margarete Willers, Gertruds Preiswerk, Lena Meyer-Bergner, Anni Albers, and Otte Berger. The

Metropolitan Museum of Art has four notebooks by Gertrud Preiswerk, one notebook plus loose papers by Hilde Reindl, and one notebook plus loose papers by Margarete Willers. The Getty Research Institute has two notebooks by Eric Comeriner, one for Klee's course in the winter semester 1927–28; three notebooks by Hilde Reindl dated 1927; one notebook dated 1927 plus works on paper by Gertrud Preiswerk, and loose papers by Margarete Willers and Lena Meyer-Bergner both dated 1927 for Klee's course. The Bauhaus-Archiv has 45 pages of notes by Anni Albers, which I have translated, and material by Otte Berger (which I have not had a chance to see yet). Eric Mrosek's c. 1928 notebook at the Getty Research Institute is neither dated nor titled but it contains information similar to the other notebooks although slightly more technical and specific to weaving. This indicates a different class but one that was nevertheless influenced if not taught by Klee. Not all the notebooks are dated but those that are range from April 1927 (Preiswerk) to January 1928 (Comeriner). Droste suggests that Klee divided his classes into two parts: one for junior students, one for senior students; see Droste, *Bauhaus*, p. 144. Based on Klee's Dessau syllabi and the early 1927 date of Preiswerk's notebook, Klee could have taught as many as eight separate sections over the period of four semesters (1927, 1927–28, 1928, 1928–29); this may explain the discrepancies of date and sequence.

21. Paul Klee, *Beiträge zur bildnerischen Formlehre*, ed. Jürgen Glaesemer, Basel: Schwabe, 1979, is a facsimile of Klee's own notebook for his 1921–22 Bauhaus course. Klee's *Pädagogisches Skizzenbuch*, published as the second of the 14 Bauhaus Books in 1925, and in English as *Pedagogical Sketchbook*, ed. Walter Gropius and Laszlo Moholy-Nagy, trans. Sibyl Moholy-Nagy, New York: Praeger, 1953, contains excerpts from the 'Beiträge'. Paul Klee, *Notebooks*, Vol. 1: *The Thinking Eye*, ed. Jürg Spiller, trans. Ralph Manheim et al., New York: Wittenborn, 1961, and Vol. 2: *The Nature of Nature*, ed. Jürg Spiller, trans. Heinz Norden, New York: Wittenborn, 1973, are confusing as to the actual dates and sequences of Klee's lectures, as many of his notes were not dated.

22. Klee's syllabus from 9 January 1928 to 9 April 1929 is reproduced on pp. 38–41 in Paul Klee, *Notebooks*, Vol. 2: *The Nature of Nature*.

23. Poling, *Bauhaus Color*, p. 9; Christian Geelhaar, *Paul Klee and the Bauhaus*, New York: New York Graphic Society, 1973, p. 29.

24. Paul Klee, 'Exakte Versuche im Bereiche der

Kunst', 1928, in *Bauhaus Zeitschrift für Gestaltung*, Vol. 2, No. 2, 1928; English version, 'Exact Experiments in the Realm of Art', in Paul Klee, *Notebooks*, Vol. 1: *The Thinking Eye*.

25. Anger, in 'Klee's Unterricht', makes similar observations.

26. Anni Albers', interview with Sevim Fesci, p. 3. (Note how Albers preferred to use the masculine pronoun for groups of mixed gender: 'his own development', etc.).

27. Paul Klee, note to Lily, in *Notebooks*, Vol. 1, p. 33.

28. Weltge, *Bauhaus Textiles*, p. 109 (and note 10, p. 194).

29. Droste, *Bauhaus*, p. 144.

30. Poling, *Bauhaus Color*, p. 34.

31. Droste, *Gunta Stölzl*, p. 144; also I would like to thank Stefan Frey, Curator of the Paul Klee Estate, for providing information about Klee's personal collection.

32. Paul Klee, *Beiträge*: 'pure', p. 42, 16 January 1922; 'primitive', p. 55 from section 4, 'Structure'. These comments were written in Klee's edited version of these notes, *Pädagogisches Skizzenbuch* (Pedagogical Sketchbook), published as the second of the 14 Bauhaus Books in 1925, p. 22. Josef and Anni Albers owned a copy of this work, now at the Josef and Anni Albers Foundation.

33. Poling, *Kandinsky*, p. 47.

34. Paul Klee, PN30 M60/71, 'Pädagogischer Nachlass (Specielle Ordnung)', no date, Paul-Klee-Stiftung, in Klee's *Notebooks*, Vol. 2, p. 146.

35. For this section of the course student Hilde Reindl used the term *Mahlenschema* (spinning pattern), Book I, F1F6, p. 27, Getty Research Institute, Los Angeles, CA.

36. Paul Klee, *Notebooks*, Vol. 2, p. 38.

37. Ibid., p. 33.

38. Weltge, in *Bauhaus Textiles*, p. 60, briefly notes Koch-Otte's indebtedness to Klee. Significantly, after leaving the Bauhaus, Koch-Otte continued to develop Klee's color theories at the Weaving Department of the German therapeutic institution Bodelschwinghsche-Anstalten from 1934 to 1957; see ibid., p. 61.

39. Droste, *Gunta Stölzl*, p. 143.

40. Poling, *Kandinsky*, p. 48. Also see Poling, *Bauhaus Color*, p. 37, and Clark V. Poling, *Kandinsky's Teaching at the Bauhaus*, New York: Rizzoli, 1986, pp. 15, 29, 66.

41. Goldwater, *Primitivism*, pp. 137–138.

42. Michael Baumgartner, 'Josef Albers und Paul Klee – Zwei Lehrerpersönlichkeiten am Bauhaus', in Helfenstein and Mentha, eds, *Josef und Anni Albers: Europa*

und Amerika, pp. 165–186.

43. Ibid., pp. 185–186.

44. Anni Albers, interview with Sevim Fesci, p. 5.

45. Anni Albers, interview with Richard Polsky for the Columbia University American Craftspeople Project, 1985, 'The Reminiscences of Anni Albers', Oral History Research Office, Columbia University, 1988, pp. 49–51.

46. Quoted in Droste, *Bauhaus*, p. 166.

47. Ibid., p. 184.

48. Mary Jane Jacob, in her article 'Anni Albers: A Modern Weaver as Artist', briefly mentioned that Anni Albers's open weaves developed from her contact with Peruvian weaving; see Weber, Jacob, and Field, *Woven and Graphic Art*, p. 72.

49. Reiss and Stübel, *The Necropolis of Ancon*, pp. 70, 71.

50. Anni Albers, interview with Richard Polsky, p. 32.

51. In *On Designing*, p. 16. (Albers always used the male pronoun for mixed-gender groups, as in her reference to the Peruvian weaver as 'he').

52. Anni Albers, 'Bauhausweberei', p. 188.

53. Anni Albers and Nicholas Fox Weber, video interview, 1984, p. 97; Droste, *Gunta Stölzl*, p. 156.

54. Jacob, 'Anni Albers', p. 72.

55. Ibid., p. 104. In her 1984 video interview with Nicholas Fox Weber, Albers told a story about when Johnson first saw her samples. He thought they were by Lily Reich, because Reich had apparently taken credit for them earlier.

Chapter Five

1. Karl A. Taube, *The Albers Collection of Pre-Columbian Art*, New York: Hudson Hill Press, 1988, preface by Nicholas Fox Weber, p. 9. Also, in a 1984 video interview, Albers stated that she had persuaded others to go to Mexico and to the ancient sites there; see Anni Albers and Nicholas Fox Weber, video interview, 1984, Josef and Anni Albers Foundation.

2. See Kirk Varnedoe, 'Abstract Expressionism', in Rubin, ed., '*Primitivism*', pp. 624–633, for political implications regarding the reception of these non-African societies by Americans in the 1930s and 1940s.

3. Diana Fane, 'Reproducing the Pre-Columbian Past: Casts and Models in Exhibitions of Ancient American Art 1824–1935', in Elizabeth Boone, ed., *Collecting the Pre-Columbian Past*, Washington, DC: Dumbarton Oaks, 1993. See also Barbara Braun, 'Diego Rivera: Heritage and Politics', in her *Pre-Columbian Art in the Post-Columbian World*, New York: Abrams, 1993, for a discussion of the journal *Mexican Folkways*.

4. Edward Lucie-Smith, *Latin American Art of the Twentieth Century*, London: Thames and Hudson, 1993, pp. 7–20.

5. James Oles, *South of the Border*, New Haven: Yale University Press, 1993, pp. 159–164. Jean Charlot, for example, who would later teach at Black Mountain College, spent three seasons working at the site as an artist-in-residence sponsored by the Carnegie Institute of Washington. See also Helen Delpar, *The Enormous Vogue for Things Mexican*, Tuscaloosa: University of Alabama Press, 1992, p. 103.

6. This well was excavated by Edward Thompson early in the century, and was eventually deposited in the Peabody Museum at Harvard University. See *National Geographic*, January 1925, p. 91, for an article by archaeologist Sylvanus Morley sponsored by the Carnegie Institute; Oles, *South of the Border*, p. 289, n. 105; and Delpar, *Enormous Vogue*, p. 99; see also Robert Brunhouse, *In Search of the Maya: the First Archaeologist*, Albuquerque: University of New Mexico Press, 1973, pp. 184–193. See Braun, *Pre-Columbian Art*, p. 193, for early-twentieth-century excavations in Mexico.

7. Albers and Coe, *Pre-Columbian Mexican Miniatures*, p. 4.

8. Elizabeth Boone, 'Collecting the Pre-Columbian Past: Historical Trends and the Process of Reception and Use', in her *Collecting*, pp. 323–325. Two articles dealing with Bingham's rediscovery of Machu Picchu were published in *National Geographic*, no. 24, 1913, and no. 27, 1915.

9. Delpar, *Enormous Vogue*, pp. 112–113.

10. Holger Cahill, *American Sources of Modern Art*, New York: Museum of Modern Art, 1933.

11. W. Jackson Rushing, *Native American Art and the New York Avant-garde: a History of Cultural Primitivism*, Austin: University of Texas Press, 1995, p. 105.

12. Cahill, *American Sources*, p. 5.

13. Ibid., p. 9.

14. Josef Albers, 'Truthfulness in Art', lecture delivered at Black Mountain College, 1939, pp. 6–7, transcript at the Josef and Anni Albers Foundation.

15. Cahill, *American Sources*, p. 8.

16. Ibid., pp. 18–20.

17. Josef Albers, 'Truthfulness', p. 9.

18. Anni Albers, *On Weaving*, 1965.

19. Black Mountain College Papers, North Carolina State Archives, Raleigh, NC, Vol. II, Box 2, January 1943.

20. See Oles, *South of the Border*, p. 145, for further comment on this exhibit.

21. Personal communication with Nicholas Fox Weber, 1995, who mentioned that the Alberses were friends with Covarrubius; however, Anni Albers wrote that they never met him; see Albers and Coe, *Pre-Columbian Mexican Miniatures*, p. 2.

22. Oles, *South of the Border*, p. 237. D'Harnoncourt is not to be confused with Raoul d'Harcourt, the French scholar of Andean textiles.

23. A list of their travels is as follows: 1934, Havana, Florida; 1935, Mexico; 1936, Mexico; 1937, Mexico; 1938, Florida; 1939, Mexico; 1940, Mexico; 1941, Mexico; 1946–47, Mexico, New Mexico; 1949, Mexico; 1952, Mexico, Havana; 1953, Chile, Peru; 1956, Mexico, Peru, Chile; 1962, Mexico; 1967, Mexico. This list was compiled from documents at the Josef and Anni Albers Foundation, and the *Black Mountain College Papers*, North Carolina State Archives, Raleigh, NC.

24. When Toni Ullstein Fleischmann and Sigfried Fleischmann came to Veracruz in 1939 it was because they were fleeing Nazi Germany. See Toni Ullstein Fleischmann, 'Souvenir', 1937, 1939. Josef Albers's photograph collection belongs to the Josef and Anni Albers Foundation.

25. Monte Albán and Mitla were at that time accessible to tourists and scholars.

26. Weber, in Taube, *Albers Collection*, pp. 9, 10.

27. The Albers Collection of Pre-Columbian Art is now housed in the Peabody Museum, the Yale University Art Gallery, New Haven, CT, the Josef and Anni Albers Foundation, and the Bottrop Museum, Germany.

28. Taube, *Albers Collection*, pp. 9–10.

29. Albers and Coe, *Pre-Columbian Mexican Miniatures*, p. 2. In her 1984 video interview with Nicholas Fox Weber, she said that they met Vaillant in Mexico when he was excavating near a railroad station.

30. Regarding the Pan-American Highway, see Oles, *South of the Border*, p. 79. See also a letter from Josef and Anni Albers to Wassily Kandinsky, 22 August 1936, in Wassily Kandinsky and Josef Albers, *Kandinsky–Albers: une correspondance des années trente*, Paris: Centre Pompidou, 1998, p. 77 (translation by Brenda Danilowitz and myself).

31. Fleischmann, 'Souvenir', pp. 1–25.

32. Black Mountain College Papers, North Carolina State Archives, Raleigh, NC, Vol. III, Box 1.

33. They stayed in Mexico at the home of Adrienne Gobert, and at the home of Mr Osborne Wood in La Luz; ibid., Vol. III, Box 1.

34. Josef Albers took numerous photographs of Rivera at Anahuacalli while the project was still under construction, between 1943 and 1955.

35. Braun, *Pre-Columbian Art*, p. 235.

36. Albers and Coe, *Pre-Columbian Mexican Miniatures*, p. 2.

37. Braun, *Pre-Columbian Art*, p. 235.

38. Albers and Coe, *Pre-Columbian Mexican Miniatures*, p. 3.

39. Ibid., p. 3.

40. Anni Albers, *On Weaving*, p. 57.

41. It is clear that by 1938 she owned a copy of Schmidt's 1929 *Kunst und Kultur von Peru*; her student Don Page also owned a copy which he ordered from Wittenborn Press with her help; letter to the author from Don Page, 4 September 1996.

42. Anni Albers, 1985 interview with Richard Polsky for the Columbia University Oral History Project, p. 44.

43. Ibid., pp. 45–46.

44. Mary Jane Jacob, 'Anni Albers: A Modern Weaver as Artist', in Weber, Jacob, and Field, eds, *Woven and Graphic Art*, p. 90. There is some discrepancy regarding the dates of these pieces; in the catalogue for a 1959 exhibition at MIT, *Monte Alban* was dated 1945. However, the Josef and Anni Albers Foundation firmly gives the date for both as 1936.

45. Albers and Coe, *Pre-Columbian Mexican Miniatures*, p. 2.

46. Mary Ellen Miller, *The Art of Mesoamerica*, London: Thames and Hudson, 1986, p. 85.

47. Anni Albers owned 113 Andean textiles upon her death in 1994. Sarah Lowengard catalogued this collection in 1995, sponsored by the Josef and Anni Albers Foundation.

48. Albers used the term 'palette' numerous times when speaking of her color choices. See Anni Albers, interview with Neil Welliver, 'A Conversation with Anni Albers', p. 21.

49. Mary Jane Jacob used the term 'margin-like borders' to describe the side portions of these two weavings; Jacob, 'Anni Albers', p. 93.

50. Anni Albers and Richard Polsky, interview, p. 43.

51. Information regarding *Zwei Kräfte* courtesy of the Josef and Anni Albers Foundation. The Alberses sold the work at some point after they came to the United States. See Michael Baumgartner, 'Josef Albers und Paul Klee – Zwei Lehrerpersönlichkeiten am Bauhaus', in Helfenstein and Mentha, eds, *Josef und Anni Albers: Europa und Amerika*, for further discussion of this and other Klee works that they owned.

52. Poling, *Kandinsky*, pp. 19–20, 36–48.

53. Anni Albers, *On Weaving*, p. 67.

54. Anni Albers, interview with Sevim Fesci, 1968, p. 5.

55. Anni Albers, interview with Neil Welliver, pp. 22–23.

56. Poling, *Kandinsky*, pp. 36, 48.

57. The piece is part of the Harriett Englehardt Memorial Collection, a textile collection established to honor one of Albers's students who died in 1945; see Chapter Six. The serape appears on an undated list of items belonging to this collection, which Albers probably typed. Ninety-two items were recorded, 76 of which were paid for in pesos, the remainder in US dollars. Not all the pieces were Mexican, however. There were 16 Peruvian pieces, three examples of tapa cloth from the South Seas, one Coptic piece, and two Italian pieces; Black Mountain College Papers, North Carolina State Archives, Raleigh, NC, Vol. II, Box 8.

58. Geelhaar, *Paul Klee and the Bauhaus*, pp. 98–106.

59. *Anni Albers: Pictorial Weavings*, exhibition catalogue, Massachusetts Institute of Technology, Cambridge MA: MIT Press, 1959.

60. Jacob, 'Anni Albers', p. 75.

61. The museum exhibition ran from 14 September to 6 November 1949. See the Anni Albers file at the Museum of Modern Art and Anni Albers, interview with Richard Polsky, p. 29.

62. Weltge, in *Bauhaus Textiles*, made a similar observation regarding the Bauhaus concerns; see p. 164.

Chapter Six

1. Lore Kadden Lindenfeld was a student at Black Mountain from 1944 to 1948; her weaving notebook is from Albers's Black Mountain course of 1948; see pp. 45, 46, 77 (the notebook is now in the Josef and Anni Albers Foundation).

2. Letter to the author from Don Page, 19 February 1996.

3. Letter to the author from Else Regensteiner, 2 January 1995.

4. Anni Albers, interview with Neil Welliver, 'A Conversation with Anni Albers', p. 20.

5. Anni Albers, interview with Sevim Fesci, p. 9.

6. Ibid., p. 9.

7. Weltge, *Bauhaus Textiles*, p. 164. Weltge also made a similar connection between Albers's weaving studies and the Bauhaus 'Preliminary Course' exercises.

8. Anni Albers, interview with Neil Welliver, p. 22.

9. Mary Emma Harris, *The Arts at Black Mountain College*, Cambridge, MA: MIT Press, 1987, p. 24.

10. Anni Albers, interview with Sevim Fesci, p. 9.

11. Anni Albers, 'One Aspect of Art Work', 1944, in her *On Designing*, p. 32.

12. Letter to author from Lore Kadden Lindenfeld, 20 November 1996. Albers owned the 1934 French

edition of d'Harcourt's text, *Les Textiles anciens du Pérou et leurs techniques* (copy at the Josef and Anni Albers Foundation).

13. Letter to the author from Tony Landreau, 25 September 1996.

14. Letter to the author from Don Page, 4 September 1996.

15. Anni Albers's slide and book collection are in the Josef and Anni Albers Foundation.

16. Letter to the author from Jack Lenor Larsen, 14 February 1996.

17. Letter to the author from Don Page, 19 February 1996.

18. Anni Albers, 'Work with Material' (1937), published first in *Black Mountain College Bulletin 5*, 1938, and in *On Designing*, p. 50.

19. Anni Albers, 'Art – A Constant' (1939), in *On Designing*, p. 52.

20. 'Bewildering' is from 'Work With Material', p. 50; 'chaotic' from 'Weaving at the Bauhaus' (1937), in Bayer, Gropius, and Gropius, eds, *Bauhaus, 1919–1928*, p. 141.

21. Anni Albers, 'Art – A Constant', p. 45.

22. Ibid., p. 46.

23. Ibid., p. 52.

24. Anni Albers, 'Weaving at the Bauhaus', in Bayer, Gropius and Gropius, eds, *Bauhaus, 1919–1928*, p. 141.

25. Ibid., p. 142.

26. 'Handweaving Today', in *Weaver*, Vol. 6, No. 1, January 1941; 'Designing', in *Craft Horizons*, Vol. 2, No. 2, May 1943; 'We Need Crafts for Their Contact with Materials', in *Design*, Vol. 46, No. 4, December 1944; 'One Aspect of Art Work', 1944; 'Constructing Textiles', *Black Mountain College Summer Art Institute Journal*, 1945; 'Design: Anonymous and Timeless', 1947; 'A Start', 1947; 'Fabrics', *Art and Architecture*, Vol. 64, March 1948; 'Weavings', *Art and Architecture*, Vol. 66, February 1949. Those essays not published previously appeared in *On Designing*.

27. Anni Albers, 'Designing', in *On Designing*, p. 57.

28. Anni Albers, 'Handweaving Today', p. 3.

29. Ibid.

30. Indeed, after her Bauhaus period, Albers made few preliminary watercolor designs. Rather, she designed at the loom.

31. Anni Albers, 'Constructing Textiles', in *On Designing*, p. 12.

32. Ibid., p. 15.

33. For example, he produced the 'Tenayuca' print series from 1938 to 1943; an oil painting 'Mexico', in 1938; 'To Mitla' (1940) from the 'Variants' screen prints series; the lithograph 'To Monte Alban' (1942)

from the 'Graphic Tectonics' series, and a wood engraving, 'Tlaloc', in 1944. See the preface by Weber, in Taube, *Albers Collection*, pp. 11–12.

34. Ibid., p. 11.

35. Neal Benezra, 'New Challenges Beyond the Studio: The Murals and Sculpture of Josef Albers', in Nicholas Fox Weber, ed., *Josef Albers: A Retrospective*, New York: Guggenheim Museum, 1988; Paternosto, 'Constructivist Histories', in his *The Stone and the Thread*; Oles, *South of the Border*, pp. 166–167. See also Helfenstein and Mentha, eds, *Josef und Anni Albers*.

36. Oles noted that Josef Albers preferred the restored buildings to the ruins, where 'the romance of a mysterious past' still lingered, implying that he was more interested in formal issues than iconographic or contextual ones. Oles, *South of the Border*, p. 167.

37. Benezra, 'New Challenges', p. 66.

38. Finkelstein, *Life and Art*, p. 117.

39. Paternosto, *The Stone and the Thread*, pp. 210, 211.

40. For a discussion about the formal and structural relationships between Andean textiles and architecture see Rebecca Stone-Miller and Gordon McEwan, 'The Representation of the Wari State in Stone and Thread', in *Res* (Cambridge, MA), Vol. 19, 1990.

41. Black Mountain College Papers, North Carolina State Archives, Raleigh, NC, Vol. III, Box I. Albers also had outside speaking engagements, and he attended many of his gallery openings, so the Alberses traveled quite often to New York, Harvard, and Washington, DC, as Don Page has recalled; letter to the author, 30 May 1996.

42. Black Mountain College Papers, North Carolina State Archives, Raleigh, NC, Vol. III, Box 2. It was during this trip that the Alberses met the Frenchman Jean Charlot, who was half Mexican, and who had in the 1920s worked on excavations at Chichén Itzá. Charlot taught at Black Mountain College for the summer of 1944; see Harris, *The Arts*, p. 96; Black Mountain College Papers, Vol. III, Box I; and Oles, *South of the Border*, p. 159. Albers may have met the Mexican artist Carlos Merida during this trip, too. Merida was at Black Mountain College in 1940 as a visiting faculty candidate; see Harris, *The Arts*, pp. 20, 21, 66.

43. Rushing, *Native American Art*, p. 123.

44. Anni Albers, 'Conversations with Artists' (1961), in *On Designing*, p. 63.

45. Rushing, *Native American Art*, p. 123.

46. Josef Albers, 'Truthfulness'. I am grateful to Kelly Feeney at the Josef and Anni Albers Foundation for providing me with copies of slides that Josef may have used for this particular lecture.

47. Ibid., p. 3.
48. Ibid., p. 11.
49. Ibid., p. 6.
50. Ibid., p. 11.
51. Black Mountain College Papers, North Carolina State Archives, Raleigh, NC, September 1939, Vol. II, Box 21.
52. Martin Duberman, *Black Mountain College: An Exploration in Community*, New York: Dutton, 1972, p. 61, and p. 458, n. 36, from the reminiscences of Peggy Bennett Cole, c. 1960s.
53. Harris, *The Arts*, p. 13, from a letter to Willard Beatty, 29 August 1940, Black Mountain College Papers, North Carolina State Archives, Raleigh, NC, Vol. I, Box 4 (however, the staff at the Archives were unable to locate this letter in the summer of 1996). See Kandinsky and Albers, *Kandinsky–Albers: une correspondance*, p. 79 for more information related to the trip.
54. Fleischmann, 'Souvenirs', p. 24.
55. Weber in Taube, *Albers Collection*, pp. 11–12.
56. Albers and Coe, *Pre-Columbian Mexican Miniatures*, p. 4.
57. Taube, *Albers Collection*, plate II-8.
58. Fleischmann, 'Souvenirs', p. 24.
59. Ibid., p. 24.
60. Anni Albers, 'Designing', in *On Designing*, p. 56.
61. Ibid., p. 56.
62. Black Mountain College received $2011.31, the entirety of Harriett's estate. A November 1947 news release from Black Mountain College stated that 77 pieces had so far been purchased for the Harriett Englehardt Memorial Collection of Textiles by Albers during her and Josef's sabbatical; the recently purchased pieces were released by Customs to Black Mountain College. An undated expense account in the file, probably typed by Anni Albers, listed 92 pieces in the collection, including Oceanic, African, and Coptic pieces, but primarily modern Mexican pieces totaling $962.57, including cleaning, shopping and miscellaneous expenses. See Black Mountain College Papers, North Carolina State Archives, Raleigh, NC, Vol. II, Box 8.
63. Anni Albers, letter, ibid., Vol. II, Box 8. At this time, Albers wrote to the Englehardts requesting a yearly donation to augment the fund.
64. Ibid., Vol. II, Box 8.
65. Ibid.
66. Yale University Art Gallery, Englehardt file, 31 May 1949. Guermonprez taught weaving during Albers's 1946–47 sabbatical. Also at this point Albers created a Trust for the collection, knowing that she would be leaving the college.

67. Landreau's accompanying notes (now in the Josef and Anni Albers Foundation) stated that he used Philip Means's 1930 text, *Peruvian Textiles*, from the Metropolitan Museum, as his source; 100 pieces were accounted for.
68. Letter to the author from Tony Landreau, 25 September 1996.
69. In 1958, 8–22 October, an exhibition of mainly the modern Mexican textiles from the Englehardt Collection, along with 35 photographs of Peru by John Cohen, took place at Yale; see Yale University Art Gallery, Englehardt file.
70. One red trunk and one green trunk, located in the office of the Curator of Ancient Art, contain the majority of the collection, mainly nineteenth- and twentieth-century Mexican and Peruvian pieces. A large Mexican serape from Queretaro is framed and hanging in the downstairs gallery. Approximately 15 textiles, mainly Andean fragments, but including South Seas and Coptic pieces, are in the original frames. These are in the textile storage room.
71. Yale University Art Gallery, Englehardt file. Some black and white photographs were made of various pieces in the Yale collection, five of which appear to be of textiles also in the Albers collection: Yale no. 1958.13.2 = Albers no. PC091 and PC112; 1958.13.3 = PC030 and PC070; 1958.13.4 = PC020 and PC092; 1958.13.6 = PC099 = Black Mountain College no. A8; 1958.13.5 = PC113 and similar to PC018. I did not locate two pieces: the Nazca braid 1958.13.8/BMC A14, and 1958.13.7/BMC A12.
72. Anni Albers, *On Weaving*, p. 45. Cutting Andean textiles continues today; one of the purposes of Rebecca Stone-Miller's 1987 Ph.D. dissertation, 'Technique and Form in Huari-style Tapestry Tunics: The Andean Artist A.D. 500–800', Yale University, was to reunite as many tunic pieces as possible.
73. See the transcript of Lowengard's research in the Josef and Anni Albers Foundation.
74. Yale University Art Gallery, no. 158.13.97.

Chapter Seven
1. Anni Albers, 'A Structural Process in Weaving' (1952), in *On Designing*.
2. Their correspondence occurred between February and May 1952. These letters were made available to me courtesy of the American Museum of Natural History; they are in the Anni Albers File in the Junius B. Bird Papers. Bird would later teach a course at Yale, Anthropology 146a: 'Pre-historic Fabric Development in the New World', in the Winter semester of 1961–62. Among those attending the class were Anni

Albers, Michael Coe, Sewell Sillman, Delores Bittleman, and Dorothy Cavalier.

3. Susan Niles in her article 'Artist and Empire in Inca Colonial Textiles', in Stone-Miller, *To Weave for the Sun*, p. 56, proposed a hinged loom that would also accomplish a large web.

4. See Troy, 'Thread as Text', pp. 28–39.

5. Yale University Art Gallery, nos 1958.13.12 and 1958.13.13.

6. Anni Albers, *On Weaving*, p. 68.

7. This information is courtesy of Dr Leverett Smith, North Carolina Wesleyan College, where the Black Mountain College Library is now housed. A 1944 copy of Klee's *Pedagogical Sketchbook* is also in the collection.

8. The author would like to thank members of the Paul-Klee-Stiftung, Kunstmuseum Bern, for their help with this project, and in locating gallery photographs. See the Albers book collection in the Josef and Anni Albers Foundation.

9. *De Stijl*, Vol. 1, No. 3. See Paul Overy, *De Stijl*, London: Thames and Hudson, 1991, Chapter 9, pp. 147–165, for a discussion of De Stijl's presence at the Bauhaus.

10. Personal communication from Nicholas Fox Weber to me, 18 November 1996.

11. Correspondence between Junius B. Bird and Anni Albers, February and March 1952, courtesy of the American Museum of Natural History, Junius B. Bird Papers.

12. *De Stijl*, exhibition catalogue, published in 1951 by the Stedelijk Museum, Amsterdam for the 1951 De Stijl exhibition there and the 1952 New York exhibition.

13. In 1947, the Bliss Collection of Pre-Columbian art was loaned to the National Gallery of Art where it remained and grew until 1962 when it became part of the Dumbarton Oaks Library and Collection, Washington, DC, in a building designed by Philip Johnson. See Elizabeth P. Benson, 'The Robert Woods Bliss Collection of Pre-Columbian Art: A Memoir', in Boone, *Collecting*, pp. 15–34. The Nazca feather tunic and the Wari tunic, both illustrated in Lehmann's text, formerly in the Gaffron Collection, are now part of the Eduard Gaffron Collection of the Art Institute of Chicago.

14. Wendell Bennett, *Ancient Art of the Andes*, New York: Museum of Modern Art, 1954, p. 78.

15. Rebecca Stone-Miller, 'Camelids and Chaos in Huari and Tiwanaku Textiles', in Richard Townsend, ed., *The Ancient Americas*, Chicago: Art Institute of Chicago, 1992, p. 336. This particular tunic, like

other Wari tunics, was woven 'sideways' in two parts and then attached at the center and turned vertically. In other words, the warp runs from left to right as the viewer faces the tunic, and therefore the pattern was woven sideways.

16. This reading was suggested by Rebecca Stone-Miller in a personal communication with the author, March 1997.

17. Toni Ullstein Fleischmann, Anni's mother, describes this purchase in her travel diaries; see Toni Ullstein Fleischmann, 'Souvenir'.

18. *Anni Albers: Pictorial Weavings*, p. 3.

19. Anni Albers, 'Handweaving swToday', p. 3.

20. Nicholas Fox Weber, 'The Last Bauhausler', p. 138, and Kelly Feeney, 'Anni Albers: Devotion to Material', pp. 118–123, in Weber and Asbaghi, eds, *Anni Albers*.

21. Nicholas Fox Weber, 'Anni Albers to Date', p. 29.

22. Feeney, 'Anni Albers', p. 122.

23. Anni Albers, *On Weaving*, p. 6.

24. Ibid., pp. 69–70.

25. Ibid., p. 69.

Select
bibliography

Albers, Anni, 'Bauhausweberei', in *Junge Menschen*,
'Bauhaus Weimar Sonderheft der Zeitschrift,
Weimar', November 1924, Vol. 5, No. 8,
Hamburg; Munich: Kraus Reprint, 1980 (pub-
lished under Albers's maiden name, Annelise
Fleischmann).

—, 'Economic Living', in *Neue Frauenkleidung und
Frauenkultur*, Karlsruhe, 1924, trans. in Frank
Whitford, *Bauhaus*, London: Thames and Hudson,
1984.

—, 'Handweaving Today', in *Weaver*, Vol. 6, No. 1,
January 1941.

—, *On Designing*, originally published in 1959 by
Pellango Press, New Haven. Re-published by
Wesleyan Press, Middletown, CT in 1961 (reprint-
ed 1987); including twelve essays published in
1937–61:
 1937 'Work with Material', in *Black Mountain College
 Bulletin 5*, 1938.
 1938 'Weaving at the Bauhaus', in Herbert Bayer,
 Ise and Walter Gropius, eds, *Bauhaus,
 1919–1928*, Museum of Modern Art, NY,
 1938.
 1939 'Art – A Constant'
 1943 'Designing', *Craft Horizons*, Vol. 2, No. 2, May
 1943.
 1944 'One Aspect of Art Work'
 1945 'Constructing Textiles' in *Black Mountain College
 Summer Art Institute Journal*
 1947 'Design: Anonymous and Timeless'
 1947 'A Start'
 1952 'A Structural Process in Weaving'
 1957 'The Pliable Plane: Textiles in Architecture',
 in *Perspecta Yale Art Journal*, Vol. 4
 1957 'Refractive?'
 1961 'Conversations with Artists'

—, *On Weaving*, Middletown, CT: Wesleyan University
Press, 1965.

—, and Neil Welliver, 'A Conversation with Anni
Albers', in *Craft Horizons*, July/August 1965.

—, and Sevim Fesci, interview, the Archives of
American Art, 1968, transcript at the Josef and
Anni Albers Foundation, Bethany, CT.

—, and Michael Coe, *Pre-Columbian Mexican Miniatures:*

The Josef and Anni Albers Collection, New York: Praeger,
1970.

—, and Nicholas Fox Weber, video interview, 1984,
at the Josef and Anni Albers Foundation, Bethany,
CT.

—, and Richard Polsky, interview, 1985, for the
Columbia University American Craftspeople
Project, 'The Reminiscences of Anni Albers', Oral
History Research Office, Columbia University,
1988, transcript at the Josef and Anni Albers
Foundation, Bethany, CT.

—, and Maximilian Schell, interview c. 1986, tran-
script at the Josef and Anni Albers Foundation,
Bethany, CT.

—, *Anni Albers: Pictorial Weavings*, exhibition catalogue,
Massachusetts Institute of Technology, Cambridge,
MA: MIT Press, 1959.

—, *Anni Albers: Drawings and Prints*, New York: Brooklyn
Museum, 1977: includes interview with Anni
Albers by Gene Baro.

Albers, Josef, 'Truthfulness in Art', lecture delivered at
Black Mountain College, 1939, transcript at the
Josef and Anni Albers Foundation, Bethany, CT.

—, and Wassily Kandinsky, *see* Kandinsky.

Atwater, Mary Meigs, *The Shuttle-Craft Book of American
Hand-Weaving*, New York: Macmillan, revised edition
1951 (first published 1928).

Baessler, Arthur, *Ancient Peruvian Art*, trans. A.H. Keane,
4 vols, Berlin: Asher and Co., and New York:
Dodd, Mead and Co., 1902–03.

Bahr, Hermann, *Expressionismus*, Munich, 1916.
Portions of the text appear in English in *Modern Art
and Modernism*, eds Francis Frascina and Charles
Harrison, New York: Harper and Row, 1982.

Bauhaus Zeitschrift für Gestaltung, Vol. 7, No. 2, July 1931
(Bauhaus-Sonderheft, 1931–32).

Baumhoff, Anja, 'Gender, Art and Handicraft at the
Bauhaus', Ph.D. dissertation, Johns Hopkins
University, 1994 (reproduced from Ann Arbor, MI:
University Microfilms International, 1994).

Bayer, Herbert, Walter Gropius and Ise Gropius, eds,
Bauhaus, 1919–1928, New York: Museum of Modern
Art, 1938 (1959 edition, Boston: C.T. Branford).

Bennett, Wendell, *Ancient Art of the Andes*, New York:
Museum of Modern Art, 1954.

Bird, Junius B., 'Technology and Art in Peruvian Textiles', in *Technique and Personality*, New York: Museum of Primitive Art, 1963.

—, and Milica Skinner, 'The Technical Features of a Middle Horizon Tapestry Shirt from Peru', in *Textile Museum Journal*, December 1974.

Boas, Franz, *Primitive Art*, Oslo: H. Aschehoug and Co., 1927 (also published in Leipzig, Paris, London, and Cambridge, MA).

Boone, Elizabeth, ed., *Collecting the Pre-Columbian Past*, Washington, DC: Dumbarton Oaks, 1993.

Braun, Barbara, *Pre-Columbian Art in the Post-Columbian World*, New York: Abrams, 1993.

Brühl, Georg, *Herwarth Walden und 'Der Sturm'*, Cologne: DuMont Buchverlag, 1983.

Cahill, Holger, *American Sources of Modern Art*, New York: Museum of Modern Art, 1933.

Cross, Anita, 'The Educational Background to the Bauhaus', in *Design Studies*, Vol. 4, No. 1, January 1983.

Delpar, Helen, *The Enormous Vogue for Things Mexican*, Tuscaloosa: University of Alabama Press, 1992.

Delphic Studios, *Four Painters: Albers, Dreier, Drewes, Kelpe*, exhibition 23 November–5 December 1936, catalogue, New York: Delphic Studios, 1936.

Douglas, Charlotte, 'Russian Textile Design 1928–33', in *The Great Utopia: The Russian and Soviet Avant-Garde 1915–1932*, New York: Guggenheim Museum, 1992.

—, 'Suprematist Embroidered Ornament', *Art Journal*, Vol. 54, No. 1, Spring 1995.

Droste, Magdalena, *Gunta Stölzl*, Berlin: Bauhaus-Archiv, 1987.

—, *Bauhaus, 1919–1933*, Berlin: Bauhaus-Archiv, 1990.

—, ed., *Das Bauhaus Webt*, Berlin: Bauhaus-Archiv, 1998.

Duberman, Martin, *Black Mountain College: An Exploration in Community*, New York: Dutton, 1972.

Eisleb, Dieter, and Renate Strelow, *Tiahuanaco*, Berlin: Museum für Völkerkunde, 1980.

Fineberg, Jonathan, ed., *Discovering Child Art: Essays on Childhood, Primitivism, and Modernism*, Princeton, NJ: Princeton University Press, 1998, with essays by Josef Helfenstein, 'The Issue of Childhood in Klee's Late Work', and Marcel Franciscono, 'Paul Klee and Children's Art'.

Finkelstein, Irving Leonard, 'The Life and Art of Josef Albers', Ph.D. thesis, New York University dissertation, 1968 (reproduced from Ann Arbor, MI: University Microfilms International).

Franciscono, Marcel, *Walter Gropius and the Creation of the Bauhaus in Weimar*, Urbana: University of Illinois Press, 1971.

—, *Paul Klee: His Work and Thoughts*, Chicago: University of Chicago Press, 1991.

Fry, Roger, 'Ancient American Art', *Burlington Magazine*, 1918, reprinted in Fry's *Vision and Design*, New York: Coward-McCann, 1932.

Fuhrmann, Ernst, *Reich der Inka*, Hagen and Darmstadt: Folkwang Museum, 1922.

Gayton, Anna, 'The Cultural Significance of Peruvian Textiles: Production, Function, Aesthetics', in John Howland Rowe and Dorothy Menzel, eds, *Peruvian Archaeology*, Palo Alto: Peek Publication, 1973.

Geelhaar, Christian, *Paul Klee and the Bauhaus*, New York: New York Graphic Society, 1973 and enlarged edition Cambridge, MA: Belknap, 1986.

Goldwater, Robert, *Primitivism and Modern Painting*, New York: Random House, 1938; revised edition, *Primitivism in Modern Art*, New York: Vintage, 1967.

Grohmann, Will, *Paul Klee*, New York: Abrams, 1954.

Harcourt, Raoul d', *The Textiles of Ancient Peru and their Techniques*, Seattle: University of Washington Press, 1987 (first published 1962), a translation, with revisions and additional material, of *Les Textiles anciens du Pérou et leurs techniques*, published in Paris in 1934.

—, and Marguerite d'Harcourt, *Les Tissus indiens du vieux Pérou*, Paris: A. Morancé [c. 1924].

Harris, Mary Emma, *The Arts at Black Mountain College*, Cambridge, MA: MIT Press, 1987.

Hartmann, Günter, *Masken Südamerikanischer Naturvölker*, Berlin: Museum für Völkerkunde, 1967.

Hausenstein, Wilhelm, *Barbaren und Klassiker: ein Buch von der Bildnerei exotischer Völker*, Munich: Piper Verlag, 1922.

Helfenstein, Josef, and Henriette Mentha, eds, *Josef und Anni Albers: Europa und Amerika* (exhibition catalogue, Kunstmuseum Bern); Cologne: Dumont, 1998.

Hesse-Frielinghaus, Herta, *Karl Ernst Osthaus. Leben und Werk*, Recklinghausen: Bongers, 1971.

Hille, Karoline, *Spuren der Moderne, Die Mannheimer Kunsthalle von 1919–1933*, Berlin: Akademie Verlag, 1994.

Hocquenghem, Anne-Marie, ed., *Pre-Columbian Collections in European Museums*, Budapest: Akademiai Kiado, 1987. Includes essays by Immina von Schuler-Schömig, 'The Central Andean Collections at the Museum für Völkerkunde, Berlin, their Origin and Present Organization'; George Bankes, 'The Pre-Columbian Collections at the Manchester Museum'; J.C.H. King, 'The North American Archaeology and Ethnography at the Museum of Mankind, London'; Christian Feest, 'Survey of the Pre-Columbian Collections from the Andean

Highlands in the Museum für Völkerkunde, Vienna'; and Corinna Raddatz, 'Christian Theodor Wilhelm Gretzer and his Pre-Columbian Collection in the Niedersächsisches Landesmuseum of Hannover'.

Itten, Johannes, *The Art of Color*, New York: Van Nostrand Reinhold, 1973 (first published as *Kunst der Farbe*, 1961).

Jones, Owen, *The Grammar of Ornament*, London: Day and Sons, 1856.

Kandinsky, Wassily, *Über das Geistige in der Kunst*, Munich: Piper, 1912, trans. as *Concerning the Spiritual in Art*, New York: Wittenborn, Schultz, Inc., 1947.

—, 'Reminiscences' (1913), in Robert Herbert, ed., *Modern Artists on Art*, Englewood Cliffs, NJ: Prentice-Hall, 1964.

—, Franz Marc and August Macke, eds, *Der Blaue Reiter Almanach*, Munich: Piper-Verlag, 1912 (*The Blaue Reiter Almanac*, trans. H. Falkenstein, intro. by Klaus Lankheit, London: Thames and Hudson, 1974).

—, and Josef Albers, *Kandinsky–Albers: une correspondance des années trente*, Paris: Centre Pompidou, 1998.

Klee, Paul, 'On Modern Art' (1924), in Robert Herbert, ed., *Modern Artists on Art*, Englewood Cliffs, NJ: Prentice-Hall, 1964.

—, *Pedagogical Sketchbook*, ed. Walter Gropius and Laszlo Moholy-Nagy, trans. of *Pädagogisches Skizzenbuch* (1925) by Sibyl Moholy-Nagy, New York: Praeger, 1953.

—, *Notebooks*, Vol. 1: *The Thinking Eye*, ed. Jürg Spiller, trans. Ralph Manheim et al., New York: Wittenborn, 1961.

—, *Notebooks*, Vol. 2: *The Nature of Nature*, ed. Jürg Spiller, trans. Heinz Norden, New York: Wittenborn, 1973.

—, *Beiträge zur bildnerischen Formlehre*, ed. Jürgen Glaesemer, Basel: Schwabe, 1979.

Felix Klee, *Paul Klee, His Life and Work in Documents*, New York: Braziller, 1962.

—, ed., *The Diaries of Paul Klee 1898–1918*, Berkeley: University of California Press, 1964.

Köch-Grünberg, Theodor, *Anfänge der Kunst im Urwald*, Berlin: Wasmuth, 1905.

Krauss, Rosalind, 'No More Play', in '*Primitivism' in Twentieth Century Art: Affinity of the Tribal and the Modern*, ed. William Rubin, New York: Museum of Modern Art, 1984.

Kühn, Herbert, *Die Kunst der Primitiven*, Munich: Delphin-Verlag, 1923.

Lehmann, Walter, *Kunstgeschichte des Alten Peru*, Berlin: Wasmuth, 1924 (written with the collaboration of Heinrich Doering); English edition, *The Art of Old Peru*, London and New York, 1924.

Levinstein, Siegfried, *Kinderzeichnungen bis zum 14. Lebensjahr*, Leipzig: R. Voigländer, 1905.

Lloyd, Jill, 'Emil Nolde's "Ethnographic" Still Lifes: Primitivism, Tradition, and Modernity', in Susan Hiller, ed., *The Myth of Primitivism*, London: Routledge, 1991.

—, *German Expressionism: Primitivism and Modernity*, New Haven: Yale University Press, 1992.

Lodder, Christina, *Russian Constructivism*, New Haven: Yale University Press, 1990 (first published 1983).

MacDonald, Stuart, *The History and Philosophy of Art Education*, London: University of London Press, 1970.

Means, P. A., *Peruvian Textiles*, New York: Metropolitan Museum of Art, 1930; introduction by Joseph Breck.

—, *A Study of Peruvian Textiles*, Boston: Museum of Fine Arts, 1932.

Miller, J. Abbott, 'Elementary School', in *The ABC's of [Triangle Square Circle]: The Bauhaus and Design Theory*, ed. Ellen Lupton and J. Abbott Miller, New York: Cooper Union, 1993.

Naylor, Gillian, *The Bauhaus Reassessed*, New York: Dutton, 1985.

Oles, James, *South of the Border*, New Haven: Yale University Press, 1993.

Osthaus, Karl Ernst, *Grudzüge der Stilentwicklung*, Hagen: Folkwang Verlag, 1919; 1918 dissertation from Julius-Maximilians-Universität, Würzburg.

Paternosto, César, *The Stone and the Thread: Andean Roots of Abstract Art*, trans. Esther Allen, Austin: University of Texas Press, 1996.

Perry, Gill, 'Primitivism and the Modern', in *Primitivism, Cubism, Abstraction*, ed. Francis Frascina, Gill Perry and Charles Harrison, New Haven and London: Yale University Press, 1993.

Pevsner, Nikolaus, *Pioneers of Modern Design*, London: Penguin, 1991 (first published 1936).

Pierce, James S., *Paul Klee and Primitive Art*, New York: Garland, 1976.

Poling, Clark, *Bauhaus Color*, Atlanta: High Museum of Art, 1976.

—, *Kandinsky: Russian and Bauhaus Years 1915–1933*, New York: Solomon Guggenheim Foundation, 1983.

—, *Kandinsky's Teaching at the Bauhaus*, New York: Rizzoli, 1986.

Prinzhorn, Hans, *Artistry of the Mentally Ill: a Contribution to the Psychology and Psychopathology of Configuration*, New York: Springer-Verlag, 1972 (translation of *Bildnerei der Geisteskranken*, 1922).

Reeves, Ruth, 'Pre-Columbian Fabrics of Peru', *Magazine of Art*, March 1949.

Reiss, W., and A. Stübel, *Das Totenfeld von Ancon*, Vol. 1, Berlin: Asher & Co., 1880–87, English edition, *The Necropolis of Ancon in Peru*, trans. A.H. Keane, London and Berlin: Asher & Co., 1906.

Riegl, Alois, *Problems of Style, Foundations for a History of Ornament*, translation of *Stilfragen: Grundlegungen zu einer Geschichte der Ornamentik* (1893) by Evelyn Kain, introduction by David Castriota, Princeton NJ: Princeton University Press, 1992.

Rossbach, Ed, 'In the Bauhaus Mode: Anni Albers', *American Craft*, December–January 1983–84.

Rotzler, Willy, and Anneliese Itten, *Johannes Itten, Werk und Schriften*, Zurich: Orell Fussli Verlag, 1972.

Rowe, Ann, Pollard, Elizabeth Benson, and Anne-Louise Schaffer, eds, *The Junius B. Bird Conference on Andean Textiles*, Washington, DC: Textile Museum, 1984.

Rubin, William, ed., *'Primitivism' in Twentieth Century Art: Affinity of the Tribal and the Modern*, New York: Museum of Modern Art, 1984, including 'German Expressionism', by Donald Gordon; 'Paul Klee', by Jean Laude; 'Gauguin', and 'Abstract Expressionism', by Kirk Varnedoe.

Rushing, W. Jackson, *Native American Art and the New York Avant-garde: a History of Cultural Primitivism*, Austin: University of Texas Press, 1995.

Scheidig, Walther, *Crafts of the Weimar Bauhaus*, New York: Reinhold, 1967.

Schmidt, Max, 'Über Altperuanische Gewebe mit Szenenhaften Darstellungen', in *Baessler-Archiv Beiträge zur Völkerkunde*, ed. P. Ehrenreich, Vol. 1, Leipzig and Berlin: Teubner-Verlag, 1910 (reprinted by Johnson Reprint Corp., 1968).

—, *Kunst und Kultur von Peru*, Berlin: Propyläen-Verlag, 1929.

Schneckenburger, Manfred, 'Bermerkungen zur "Brücke" und zur "primitiven" Kunst', in *Welt Kulturen und Moderne Kunst*, ed. Siegfried Wichmann, Munich: Verlag Bruckmann, 1972.

Selz, Peter, *German Expressionist Painting*, Berkeley: University of California Press, 1974 (first published 1957).

Staatliche Museen zu Berlin, Museum für Völkerkunde, collection catalogues: Vol. 15, 1911: *Führer durch das Museum für Völkerkunde*; Vol. 16, 1914: *Die Ethnologischen Abteilungen*, both Berlin: Verlag Georg Reimer; Vol. 18, 1926: *Vorläufiger Führer*; Vol. 19, 1929: *Vorläufiger Führer*, both Berlin: Verlag Walter de Gruyter & Co.

Stone-Miller, Rebecca, *To Weave for the Sun: Andean Textiles in the Museum of Fine Arts, Boston*, Boston: Museum of Fine Arts, 1992. Includes essay by Margaret Young-Sanchez, 'Textile Traditions of the Late Intermediate Period'.

—, 'Camelids and Chaos in Huari and Tiwanaku Textiles', in Richard Townsend, ed., *The Ancient Americas*, Chicago: Art Institute of Chicago, 1992.

—, *Art of the Andes*, London: Thames and Hudson, 1995.

Stonge, Carmen, 'Karl Ernst Osthaus: The Folkwang Museum and the Dissemination of International Modernism', Ph.D. dissertation, City University of New York, 1993.

Stübel, Alphons, and Max Uhle, *Die Ruinenstätte von Tiahuanaco im Hochlande des Alten Perú*, Breslau: C.T. Wiskott, 1892.

Sydow, Eckart von, *Die Kunst der Naturvölker und der Vorzeit*, Berlin: Propyläen-Verlag, 1923.

—, *Die Deutsche Expressionistische Kultur und Malerei*, Berlin: Furche-Verlag, 1920.

Taube, Karl A., *The Albers Collection of Pre-Columbian Art*, preface by Nicholas Fox Weber, New York: Hudson Hill Press, 1988.

Tower, Beeke Sell, *Klee and Kandinsky in Munich and at the Bauhaus*, Ann Arbor, MI: UMI Research Press, 1981.

Troy, Virginia Gardner, 'Anni Albers: the Significance of Ancient American Art for her Woven and Pedagogical Work', Ph.D. dissertation, Emory University, 1997 (reproduced 1997, Ann Arbor, MI: University Microfilms International).

—, 'Anni Albers: the Significance of Pre-Columbian Art for Her Textiles and Writings', *Textile Society of America Proceedings*, Vol. 4, 1994.

—, 'Andean Textiles at the Bauhaus: Awareness and Application', *Surface Design Journal*, Vol. 20, No. 2, Winter 1996.

—, 'Anni Albers und die Textilkunst der Anden' (Anni Albers and the Andean Textile Paradigm), in *Josef und Anni Albers, Europa und Amerika*, ed. Josef Helfenstein and Henriette Mentha, exhibition catalogue, Kunstmuseum, Bern, Cologne: Dumont, 1998.

—, 'Thread as Text: The Woven Work of Anni Albers', in Nicholas Fox Weber and Pandora Tabatabai Asbaghi, eds, *Anni Albers*, New York: Abrams for Guggenheim Museum Publications, 1999, pp. 28–39.

Uhle, Max, *Kultur und Industrie Sudamerikanischer Volker*, 2 vols, Berlin, 1889–90.

—, *Pachacamac*, Philadelphia: University of Pennsylvania Press, 1903.

Weber, Nicholas Fox, Mary Jane Jacob, and Richard Field, *The Woven and Graphic Art of Anni Albers*, Washington, DC: Smithsonian Institution Press, 1985.

—, ed., *Josef Albers: A Retrospective*, exhibition catalogue, Solomon R. Guggenheim Museum, New York: Solomon R. Guggenheim Foundation, 1988.

—, and Pandora Tabatabai Asbaghi, eds, *Anni Albers*, New York: Abrams for Guggenheim Museum Publications, 1999.

Weiss, Peg, *Kandinsky in Munich, the Formative Jugendstil Years*, Princeton: Princeton University Press, 1979.

—, *Kandinsky and Old Russia, the Artist as Ethnographer and Shaman*, New Haven: Yale University Press, 1995.

Weltge, Sigrid Wortmann, *Bauhaus Textiles*, London: Thames and Hudson, 1993.

Werckmeister, O.K., 'The Issue of Childhood in the Art of Paul Klee', *Arts Magazine*, Vol. 52, No. 1, September 1977.

—, 'From Revolution to Exile', in *Paul Klee*, ed. Carolyn Lanchner, New York: Museum of Modern Art, 1987.

—, *The Making of Paul Klee's Career, 1914–1920*, Chicago: University of Chicago Press, 1989.

Wilk, Christopher, *Marcel Breuer*, New York: Museum of Modern Art, 1981.

Willet, John, *Art and Politics in the Weimar Period*, New York: Pantheon, 1978.

Willey, Gordon, and Jeremy Sabloff, *A History of American Archaeology*, New York: Freeman, 1993 (first published 1974).

Wingler, Hans, *The Bauhaus*, Cambridge MA: MIT Press, 1986 (first published 1969).

Worringer, Wilhelm, *Abstraktion und Einfühlung: ein Beitrag zur Stilpsychologie*, Munich: Piper-Verlag, 1908 (English edition, *Abstraction and Empathy*, trans. Michael Bullock, London: Routledge, 1953).

Index